PAUL SOLBERG

First published in 2015 by

Glitterati
INCORPORATED
New York | London

New York Office
630 Ninth Avenue, Suite 603
New York, NY 10036
Telephone: 212 362 9119

London Office
1 Rona Road
London NW3 2HY
Tel/Fax +44 (0) 207 267 8339

Glitteratiincorporated.com
media@GlitteratiIncorporated.com for inquiries

First edition, 2015

Library of Congress Cataloging-in-Publication
data is available from the publisher.

Hardcover edition ISBN 13: 978-0-9905320-3-3

Design by Pau Garcia

Learn more about Paul Solberg at **paulsolberg.com**

Printed and bound in China by Artron
10 9 8 7 6 5 4 3 2 1

PAUL SOLBERG

TEN YEARS IN PICTURES

CONTENTS

PAUL SOLBERG: THE ESSENTIAL BEAUTY OF THINGS

Photography, whether professional, artistic, documentary, or amateur, reveals the world to us. Never before has the subject been perceived as it is after being photographed, captured for posterity at a precise moment in history, under a certain light and with a specific framing.

There are certain photographers who, in their gaze and personal way of understanding photography, strive to create other worlds where object and author are imbricated in a way that allows both to be fruitful and multiply, giving rise to a creative act. Others, under the pretext of that same quest for authorship, use the object of their work merely to deploy a preconceived vision of that which has caught their eye. They take what exists and twist it to suit their own interests, with the aim—often vain and trivial—of transforming it, laying claim to it, divesting it of all or part of its essence in a kind of vampirical act where the object is pushed into the background while the sole author hogs the limelight. This act of creative hubris is rarely found in combination with virtue, but when it is, we find ourselves before a masterpiece, a creation inextricably bound to its creator, and in it we recognize the genius of one who has managed to enter into a kind of positive communion with the objects, landscapes, or people he or she finds interesting. In short, we find ourselves facing the work of an artist.

Yet there are other roads by which a few privileged artists manage to show us other worlds— realms of greater intimacy, precision, and truth. Those who travel such paths have a very different point of departure, which consists in shedding all prejudices and all preconceived intentions other than the determination to discover the essence of the object before their eyes. It is an exercise in letting go, like those masters of Zen philosophy who discover the true nature of the very act of thinking by emptying their minds of thought. In this way, each image they manage to produce becomes in itself an act of thinking, where nothing is wanting and nothing is superfluous. They attain that quasi-mystical state where objects and beings reveal their true essence, that which contains them entirely and makes them unique: not because they are intrinsically unique, nor because their initial appearance powerfully captures our attention at first glance, on first impression, but because someone—the photographer's eye—has been able to reveal to us, the surprised spectators, what makes them unique and universal in our eyes, to our understanding.

It is in this less obvious, more complex territory that Paul Solberg works, searching for something the rest of us are incapable of seeing or finding even when we seek it with dogged determination. To paraphrase Picasso, we might say that Solberg belongs to a class of artists who "do not seek, but find." It is no easy task, and most are not up to the challenge; only those who have flushed all accoutrements and superfluous temptations from their eyes can offer us an essential vision of the world, one in which we viewers recognize ourselves in a different way, transformed by the powerful, subtle gaze of the other, the author, who has worked the miracle of unveiling our own mystery, the mystery that alien enigmas hold for our eyes only.

When I observe Paul Solberg's images carefully, what I find surprising is not his often poignantly familiar motifs, but that essential way he has of approaching them: he seems bound and determined to show them with absolute frankness, as if each image he presents to us were the only one possible. Once we have seen them, we cannot imagine them any other way. The artist's frankness leads to another reflection on the contemporary quality of photography and its possible fate, as an image that may or may not stand the test of time. Photographic images often betray, intentionally or unintentionally, the historical period in which they were taken, and in many cases—the majority, in fact—this betrayal makes them victims of the passing years. They will undoubtedly be useful for telling us what the world was like at a given historical moment; however, in such cases they will have survived by virtue of their documentary value, not the timelessness that every work of art aspires to achieve in order to make the passage of time its best ally rather than its worst enemy. In Solberg's images, we can detect that aura of timelessness which ensures that in the future they will retain all their freshness and suggestive power, and his work's promising future is precisely what also makes it more present.

José Guirao, Madrid,
January 2015

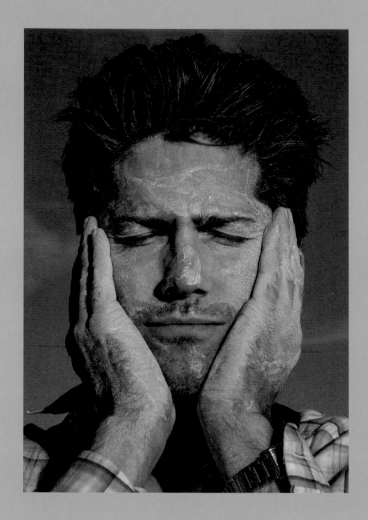

Paul in Atacama, photograph
by Christopher Makos, 2010

INTRODUCTION

Over time, we build an elaborate universe of experience. What's in front of us is already behind us. Here becomes there. We turn around and this moment falls into the distance. We recall amorphous shapes more than the details hovering in the shadows. Clusters of memory huddle together- the dim and the bright - waiting to be ignited. Shifting, twisting collages color our past. To cope with this trickery of time, we use religion, medication, money and reproduction. At our best, we use love.

The camera is another way to calm the anarchy of time. To wrestle one moment to the ground and quickly put it under glass. The objective is not always to take the best picture, but to preserve one of the many moments lost. To freeze the microbes of memory that hang on each picture. A particular cloud or the crackling of a glacier. It's a selfish intent, to take pictures as a memory bank, but it places feeling above perfection, avoiding the deception of the photographer's eye.

Cameras everywhere. Electricity blazing. Everyone is taking pictures, but few are looking through a viewfinder. We're pleading with ourselves that we exist, our senses in spasm. We're in the prequel of space tourism, while here on earth, connection and disconnection seem the same.

People have grown accustomed to posing on cue, and portraiture has become more challenging. In the ten years these pictures were taken, there were years I was more interested in clouds, objects, or flowers. In some places, however, people still look into the camera with startling honesty. Vietnam. Spain. Navajo Nation. And still, Manhattan.

Thank you, people on and off the street, for being open in this guarded world. We shared a moment before you flew off into the mind's universe.

Paul Solberg, NYC
February 2015

TEN YEARS IN PICTURES

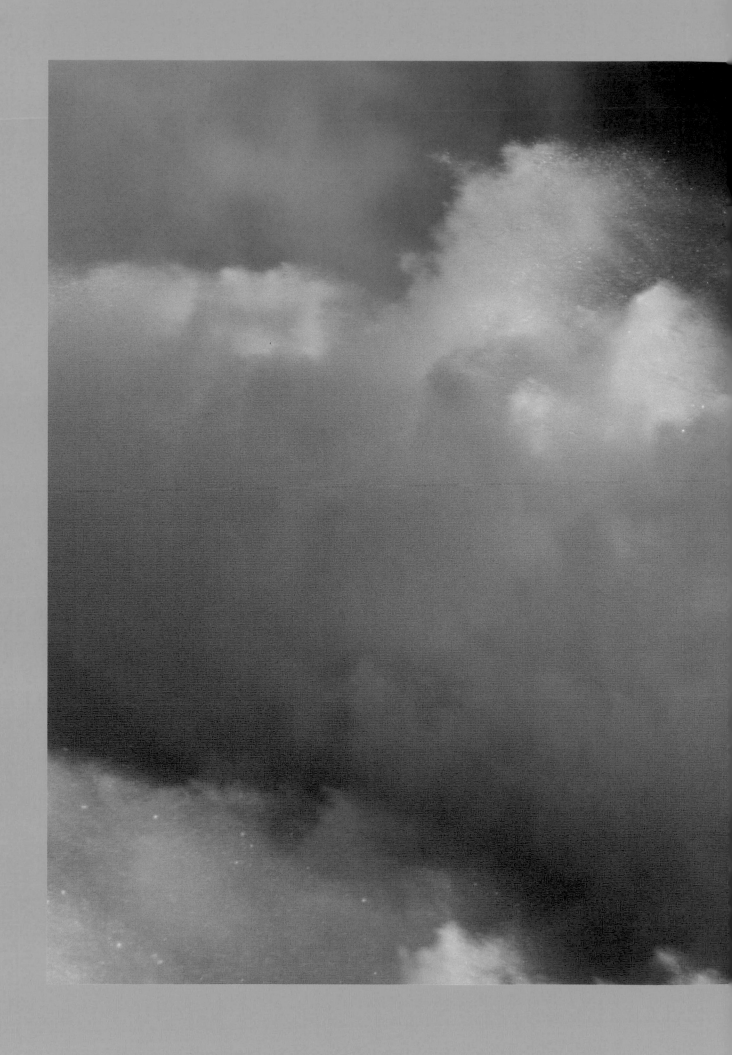

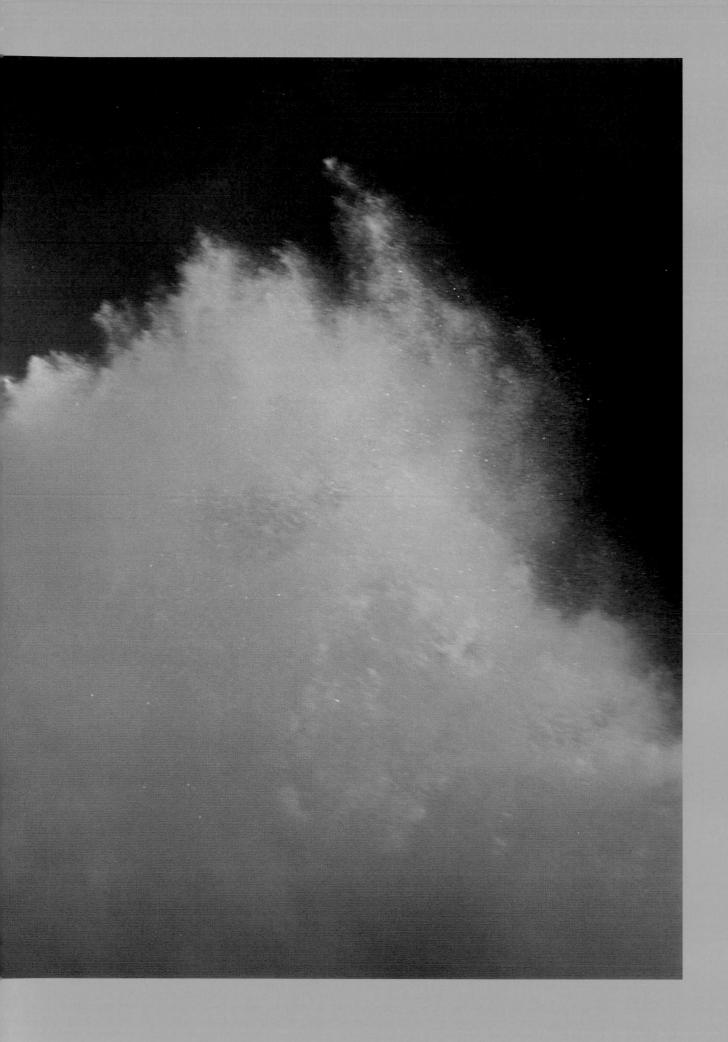

Iguassu, 2011

I'd call you but it's Christmas, 2006 15

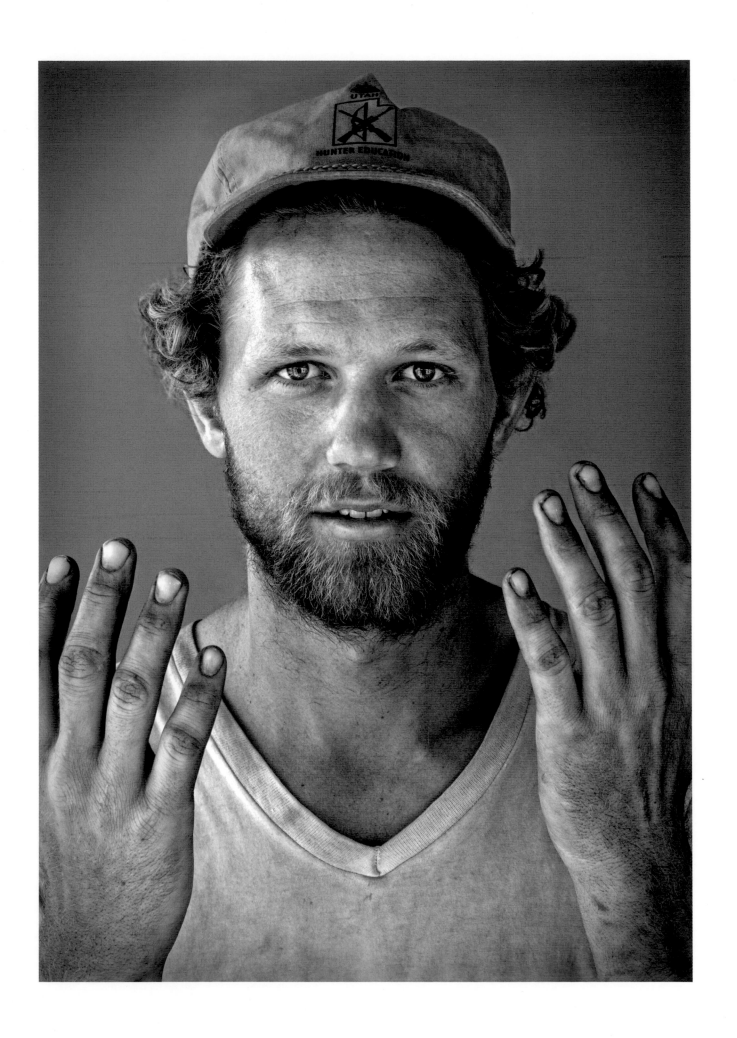

Cheese Farmer, 2013

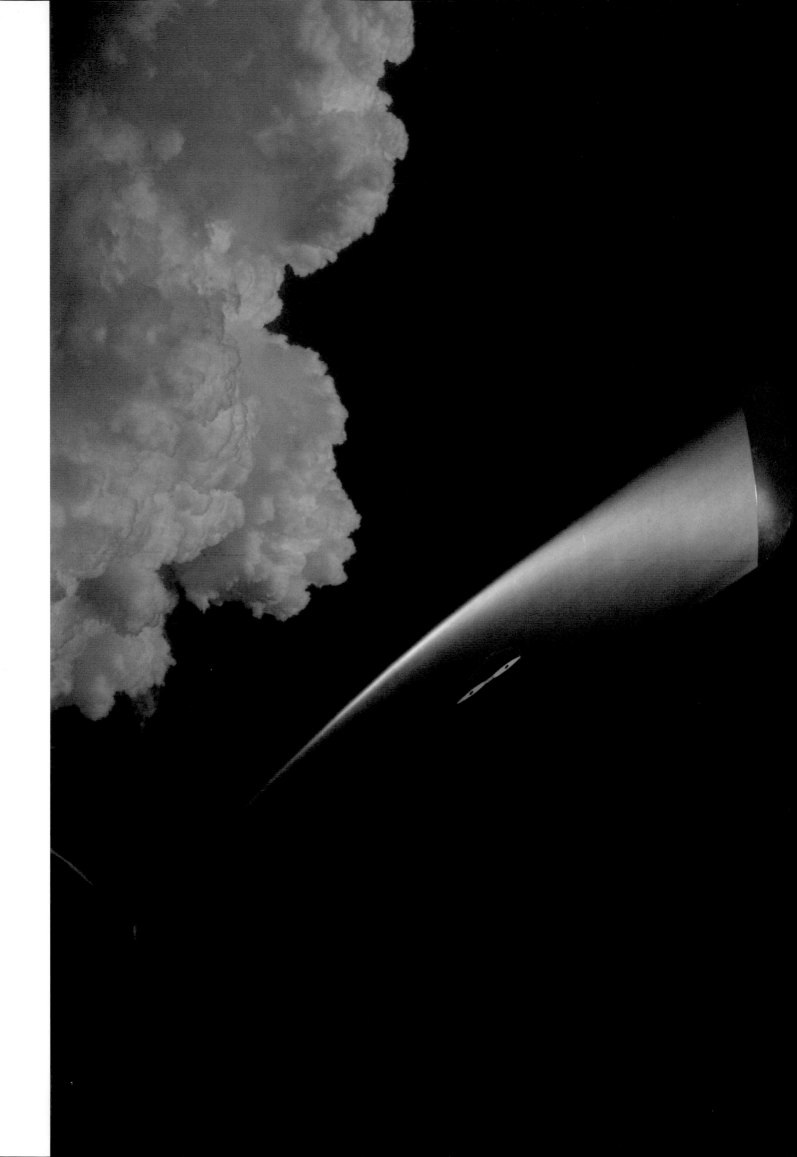

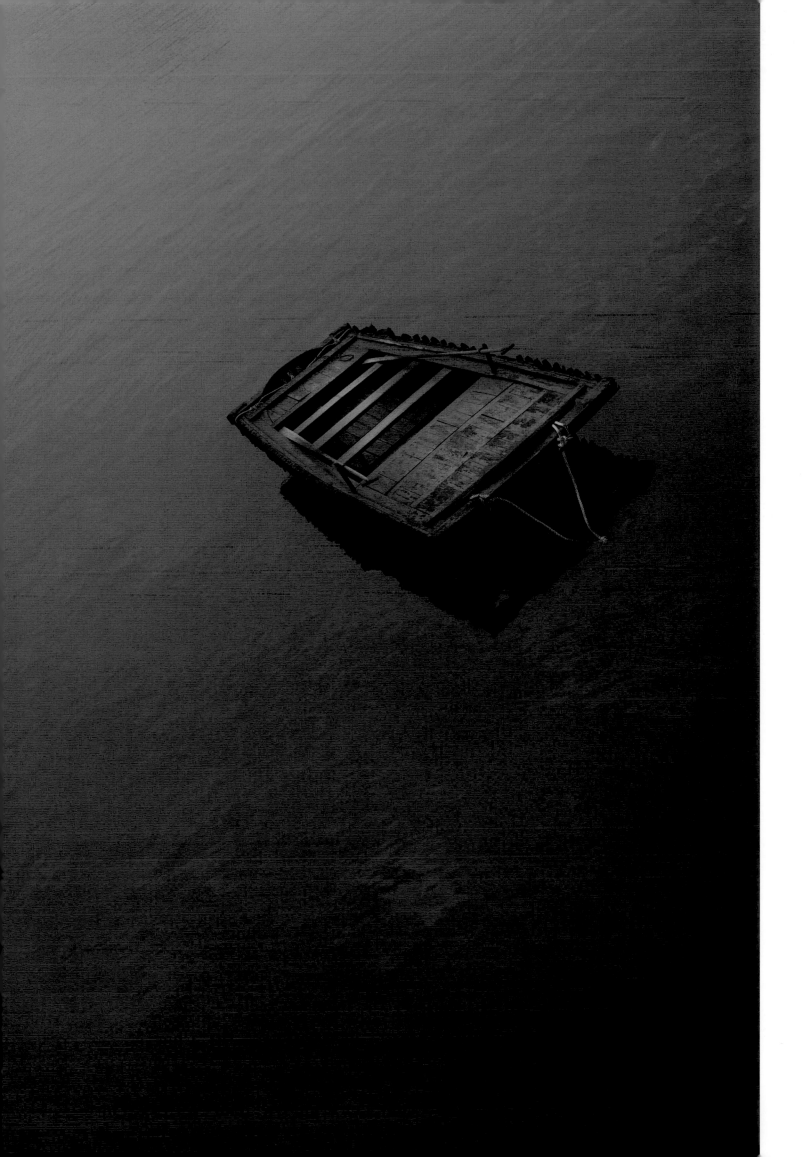

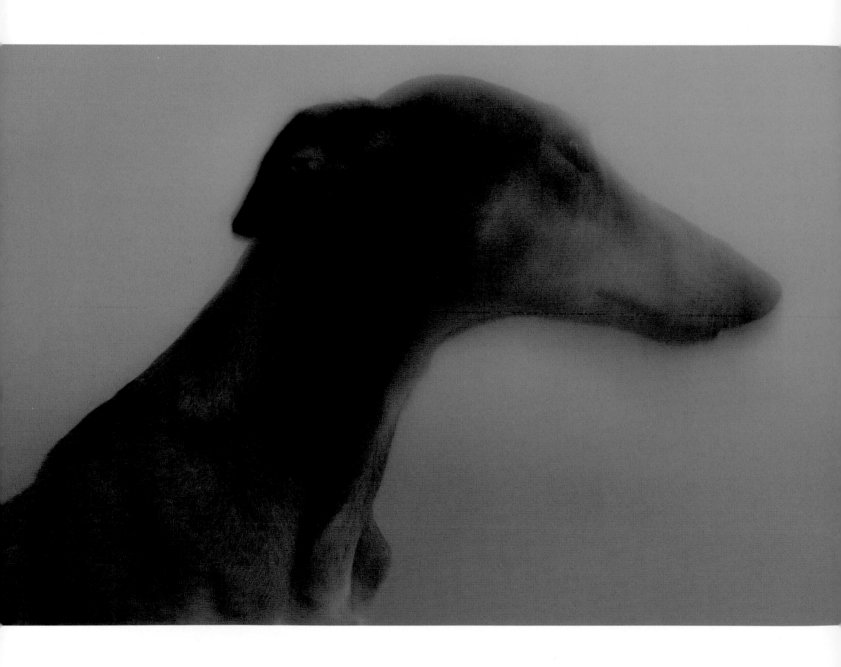

Powder River, 2009

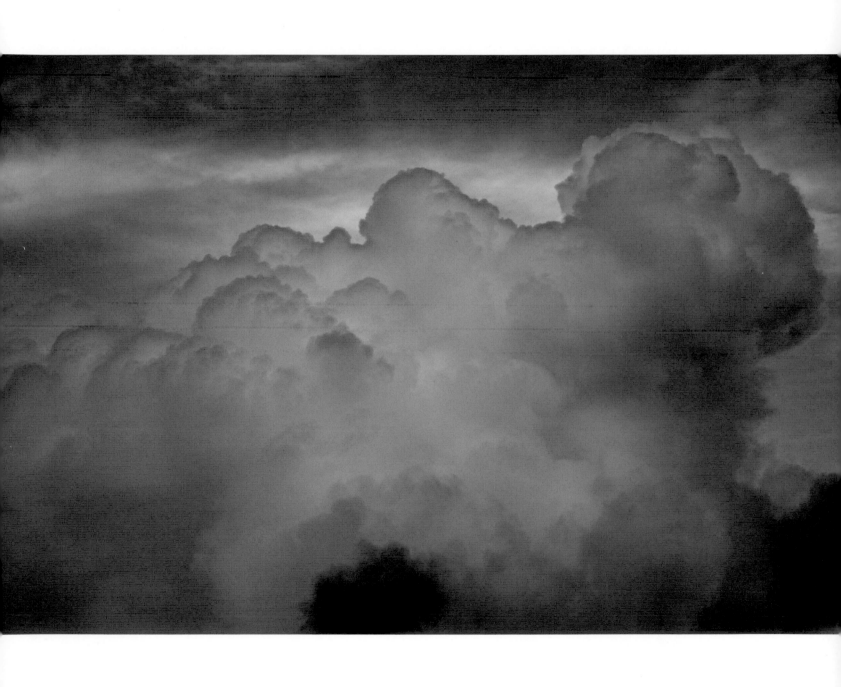

Above Lake Bolsena, 2014

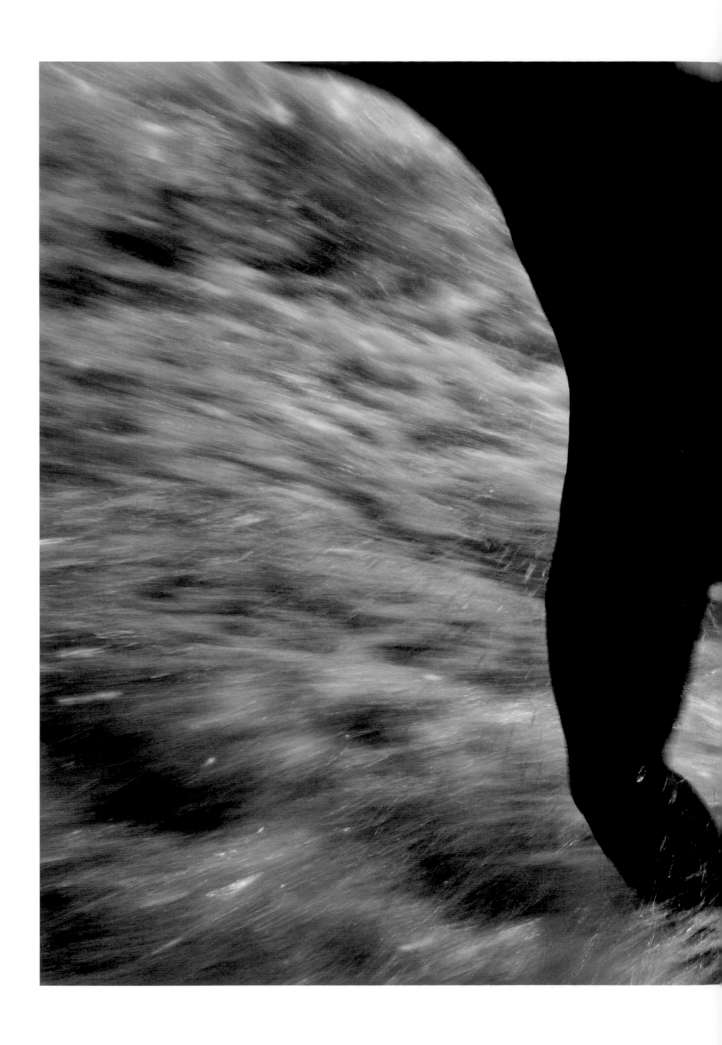

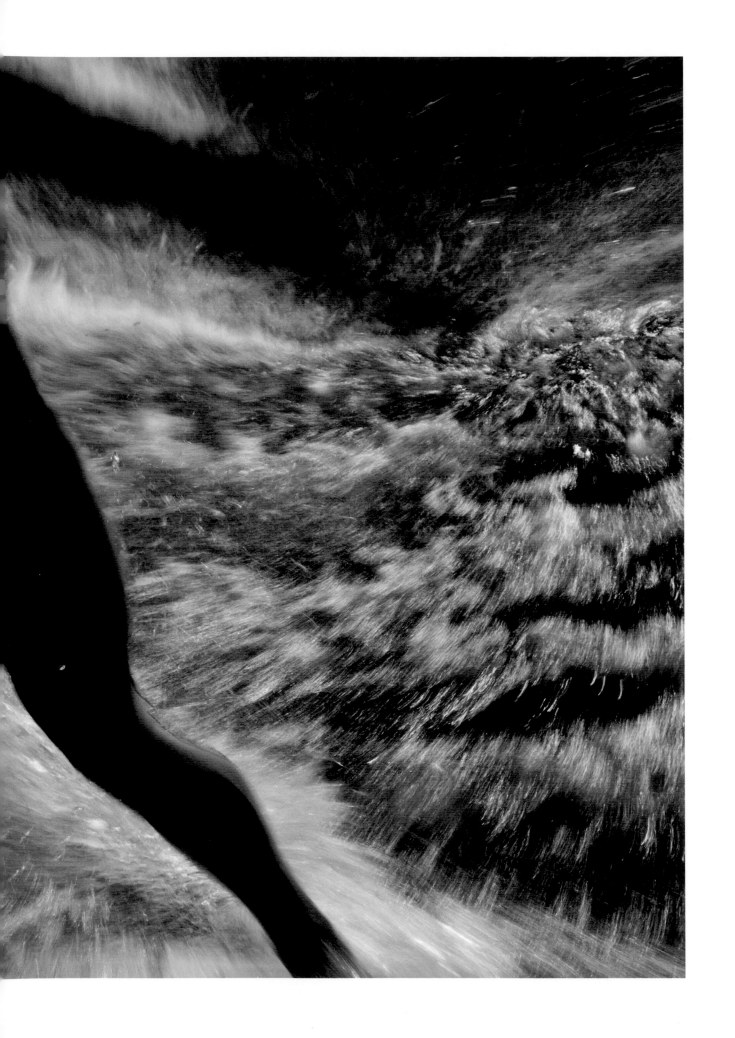

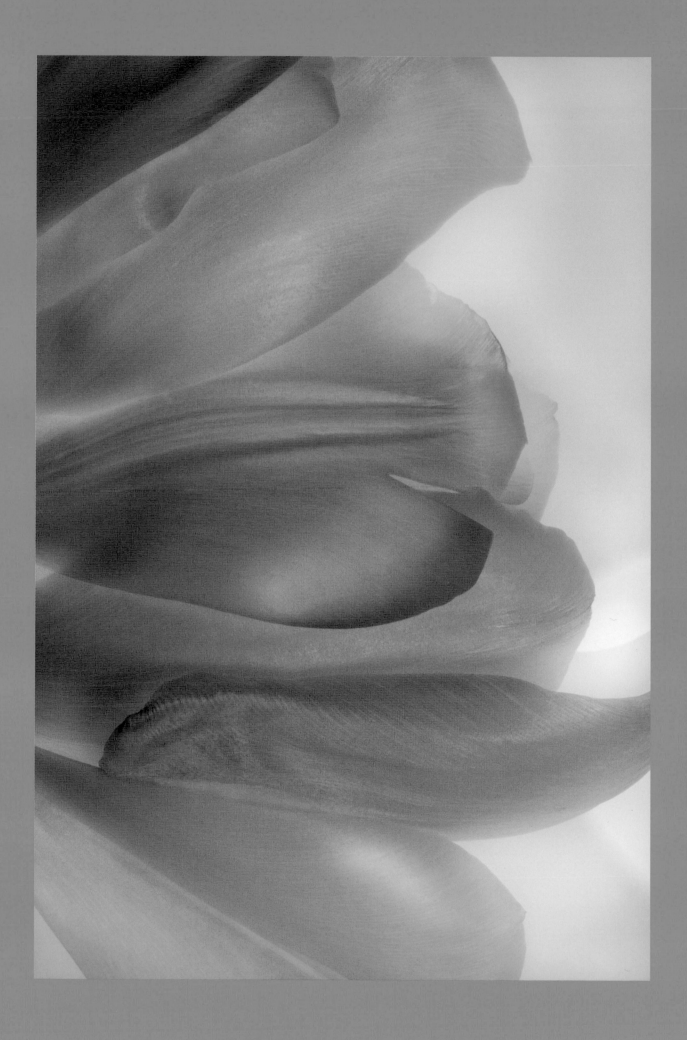

Study 626, 2008

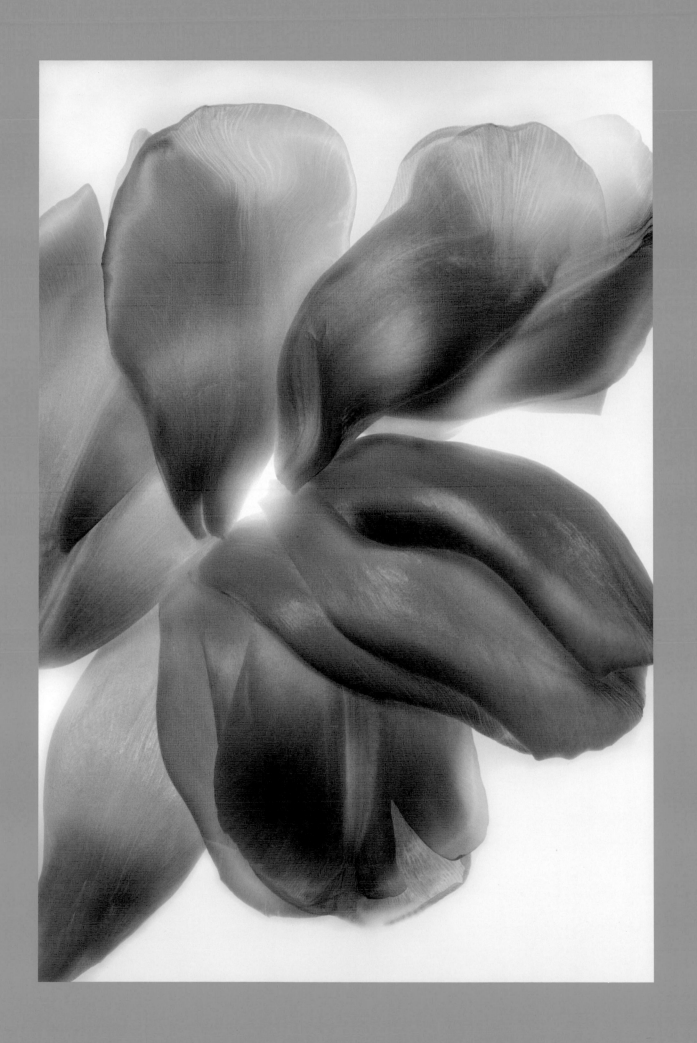

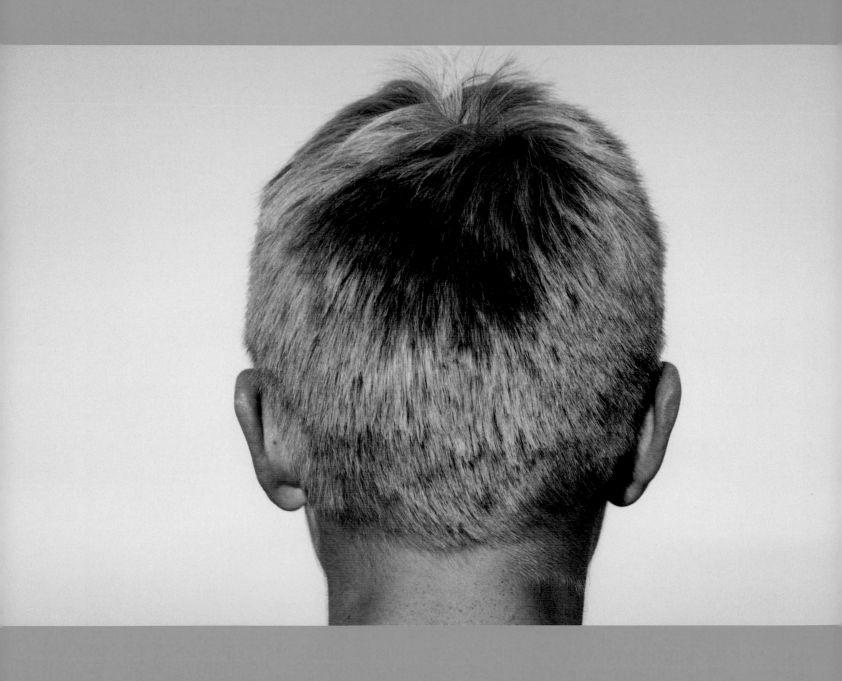

Corn, 2009

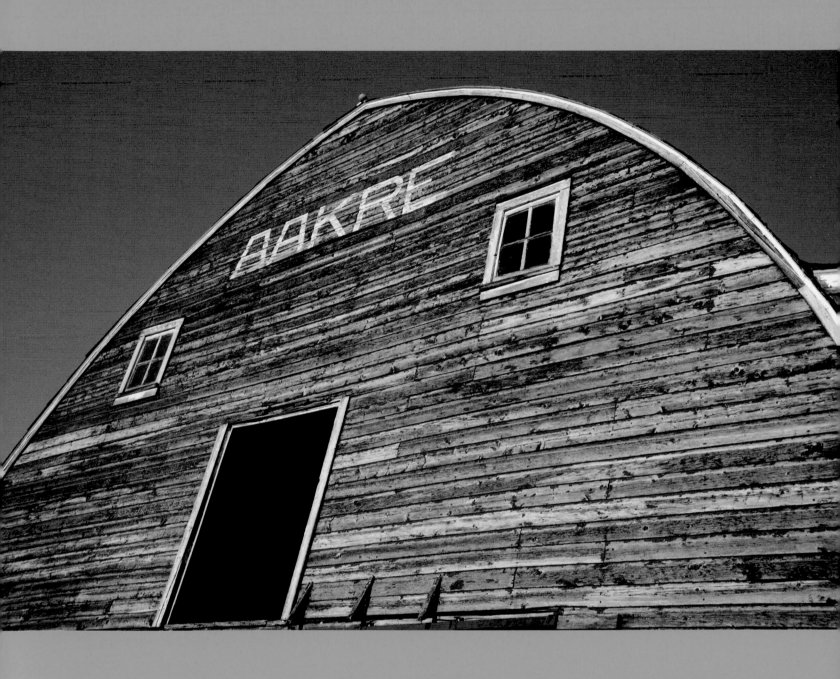

Barn, 2009

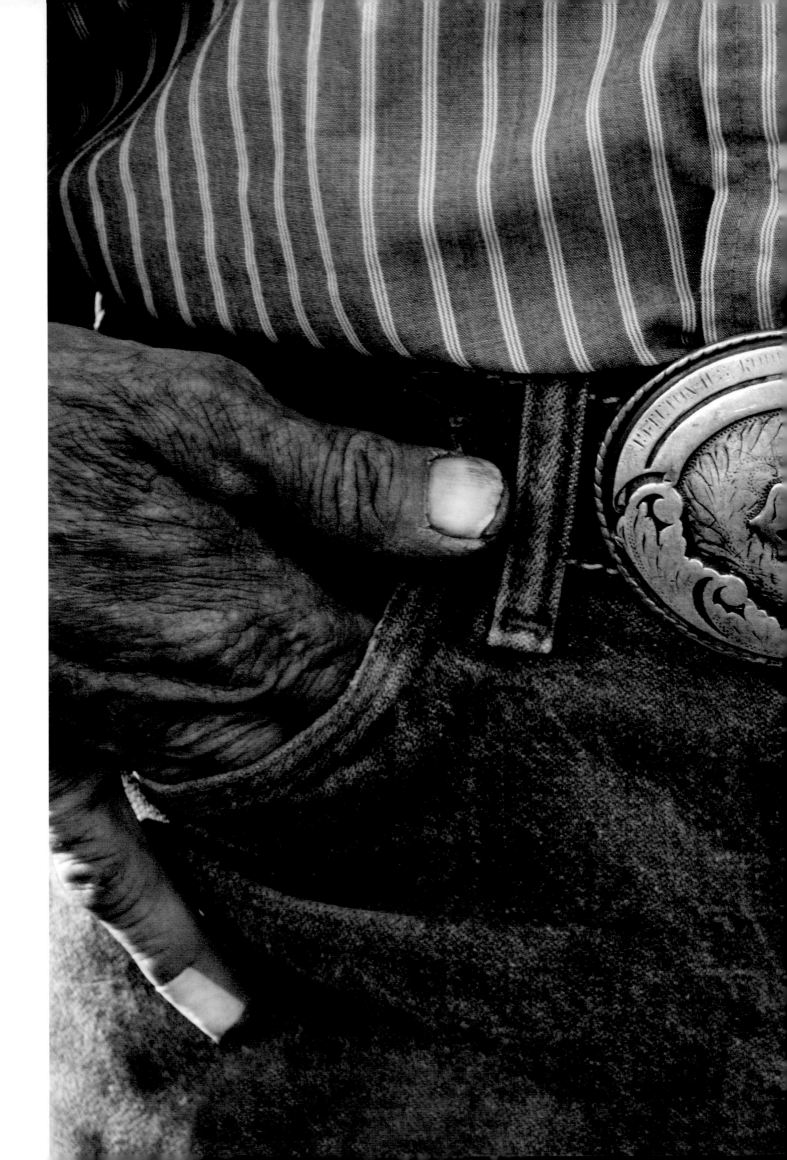

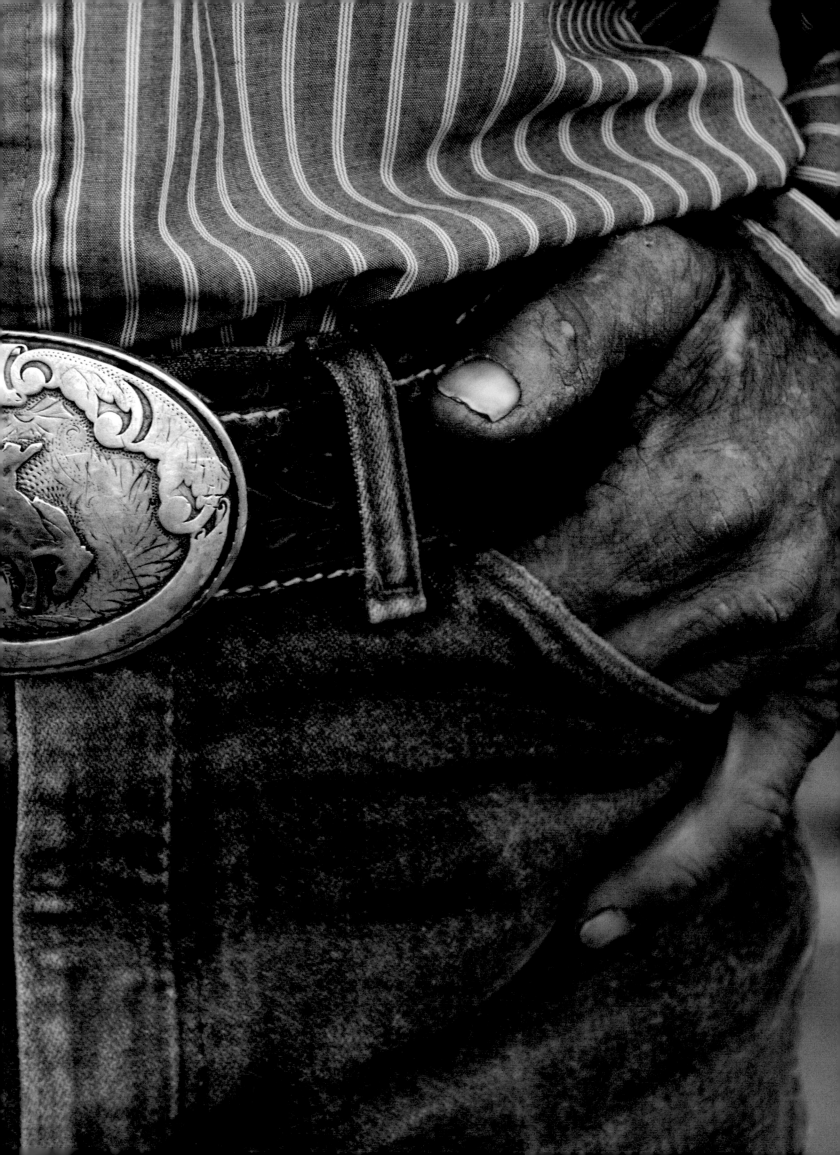

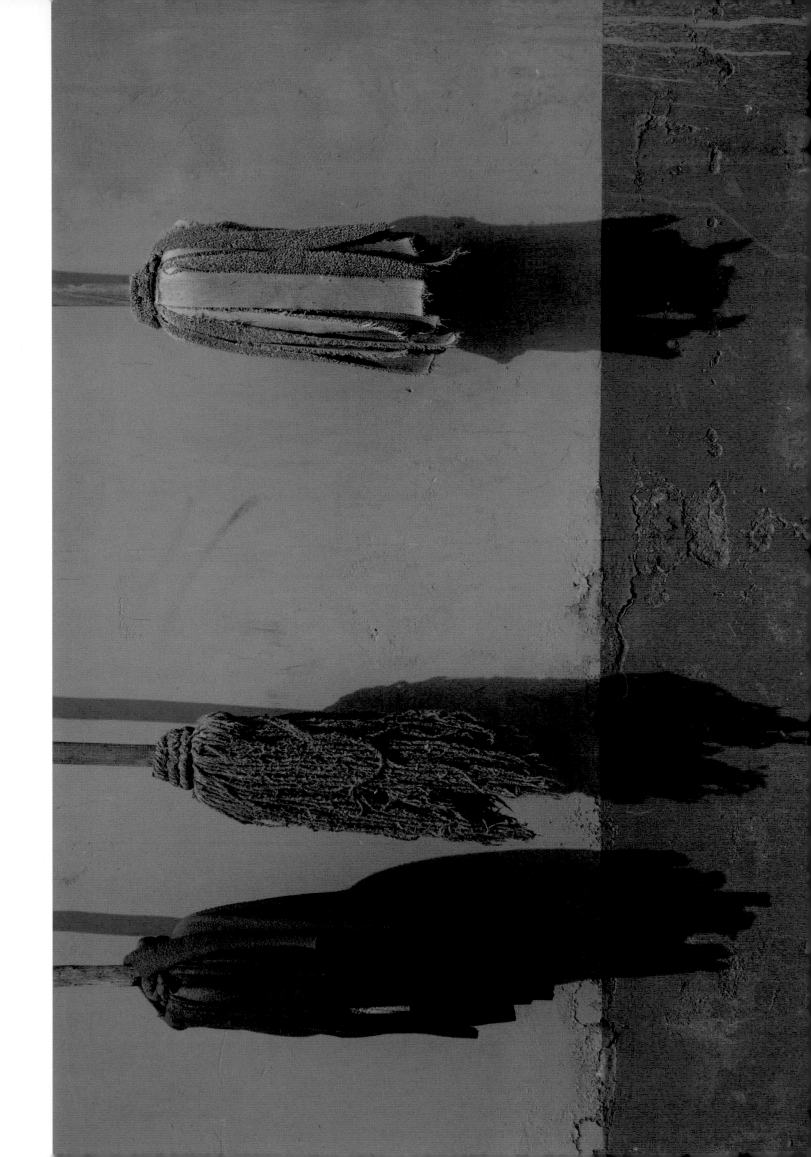

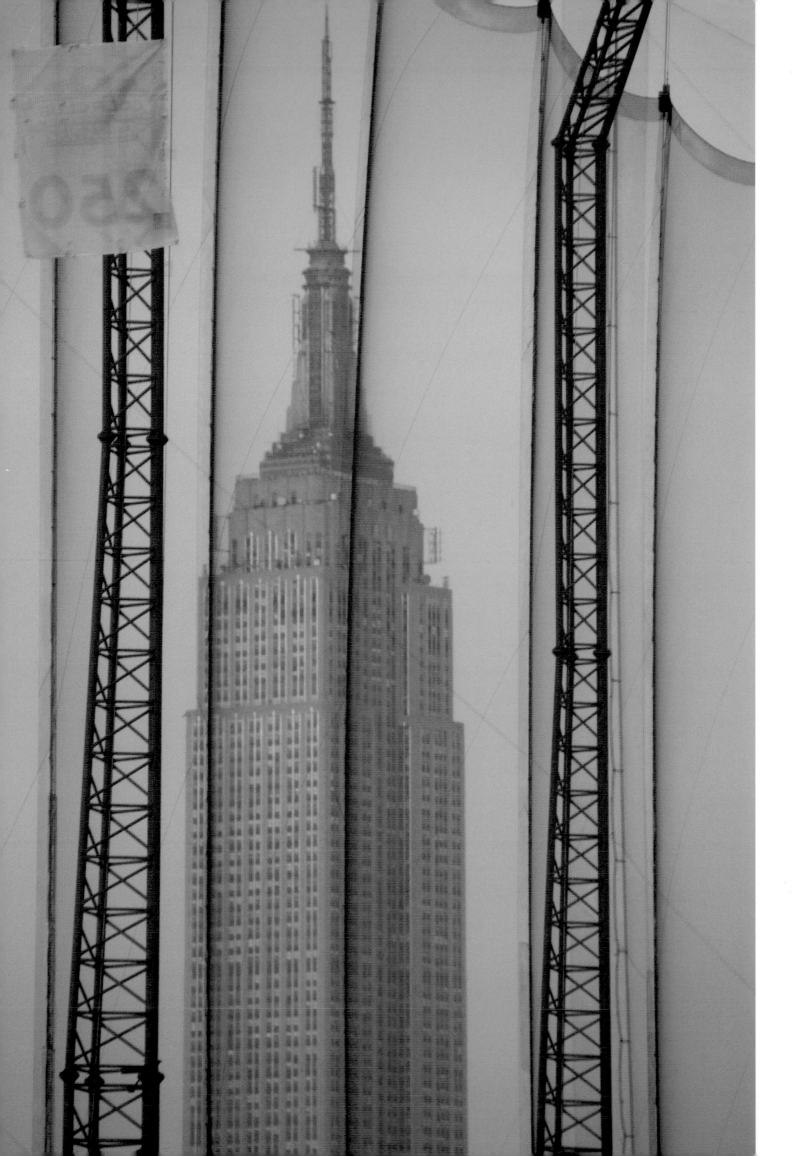

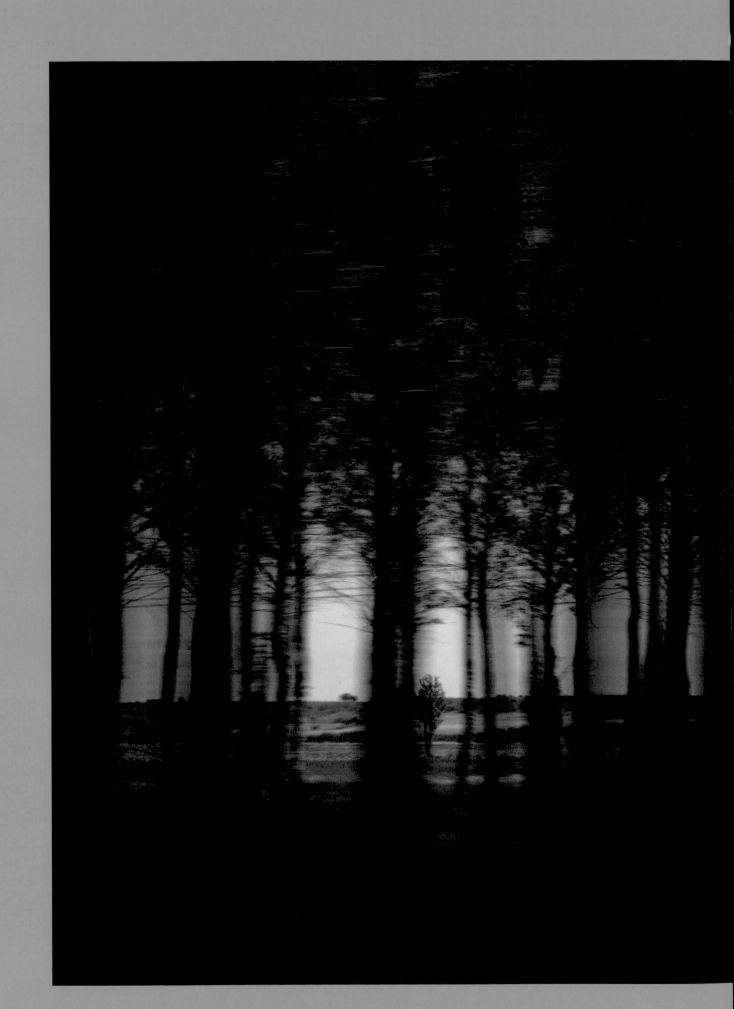

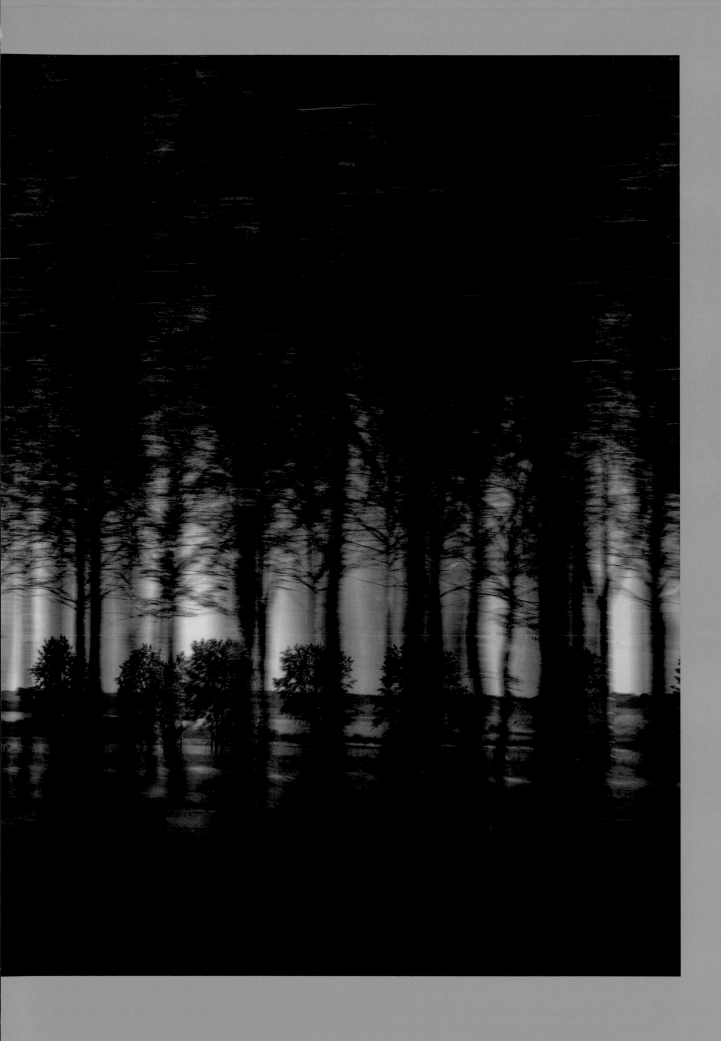

Toro, Spain, 2006

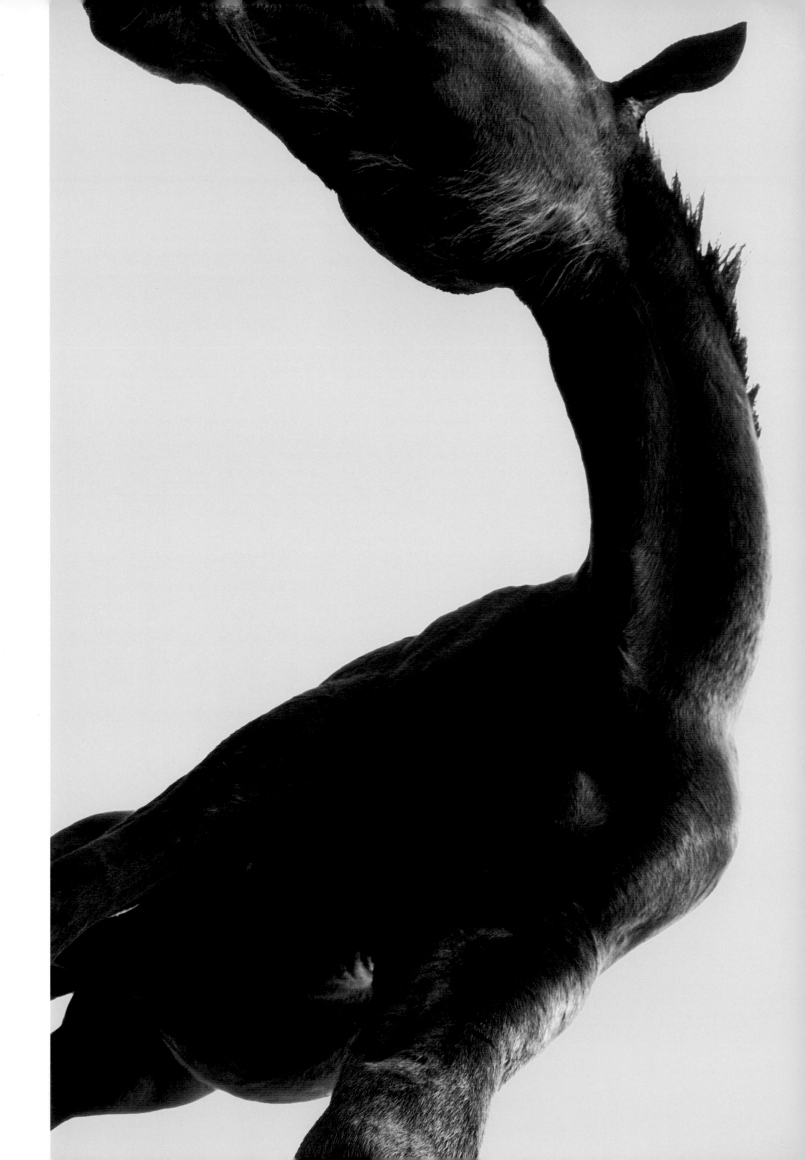

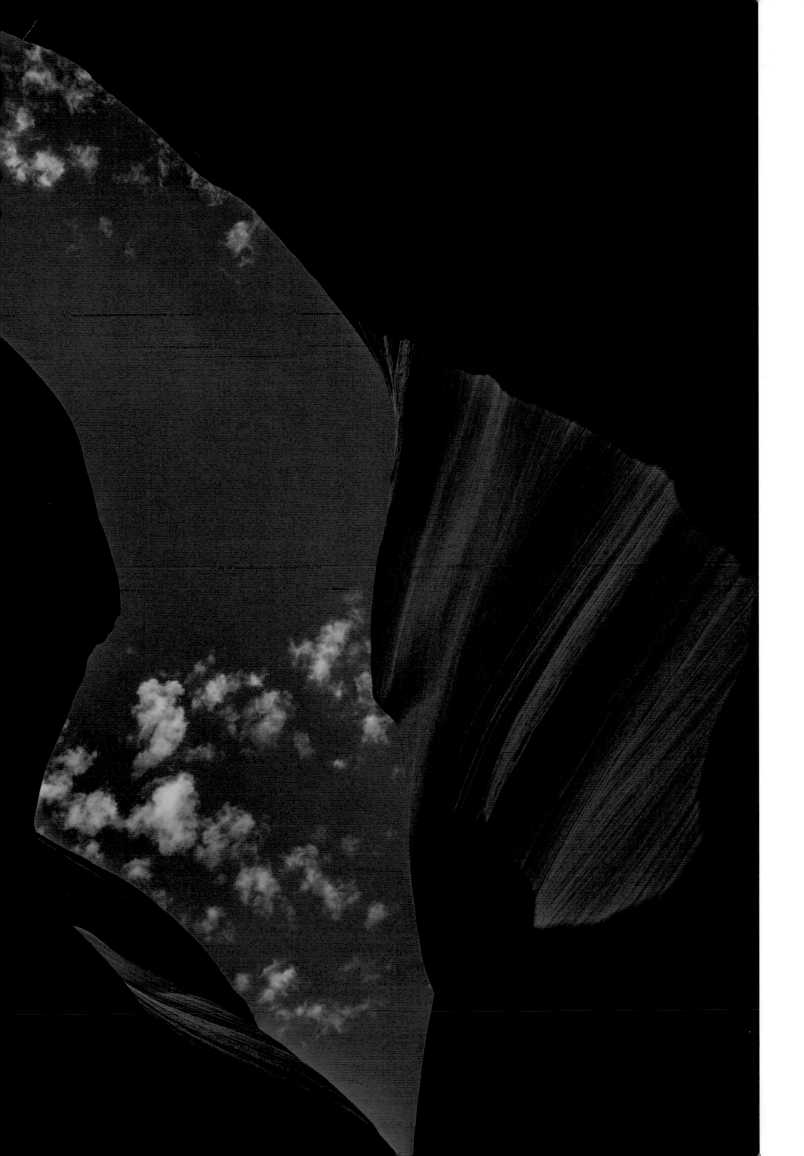

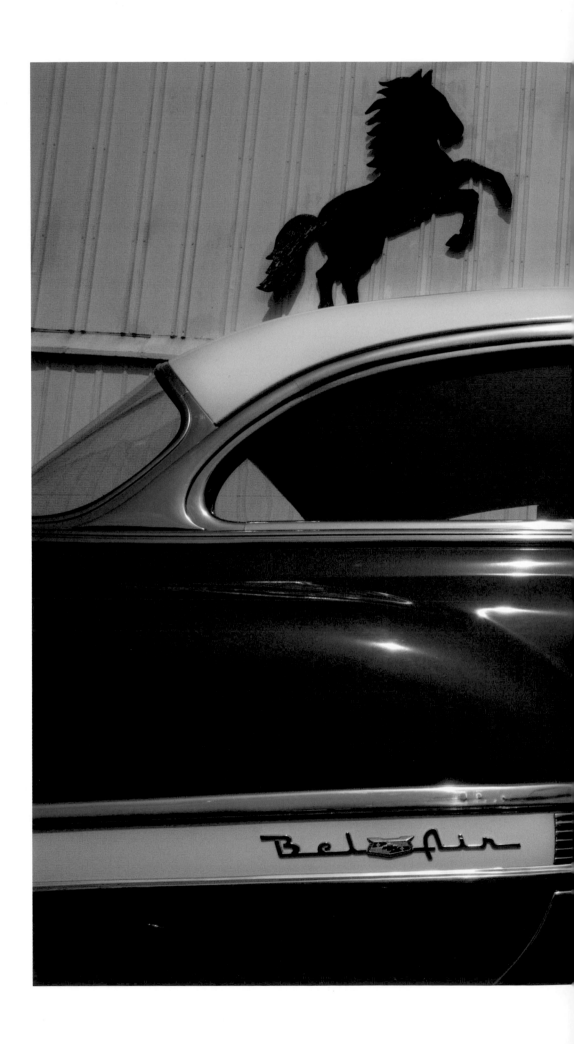

Ice Cream Social, 2014

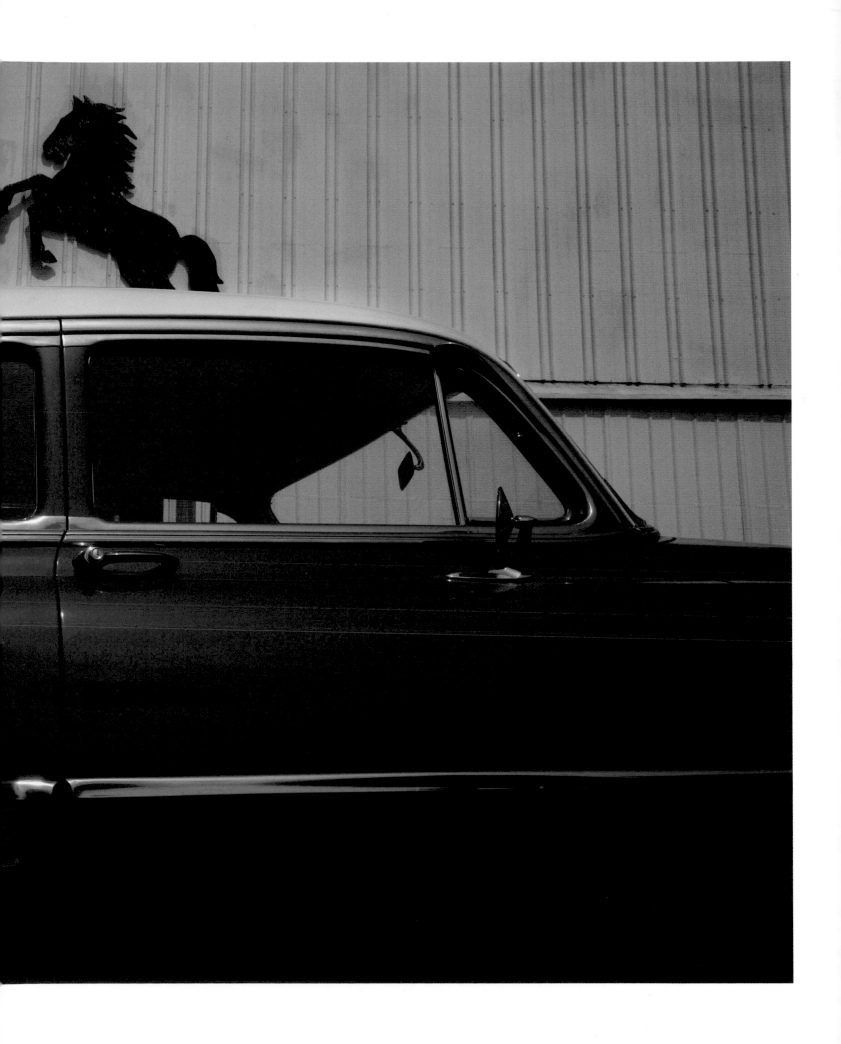

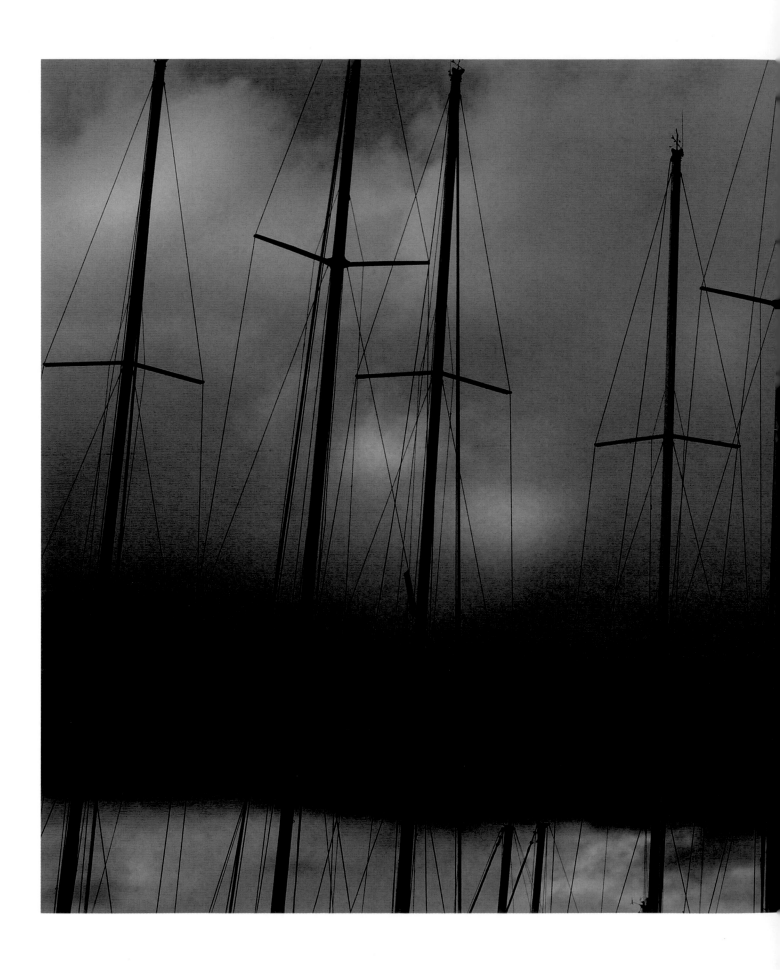

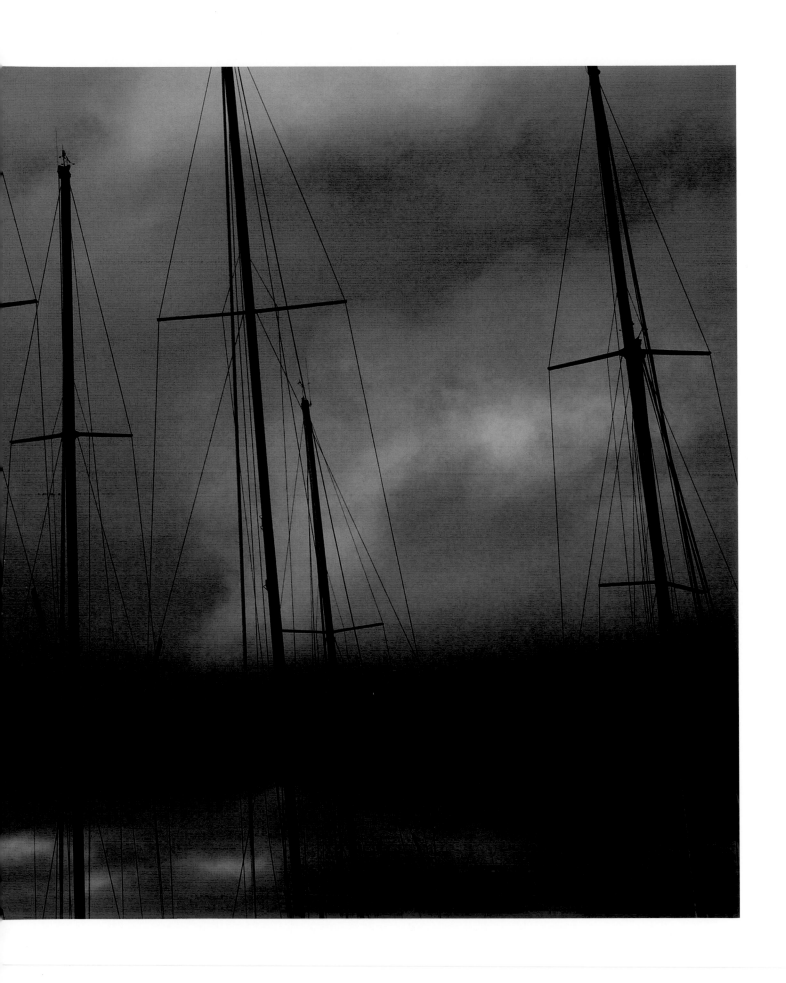

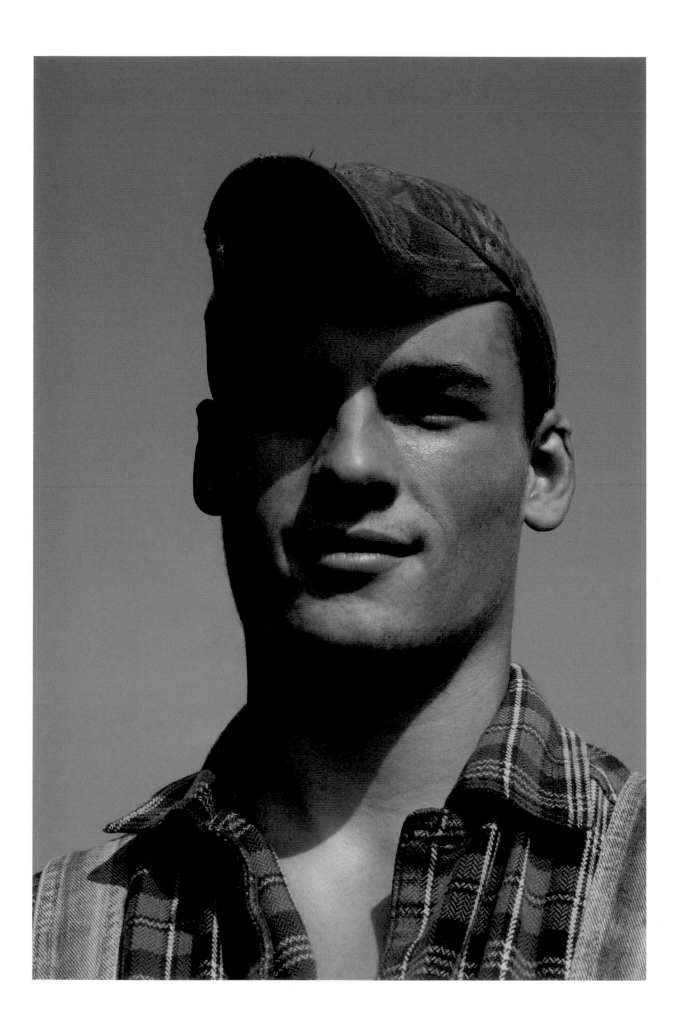

Son of a Farmer, 2009

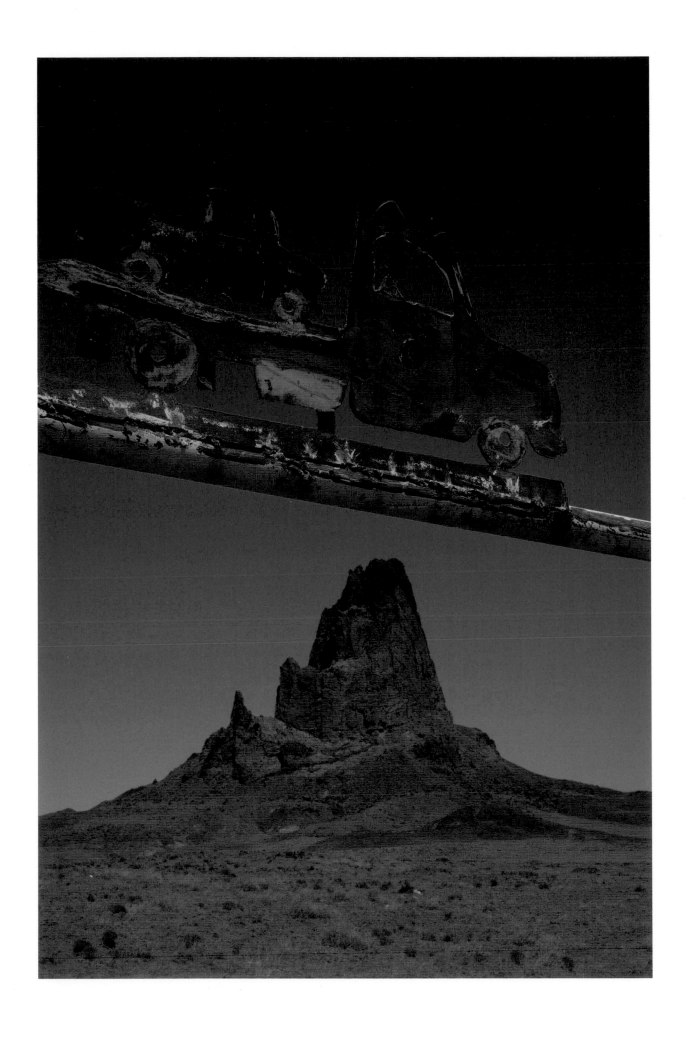

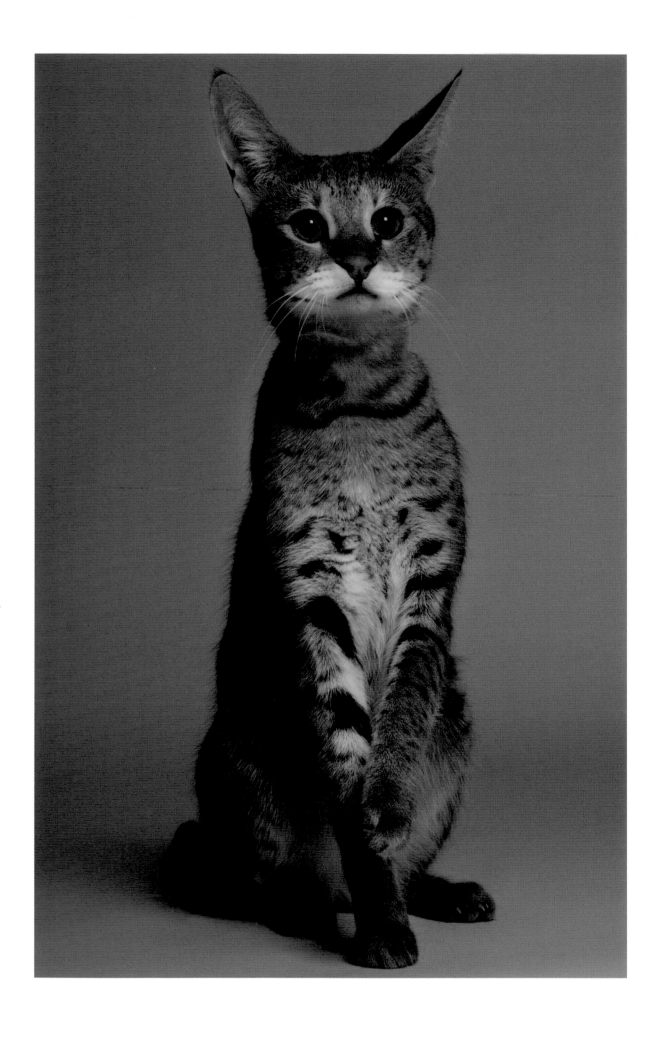

Savannah, 2012

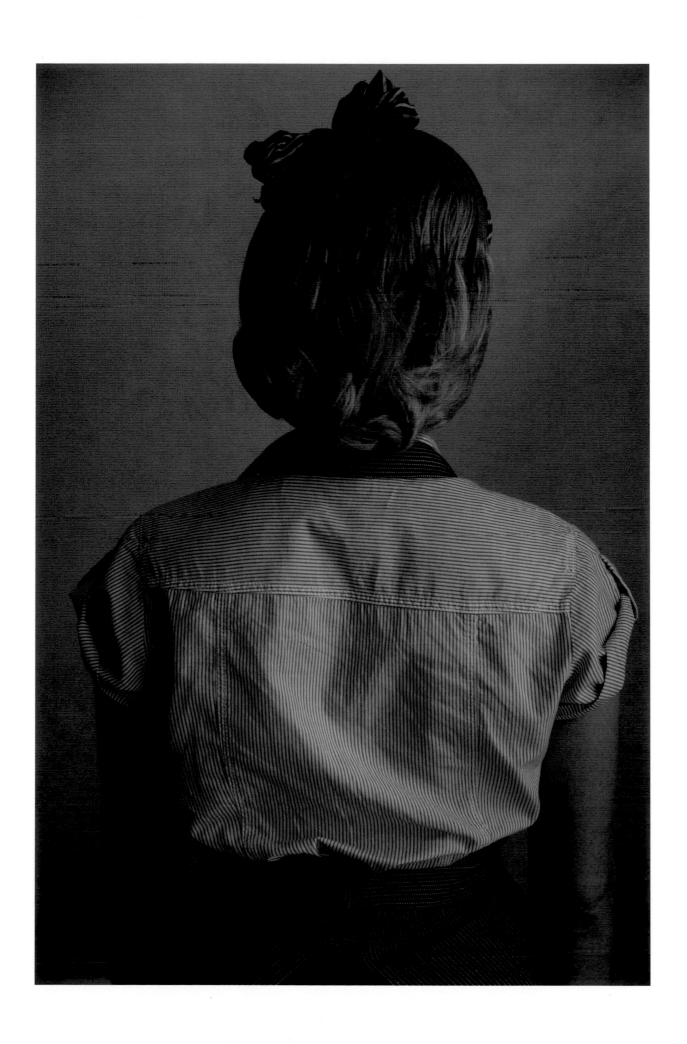

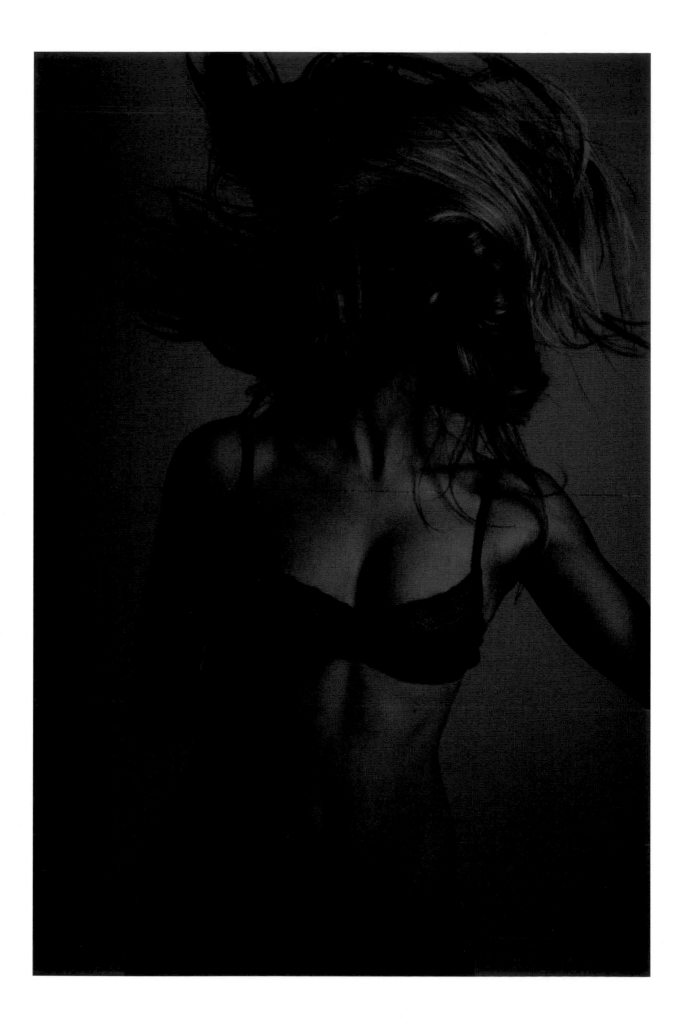

The Room is Loud, 2015

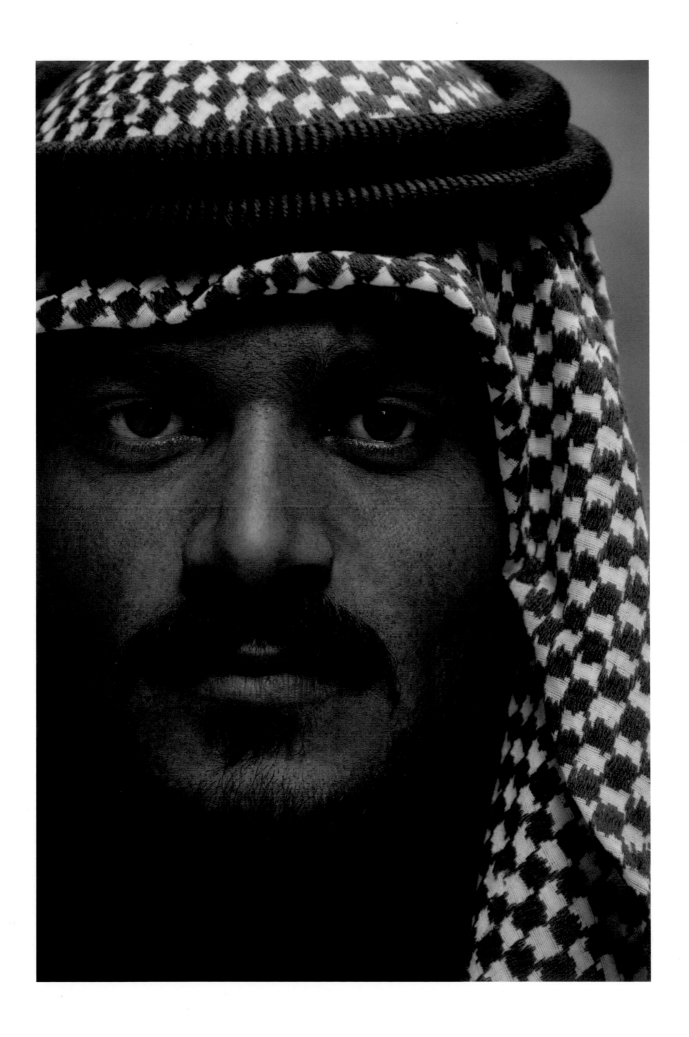

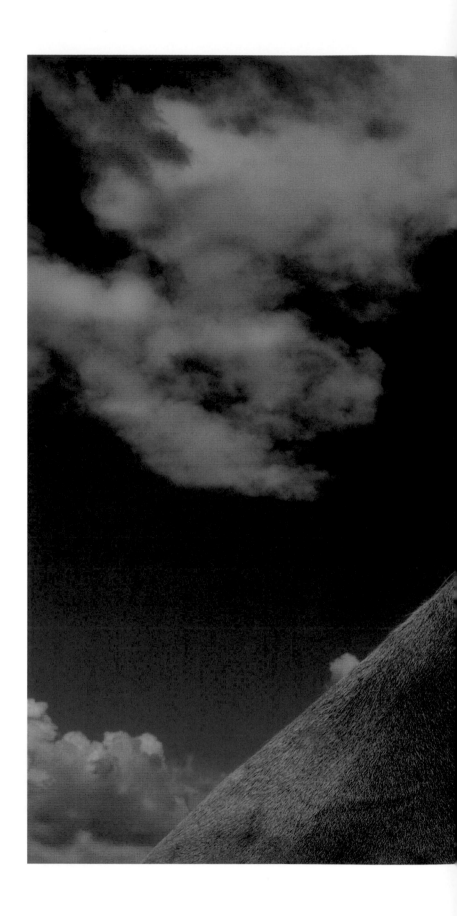

Twin Creek Ranch, 2007

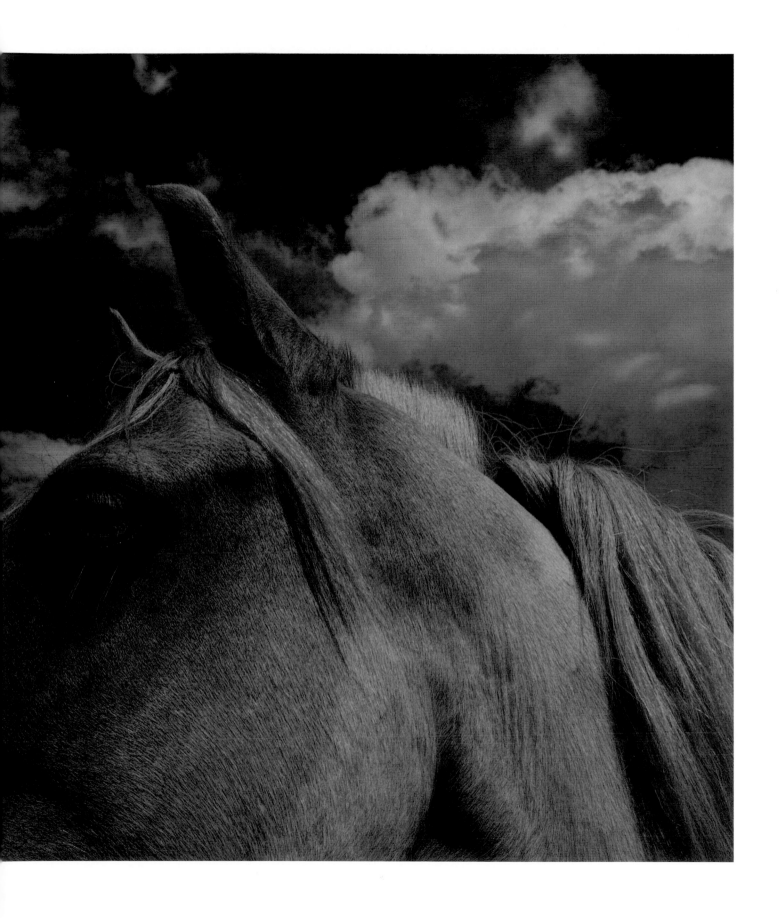

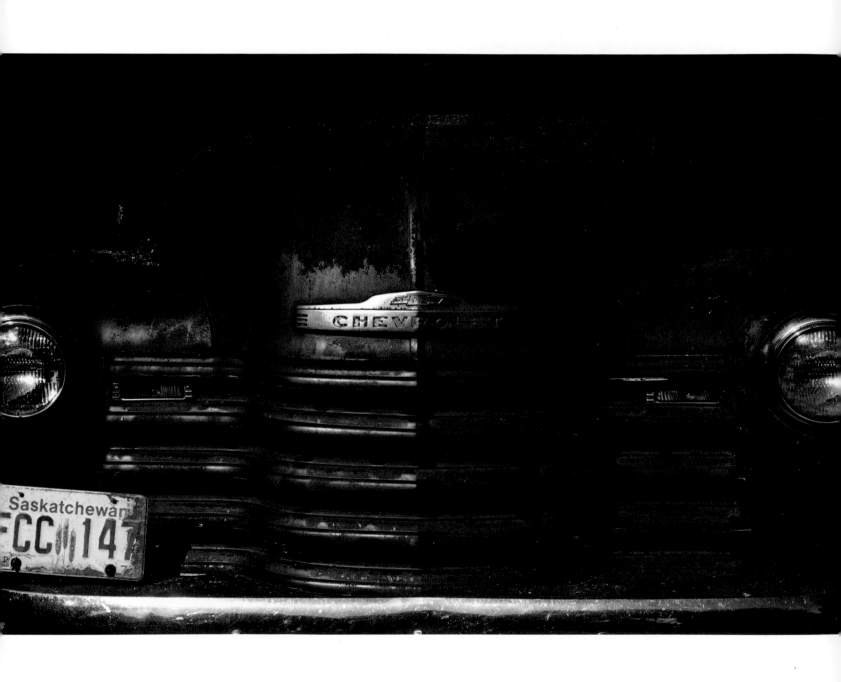

White Bear Lake, 2006

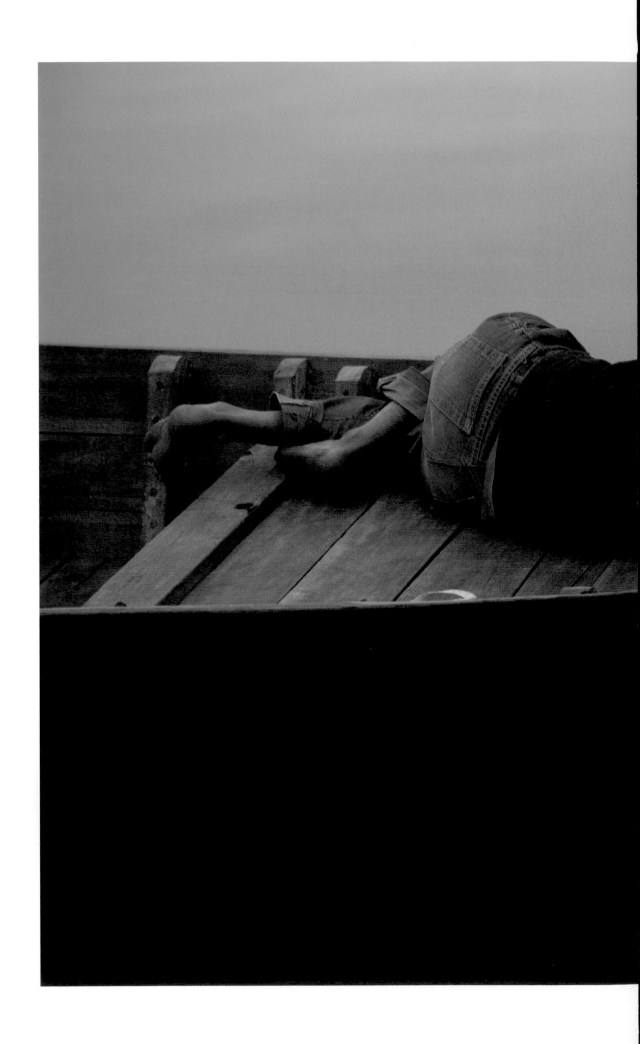

Hoi An, Vietnam, 2009

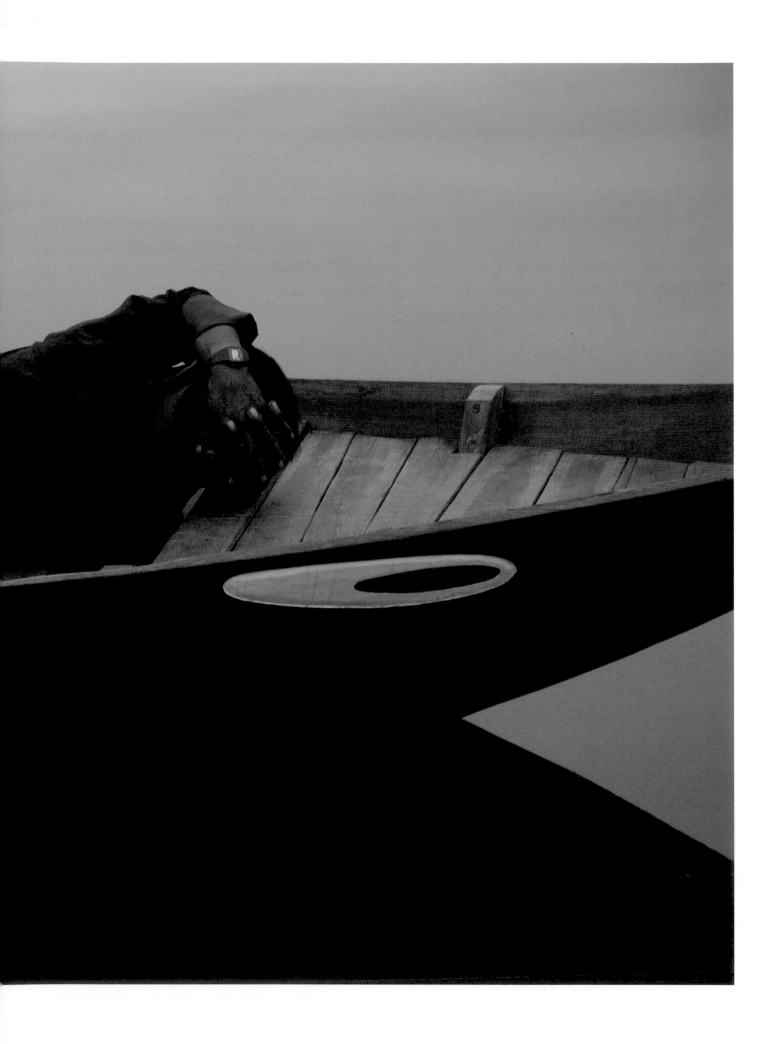

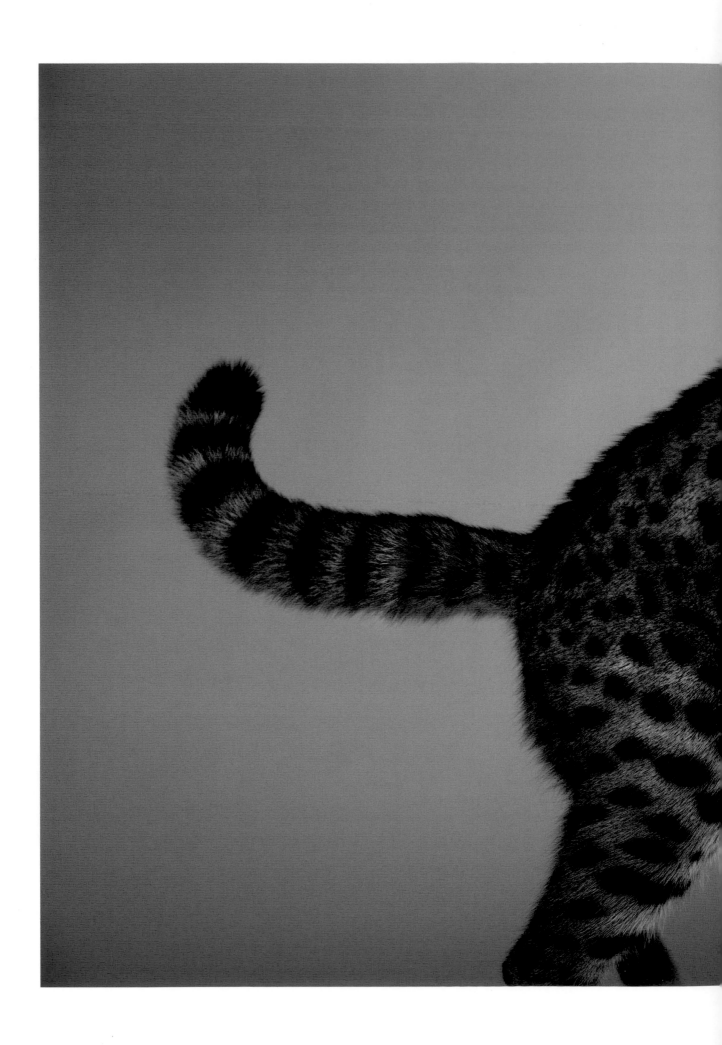

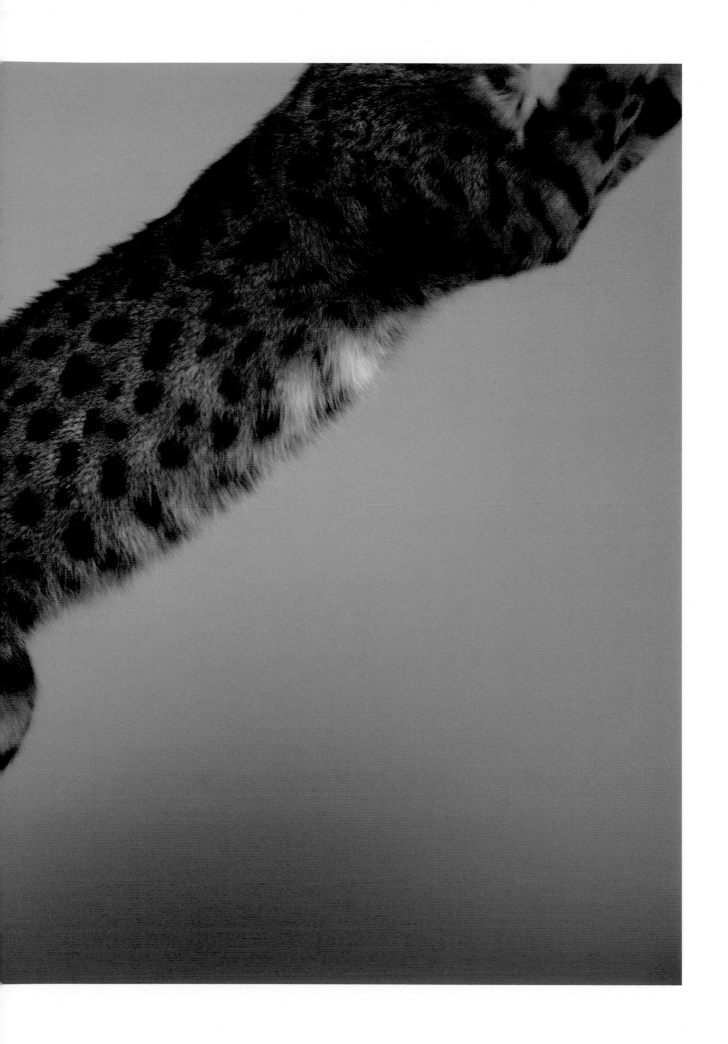

Big Cat, 2012

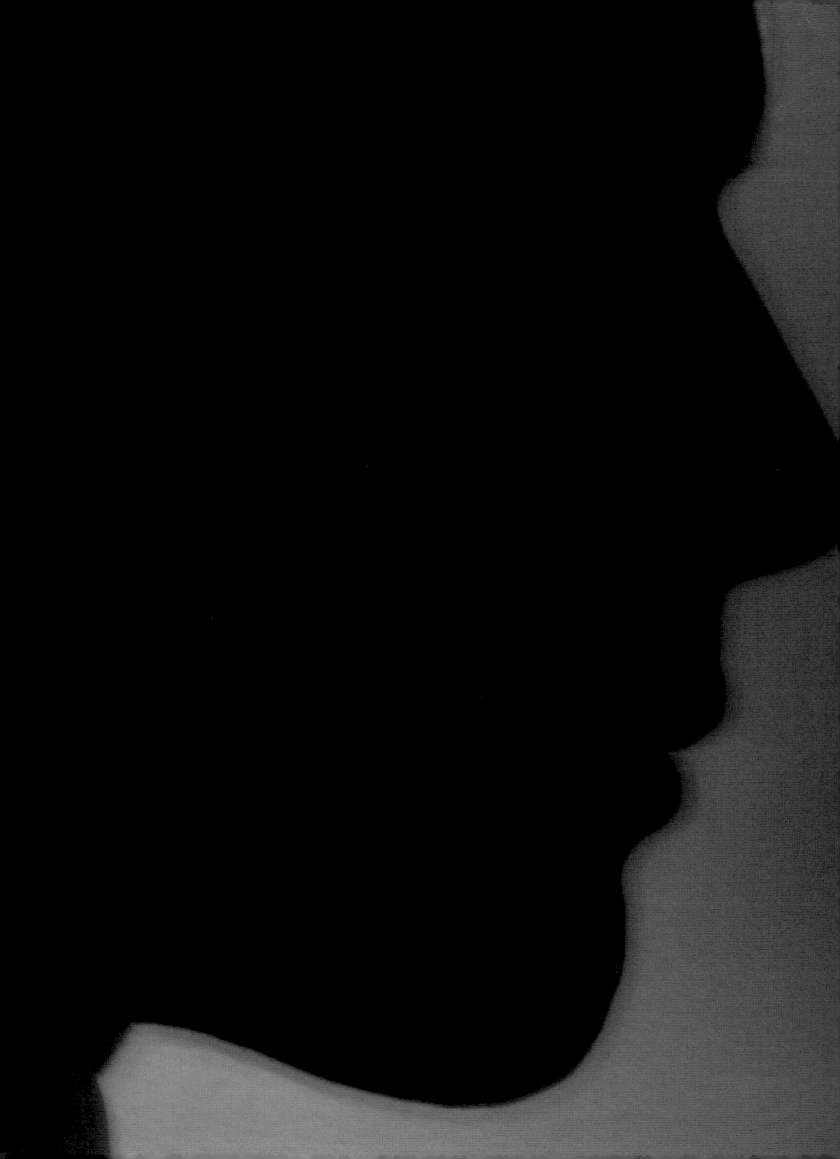

Bell Boy, Madrid, 2010

Bus Boy, New York, 2013

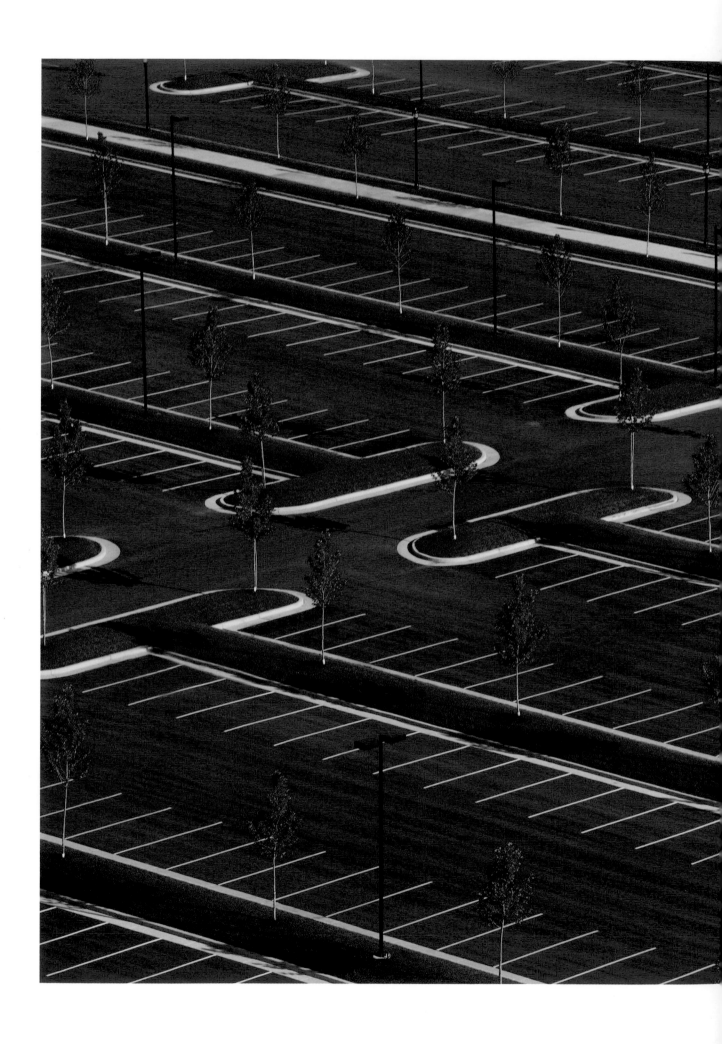

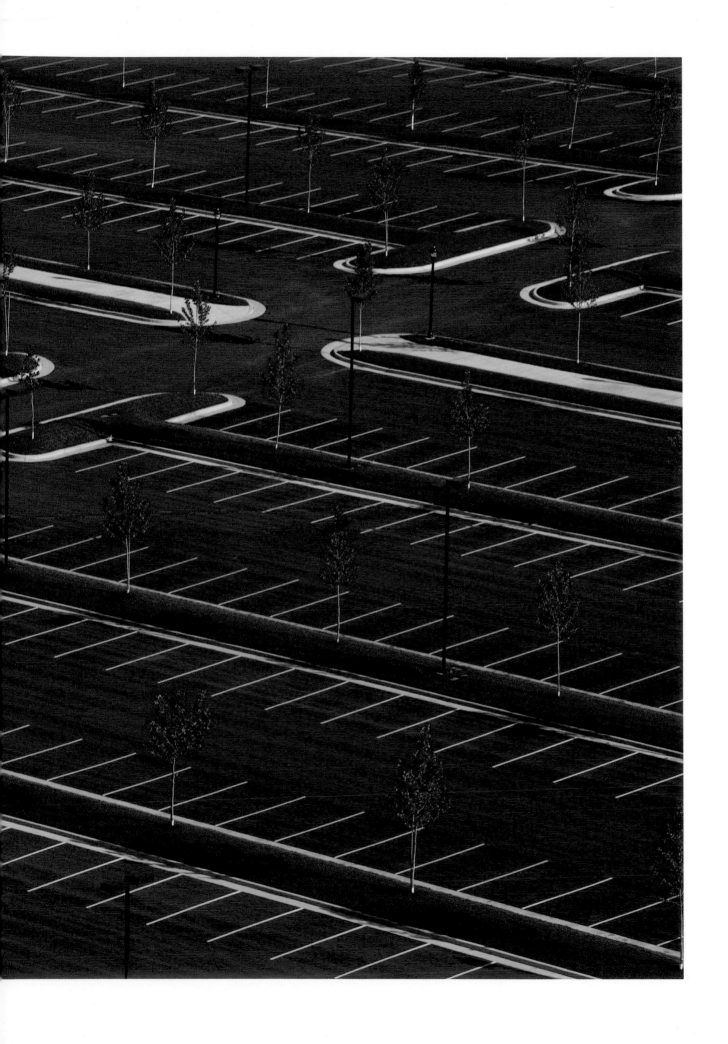

Utah, 2007

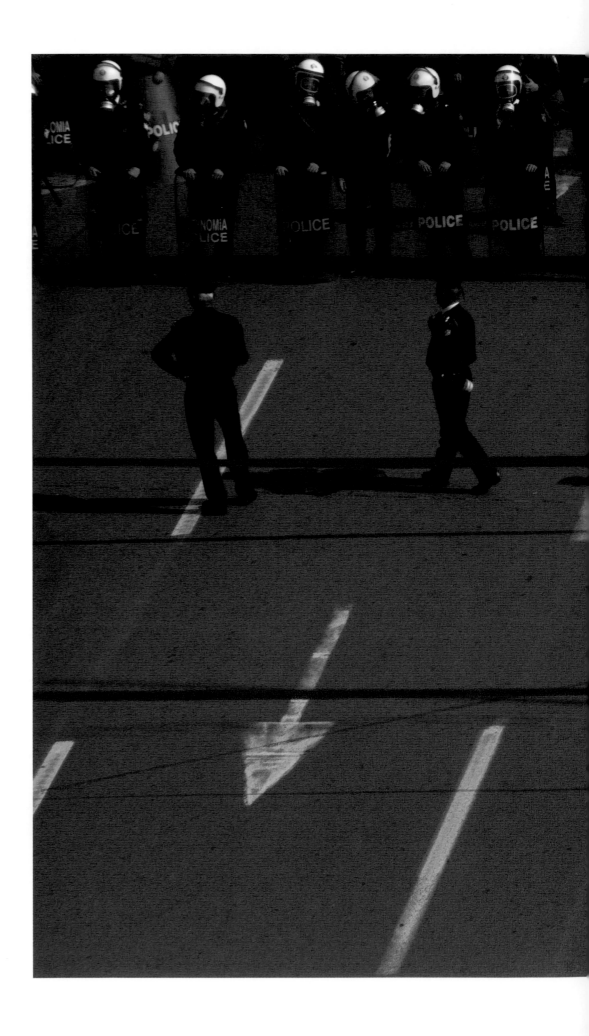

Constitution Square, 2007

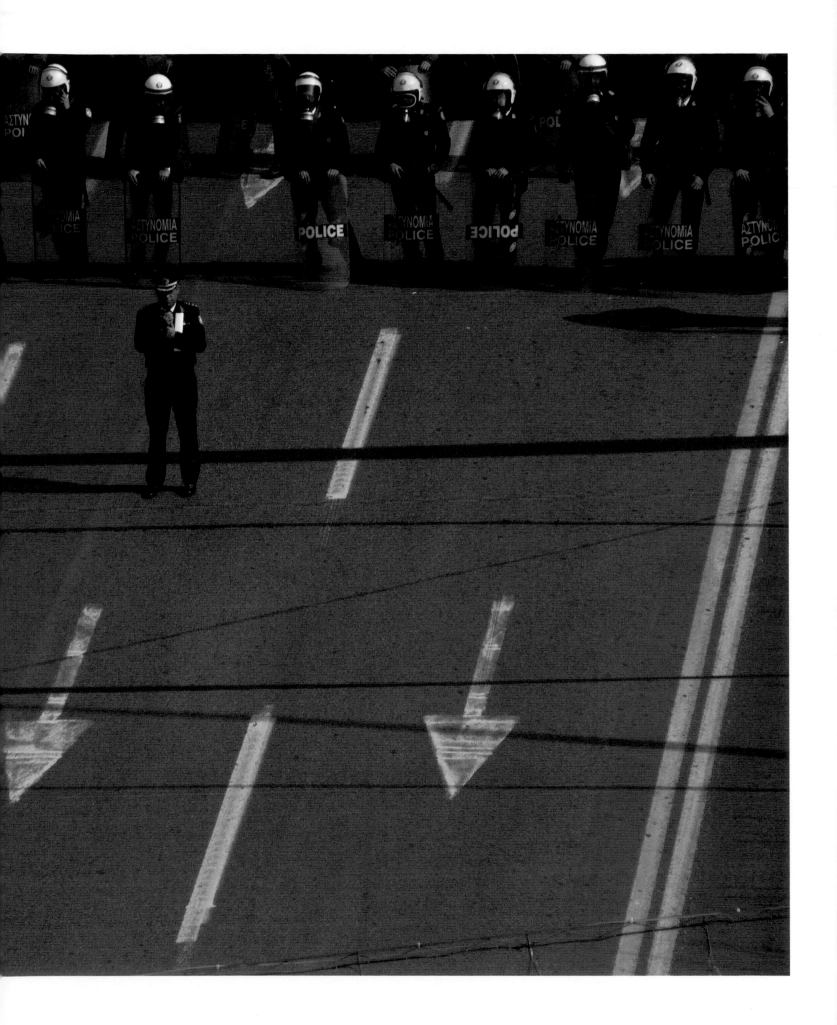

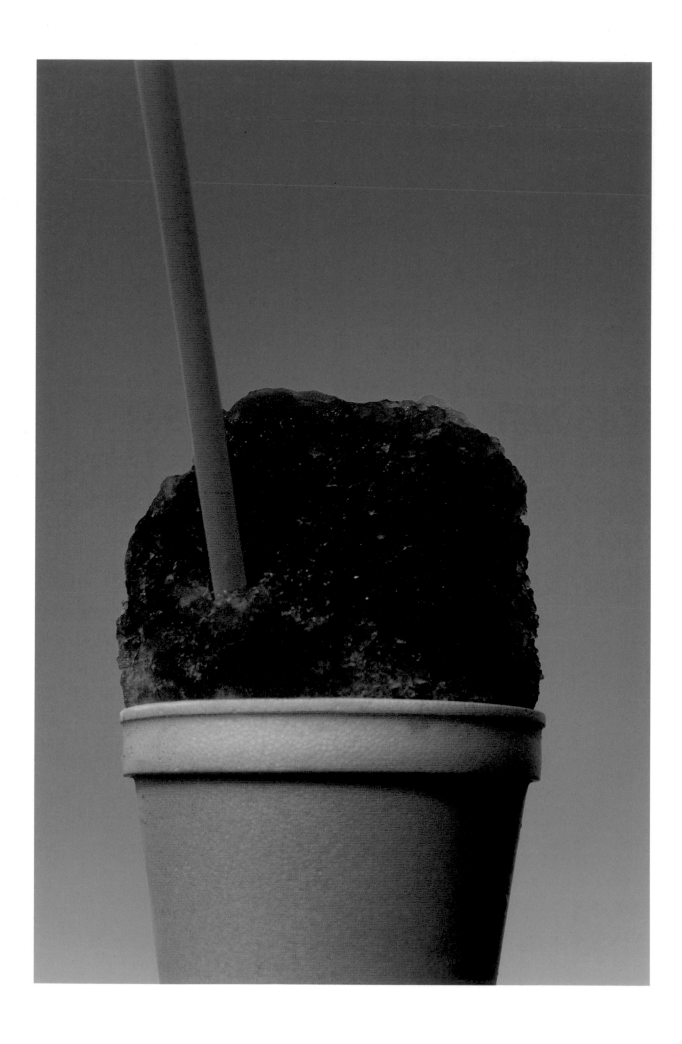

Sandra Dee, 2011

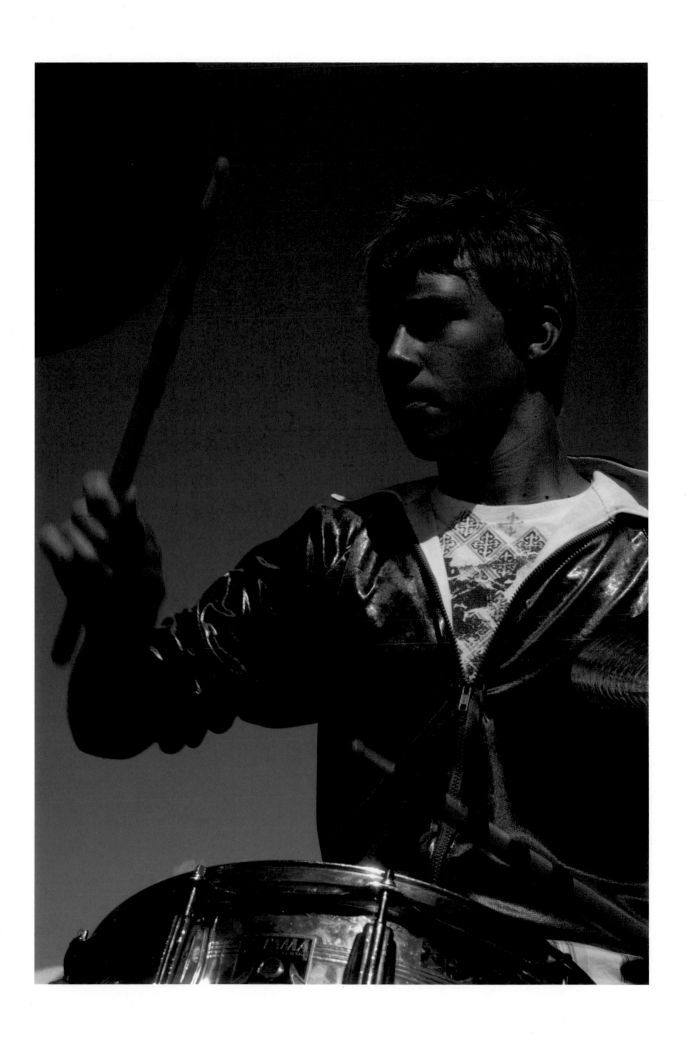

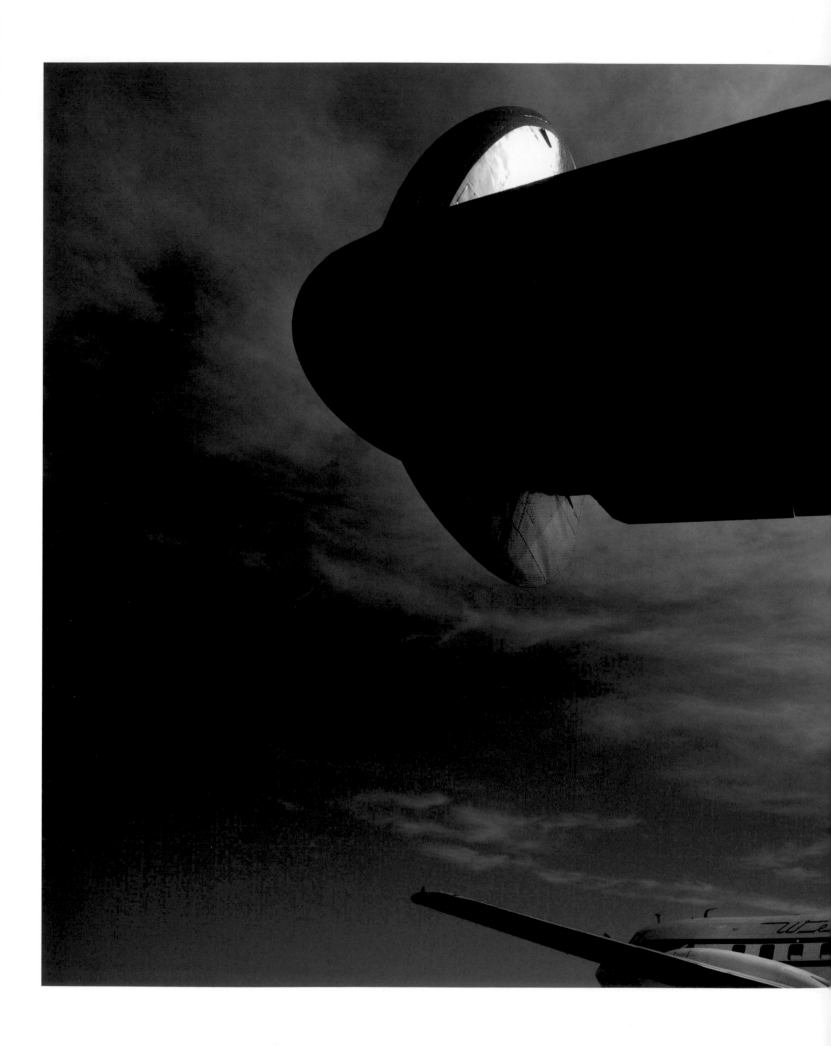

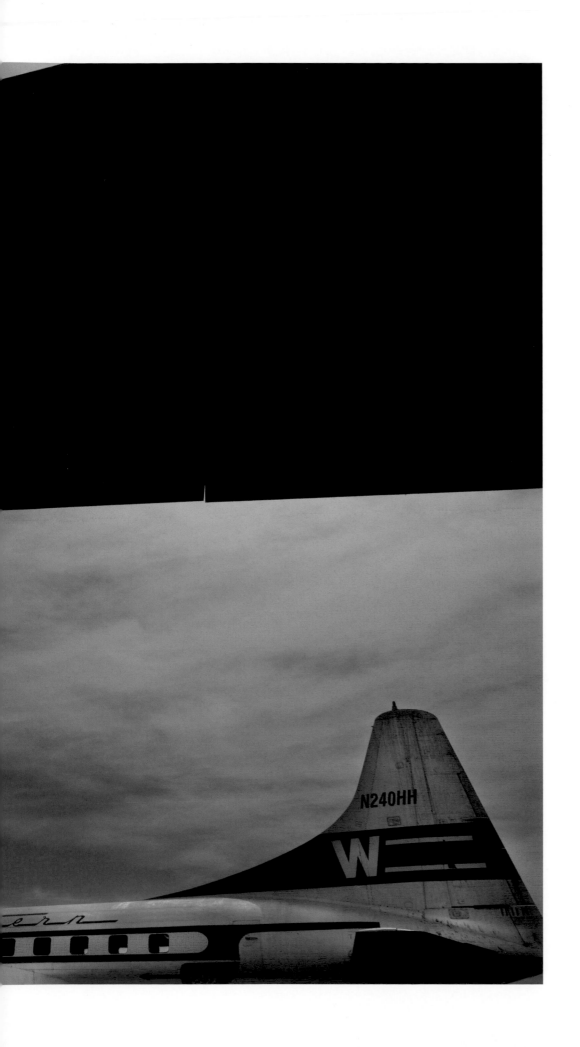

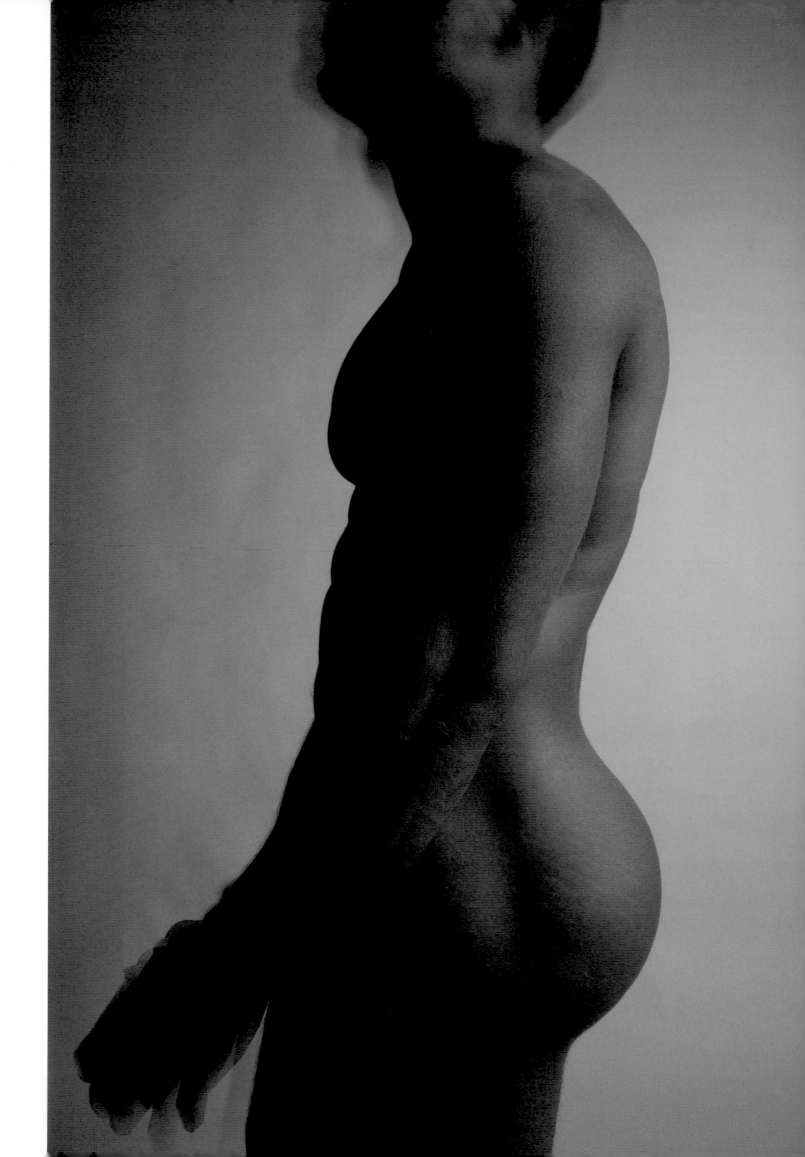

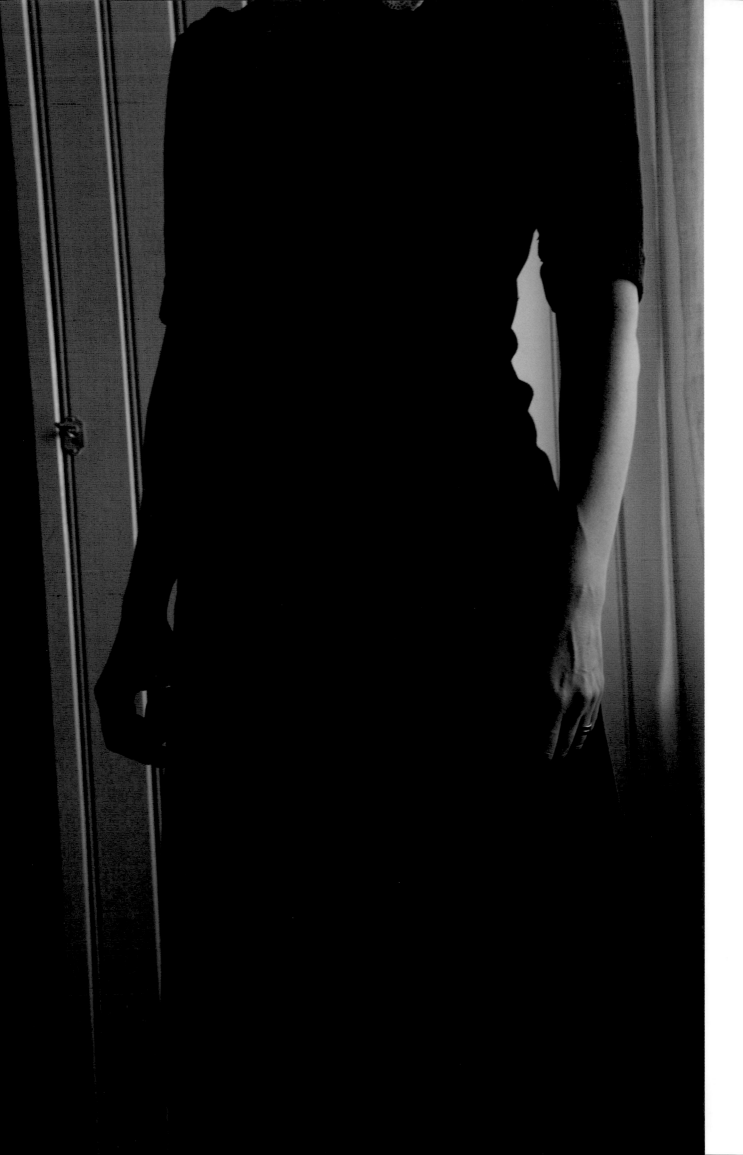

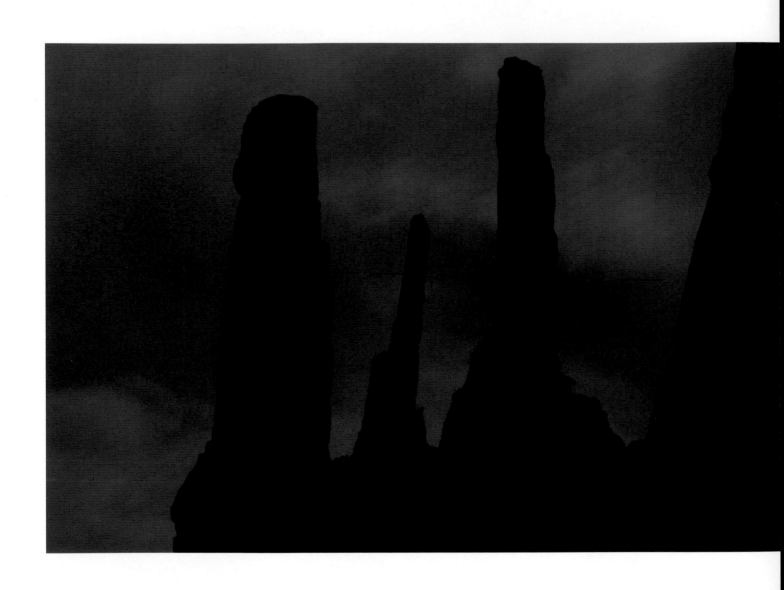

Half Moon, 2007

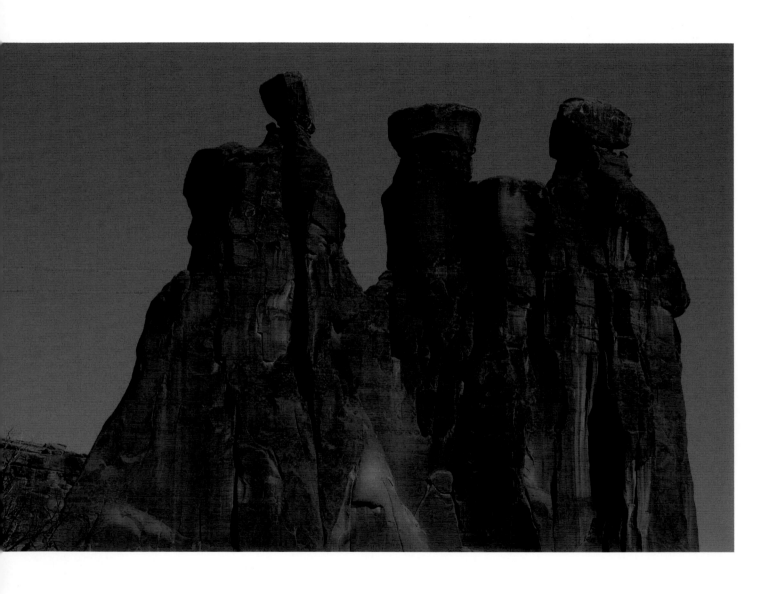

Full Moon, 2007

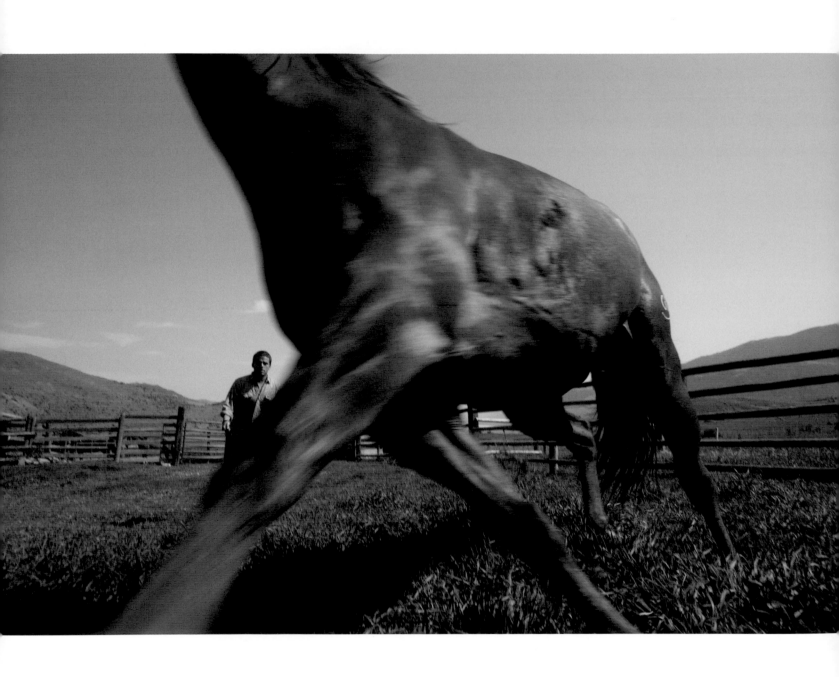

Livingston, 2009

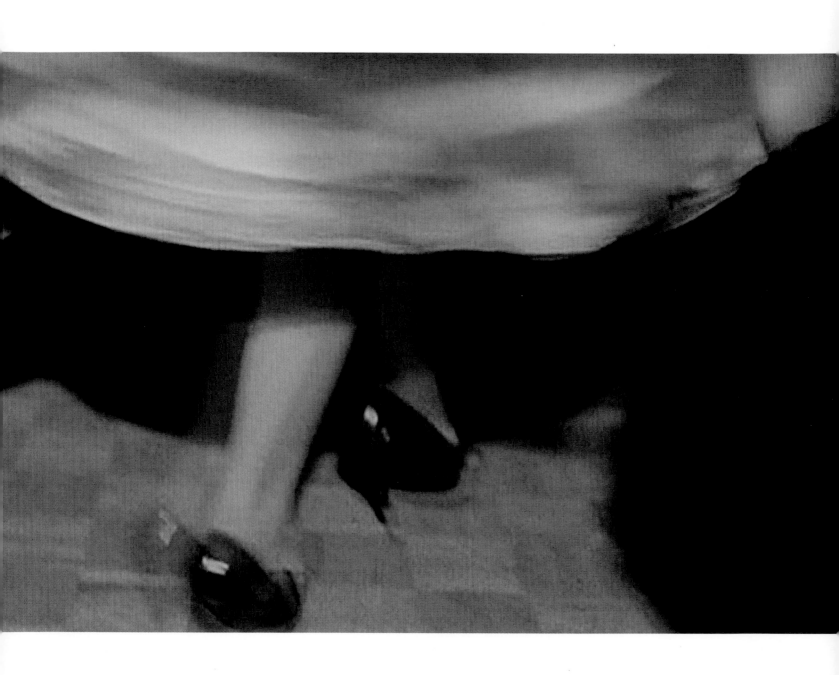

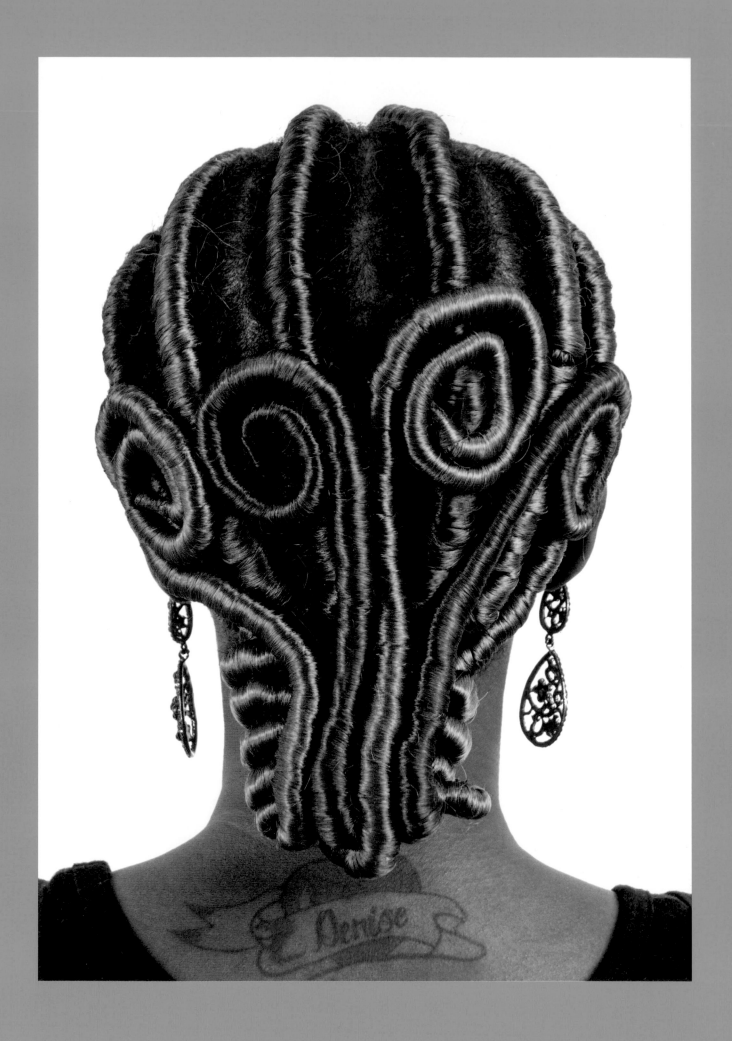

Denise, 2011

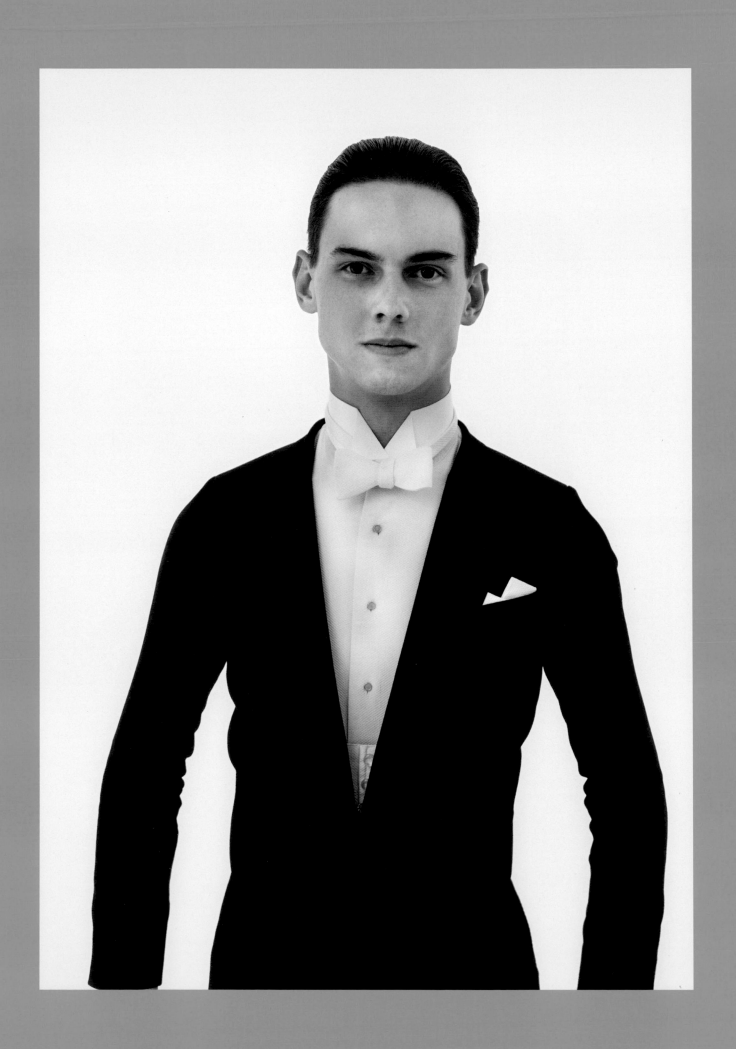

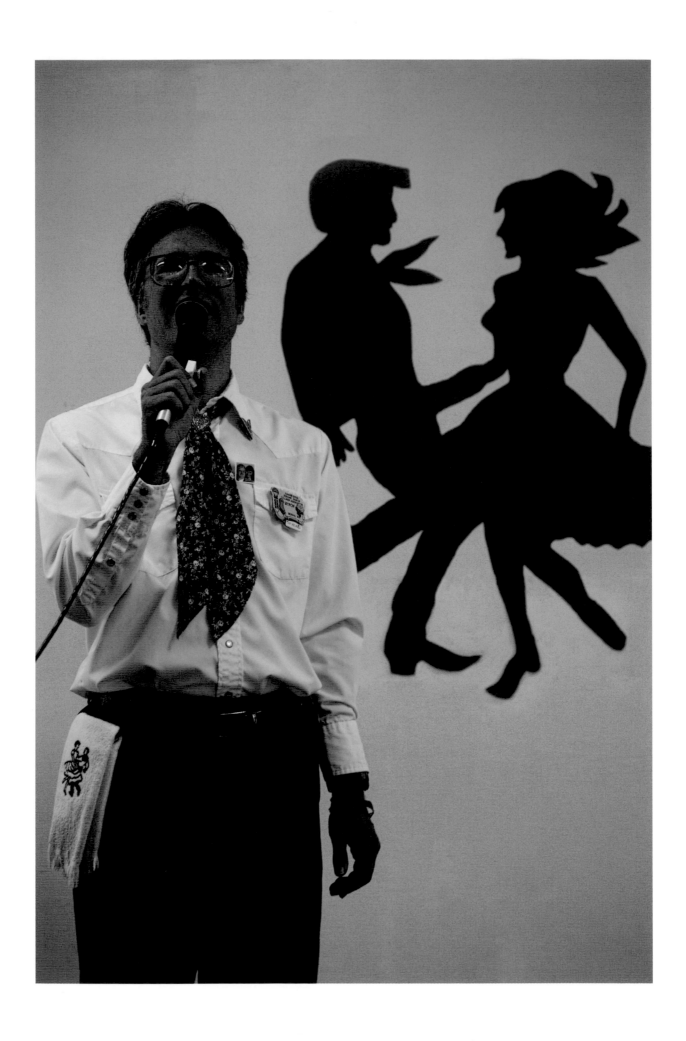

This is the Day, 2009

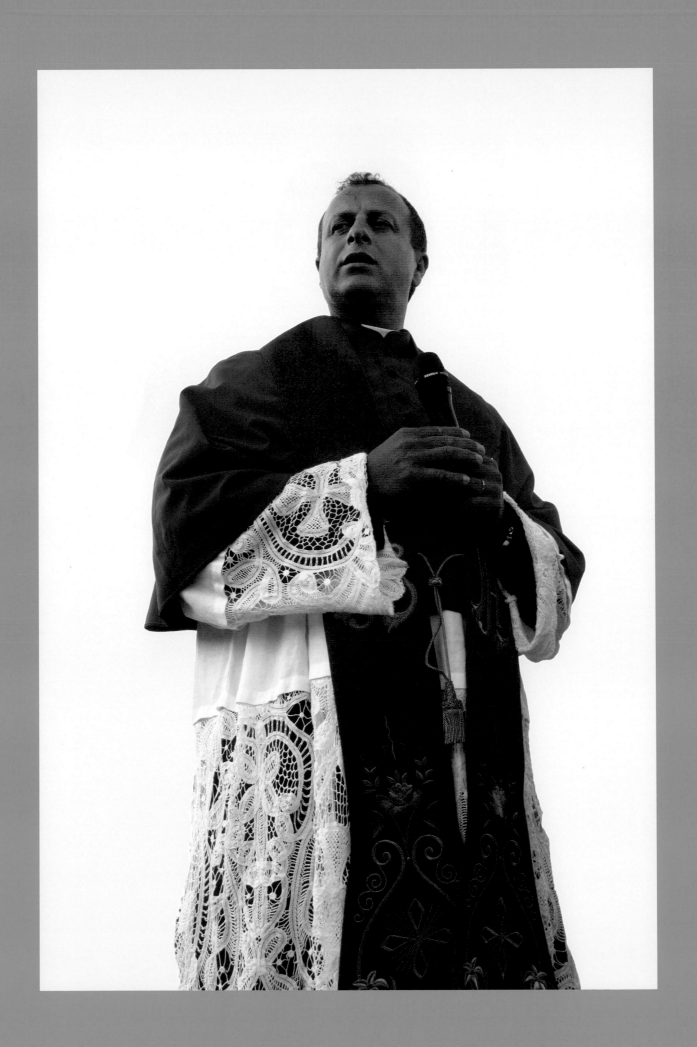

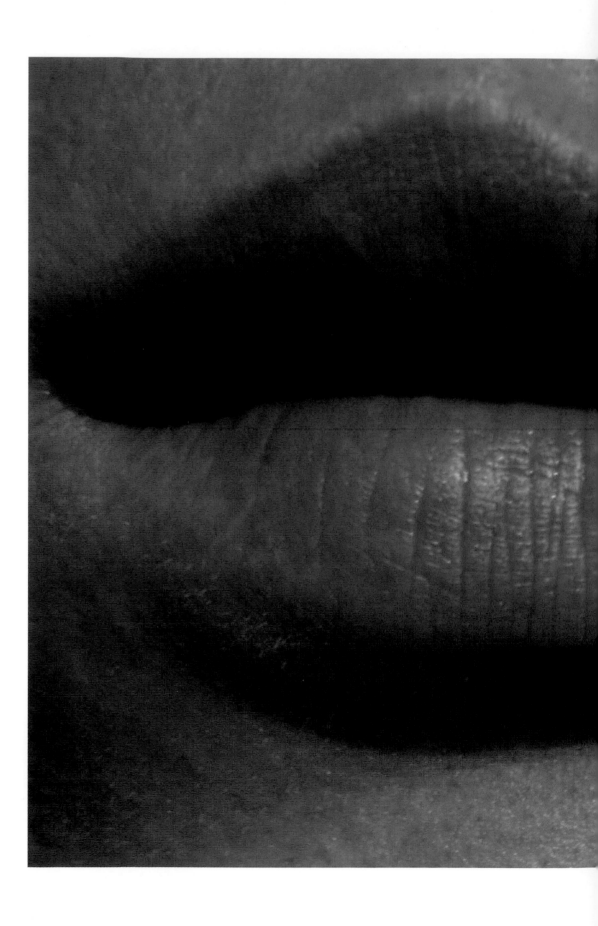

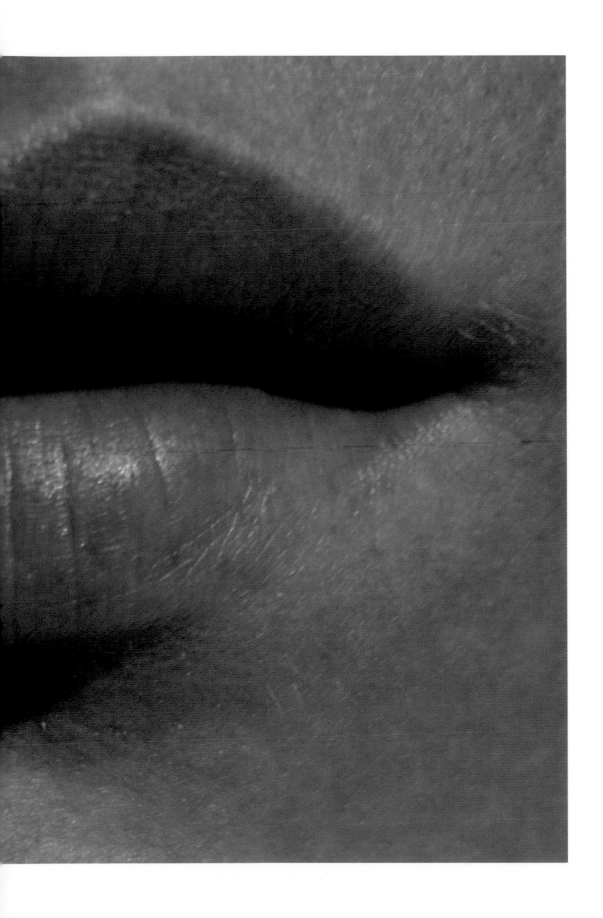

Kiss me Deadly, 2010

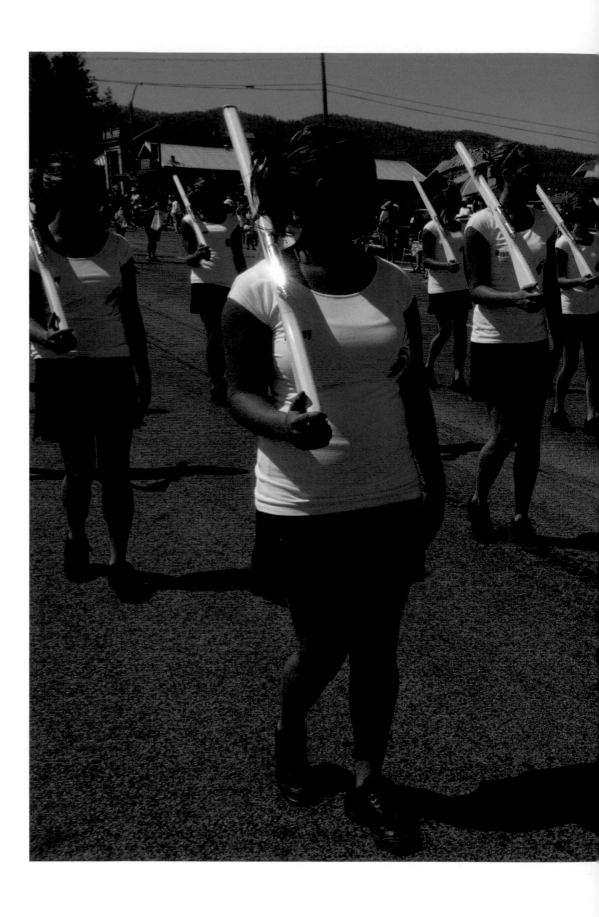

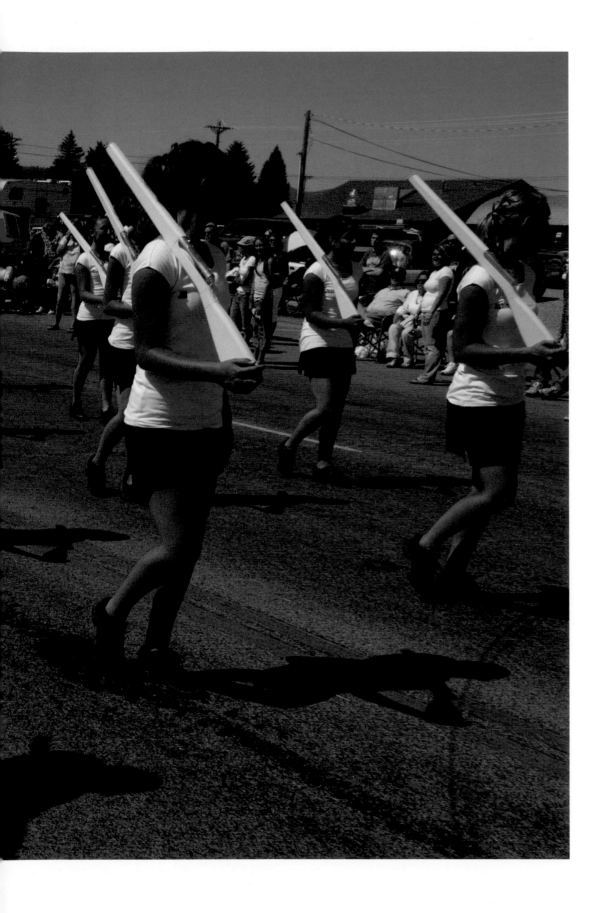

Heston's Commandments, 2007

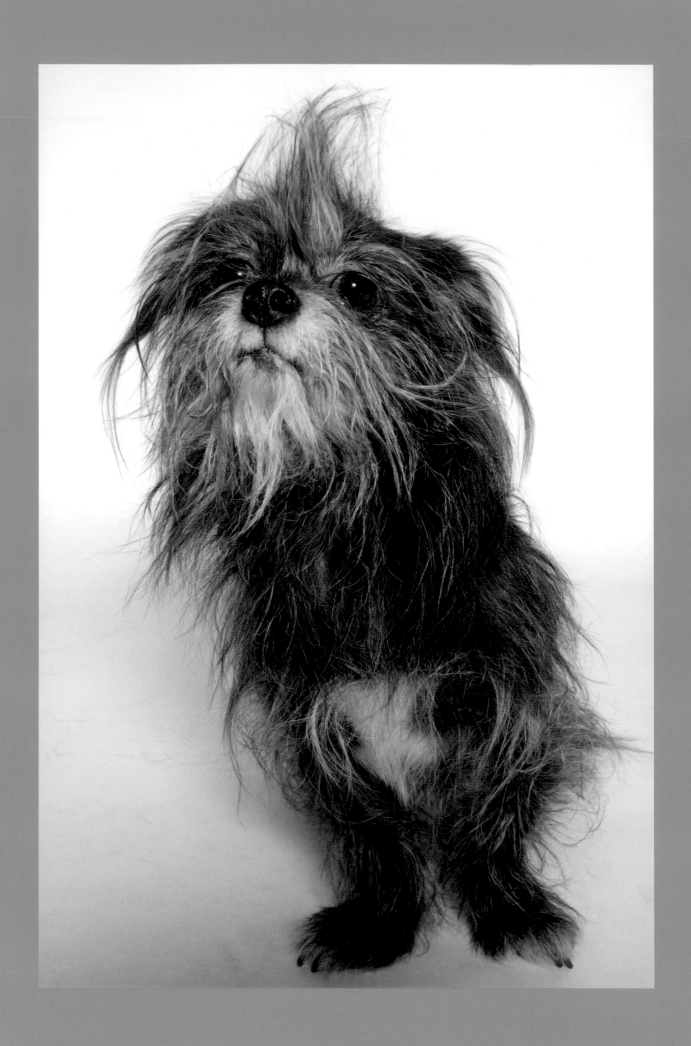

Come with Me, 2007

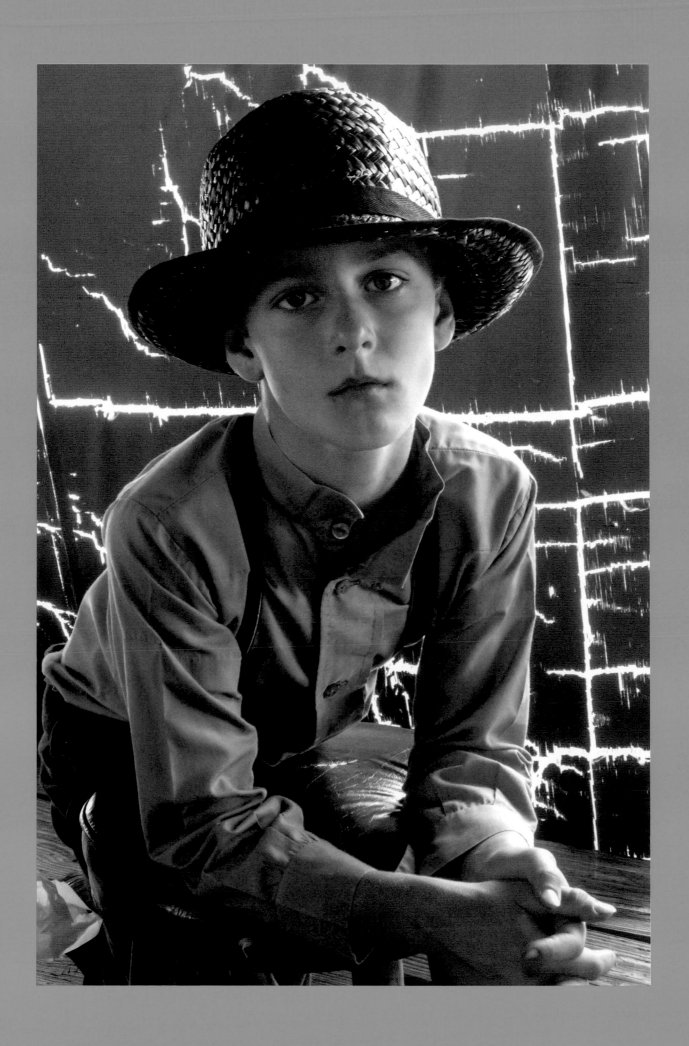

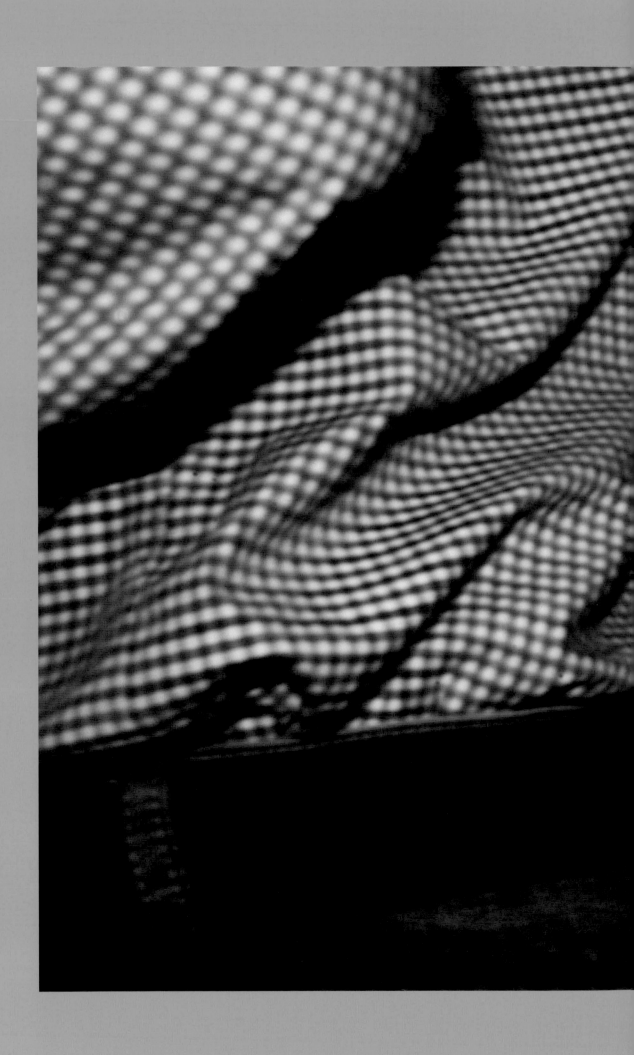

The Great Escape, 2013

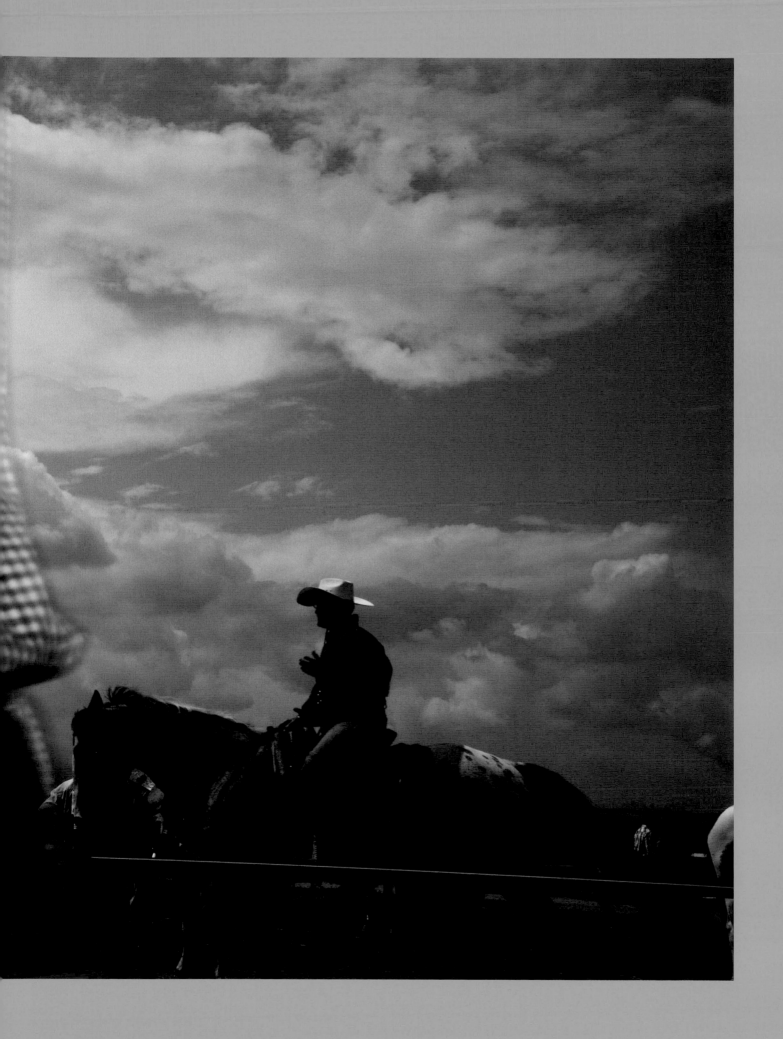

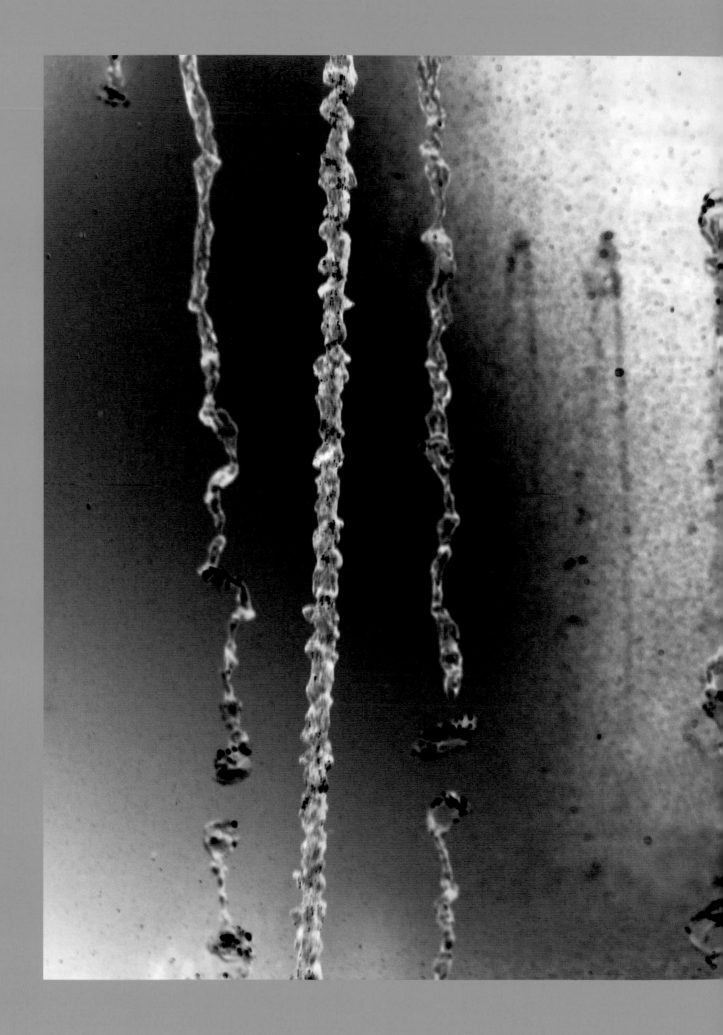

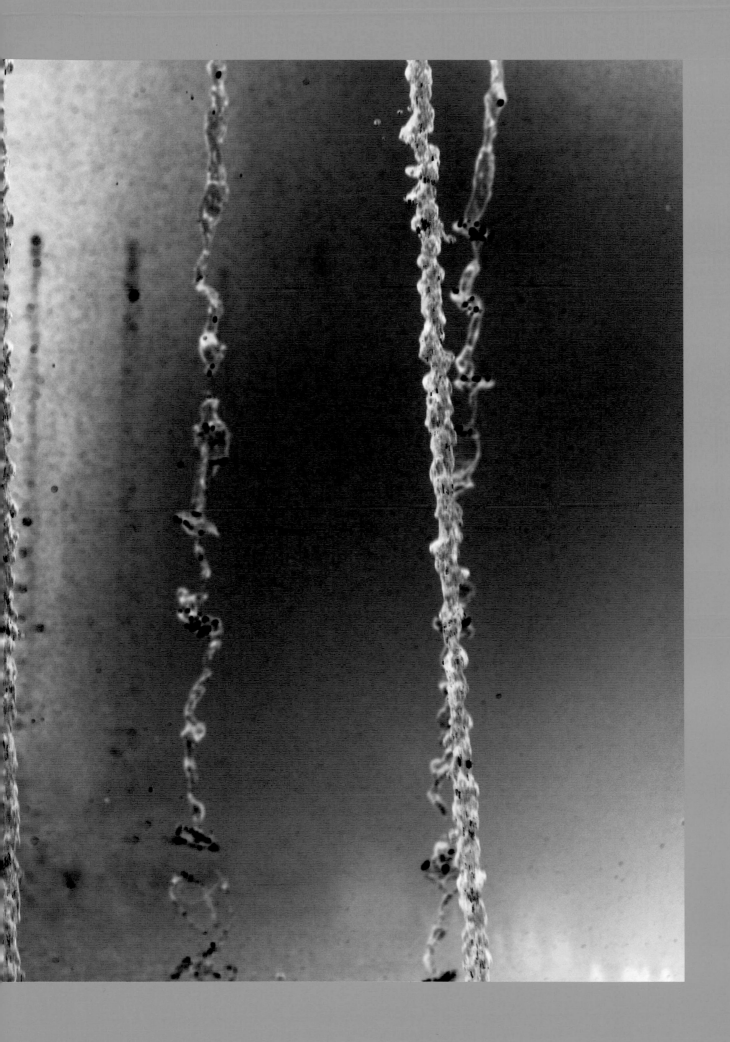

Urination Emancipation, 2006

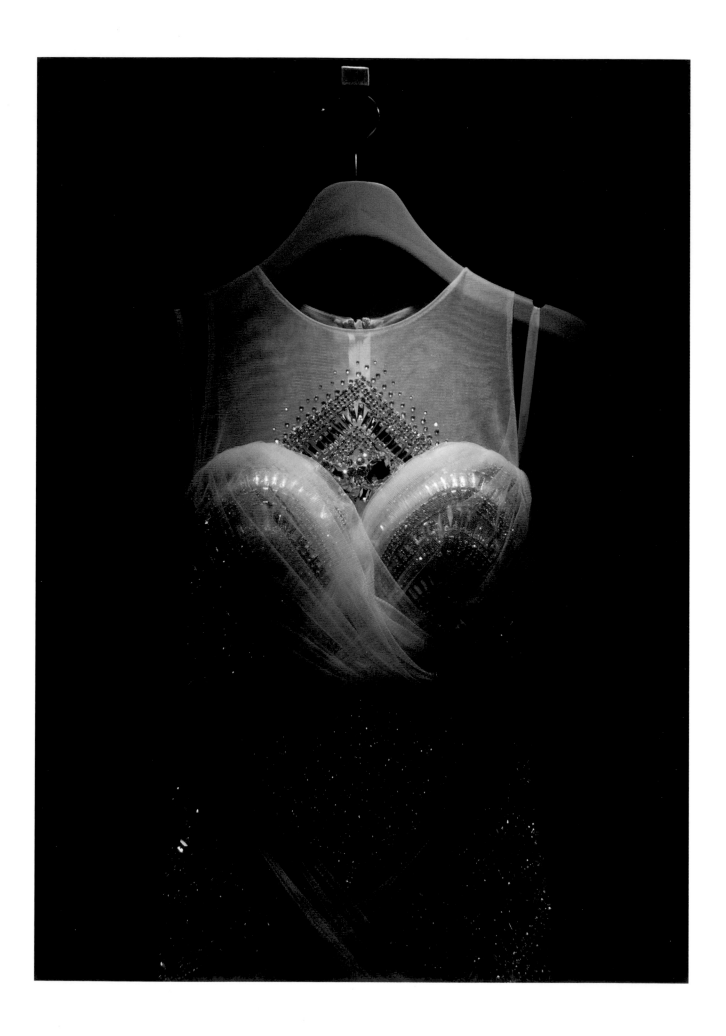

Before the War, 2013

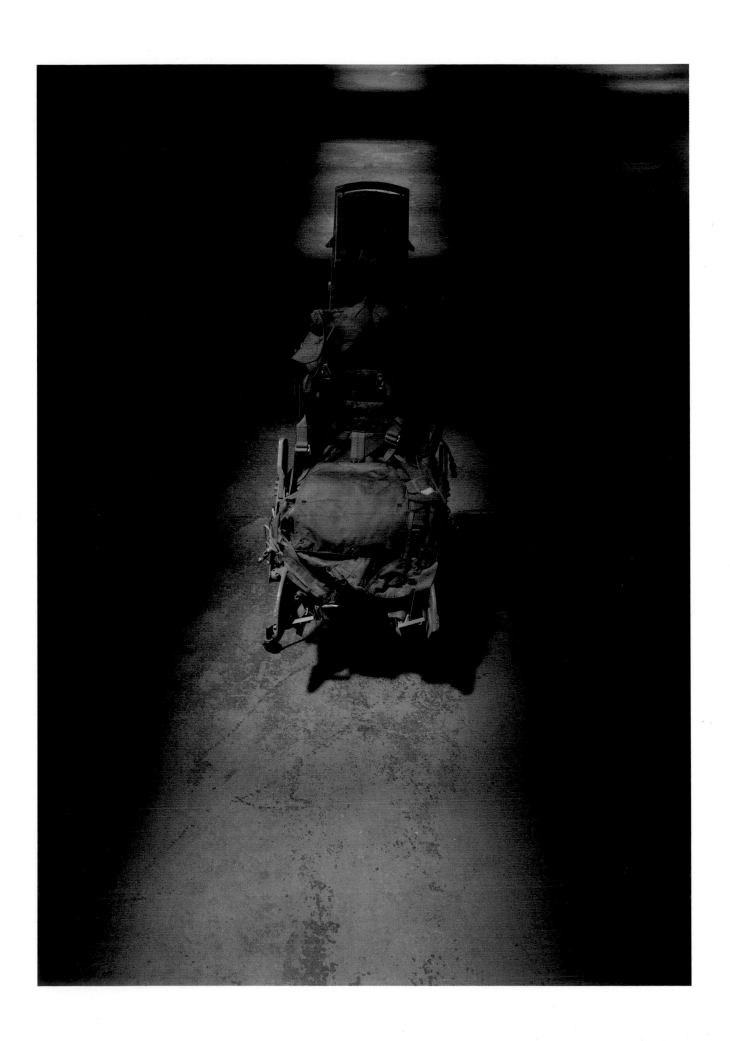

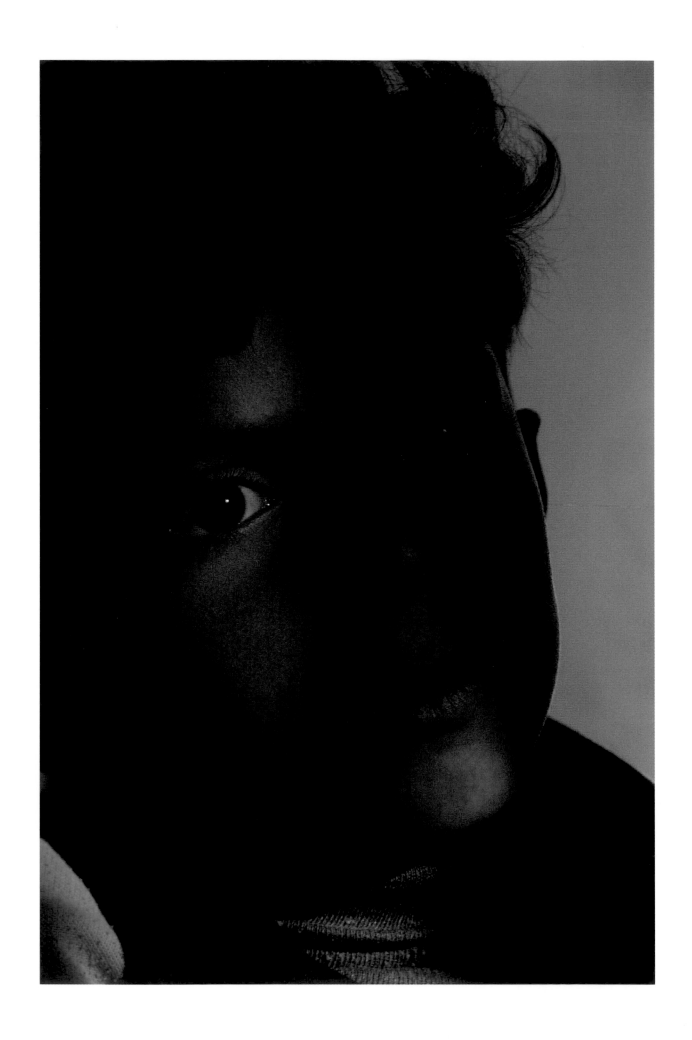

90 Jordan, 2008

Michael Avedon, 2011

Opium Hill, 2013

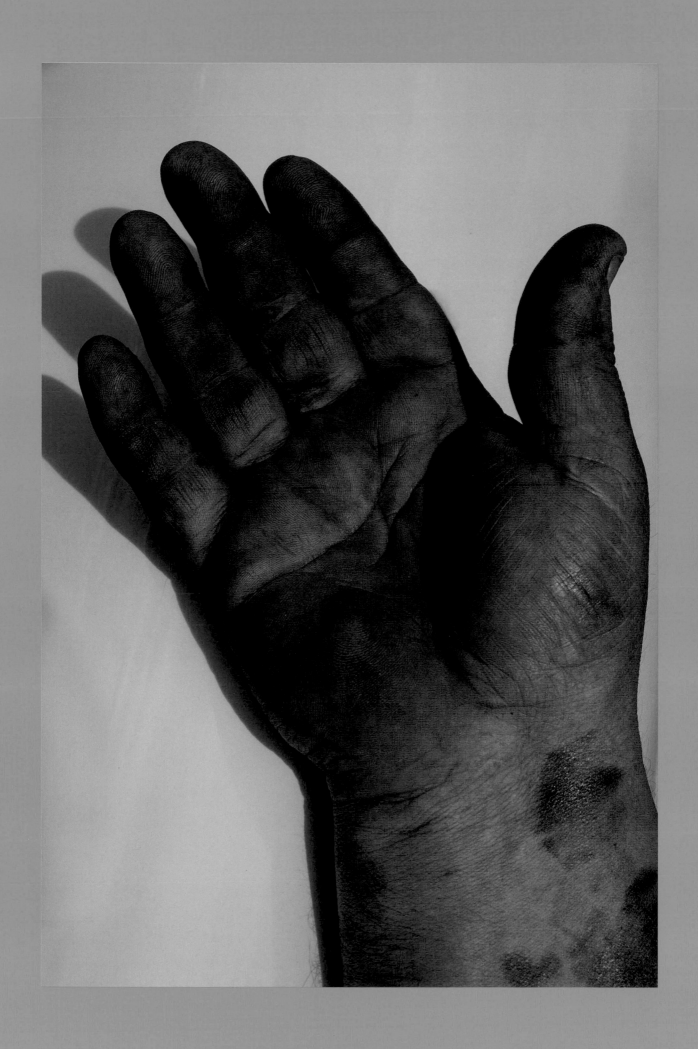

Blue Collar, 2011

White Glove, 2012

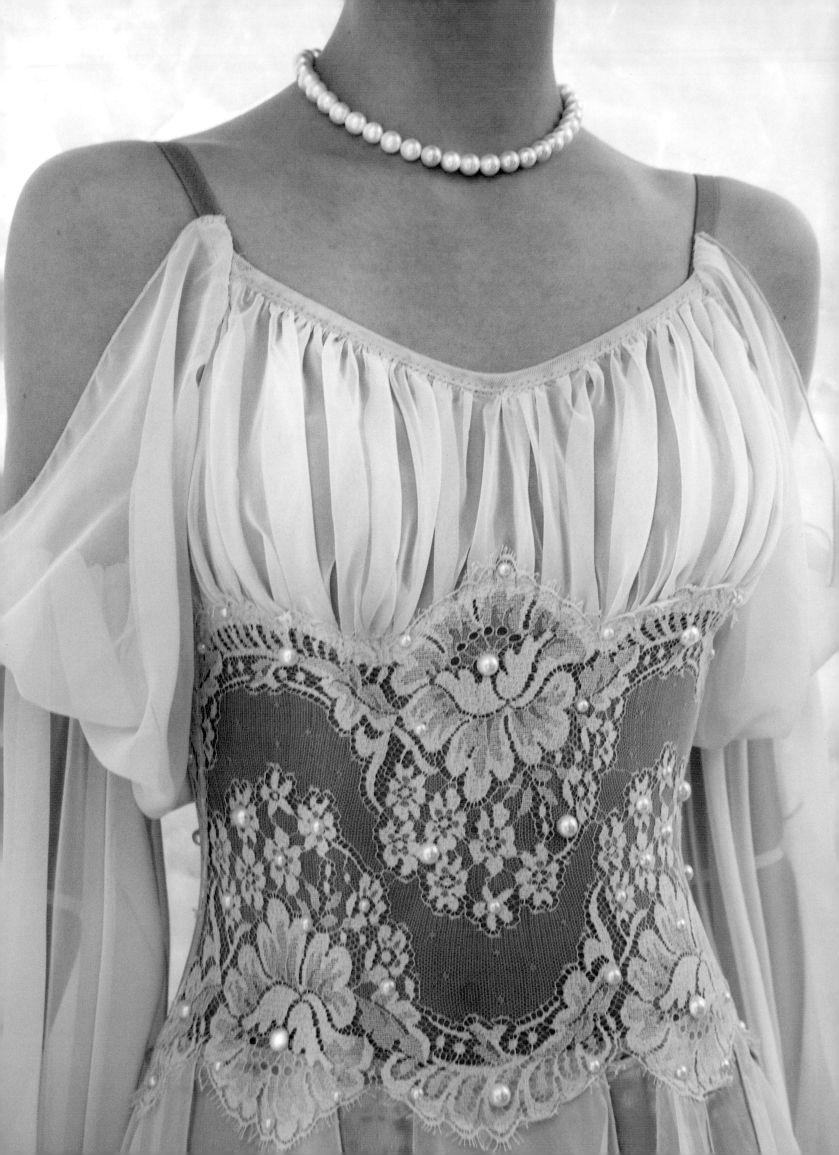

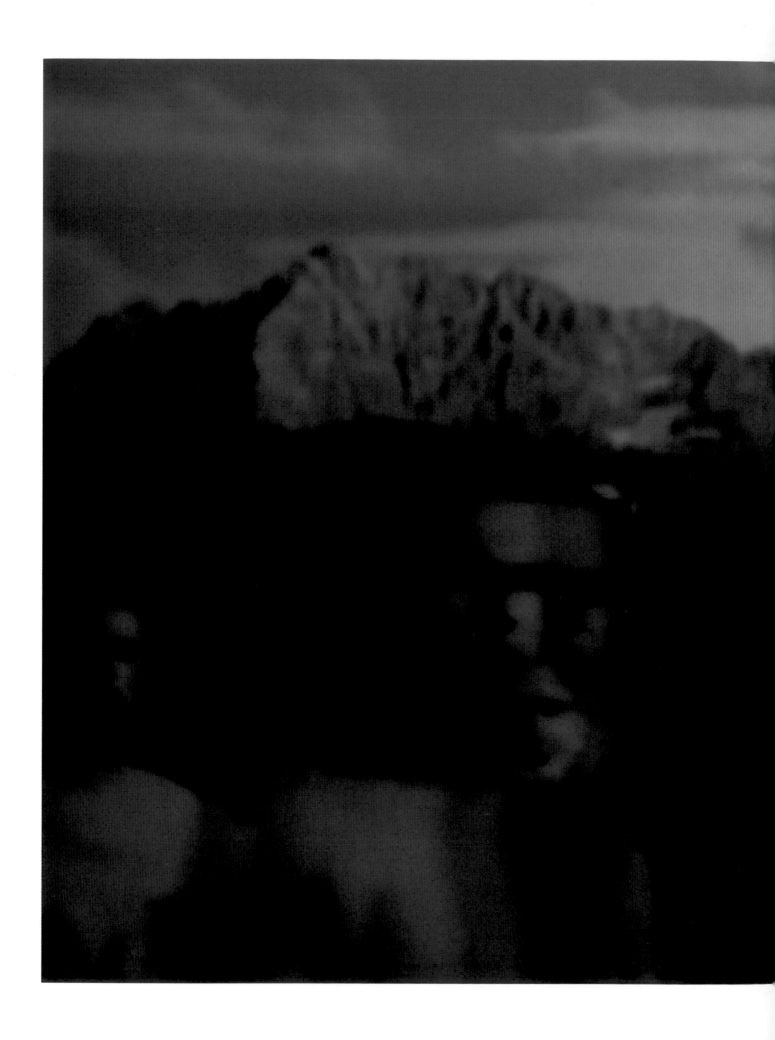

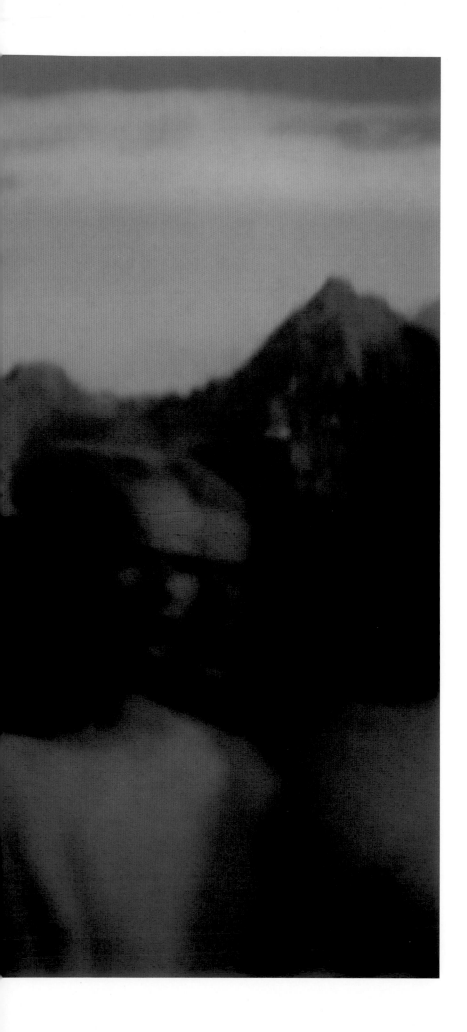

Consequence of Kings, 2005

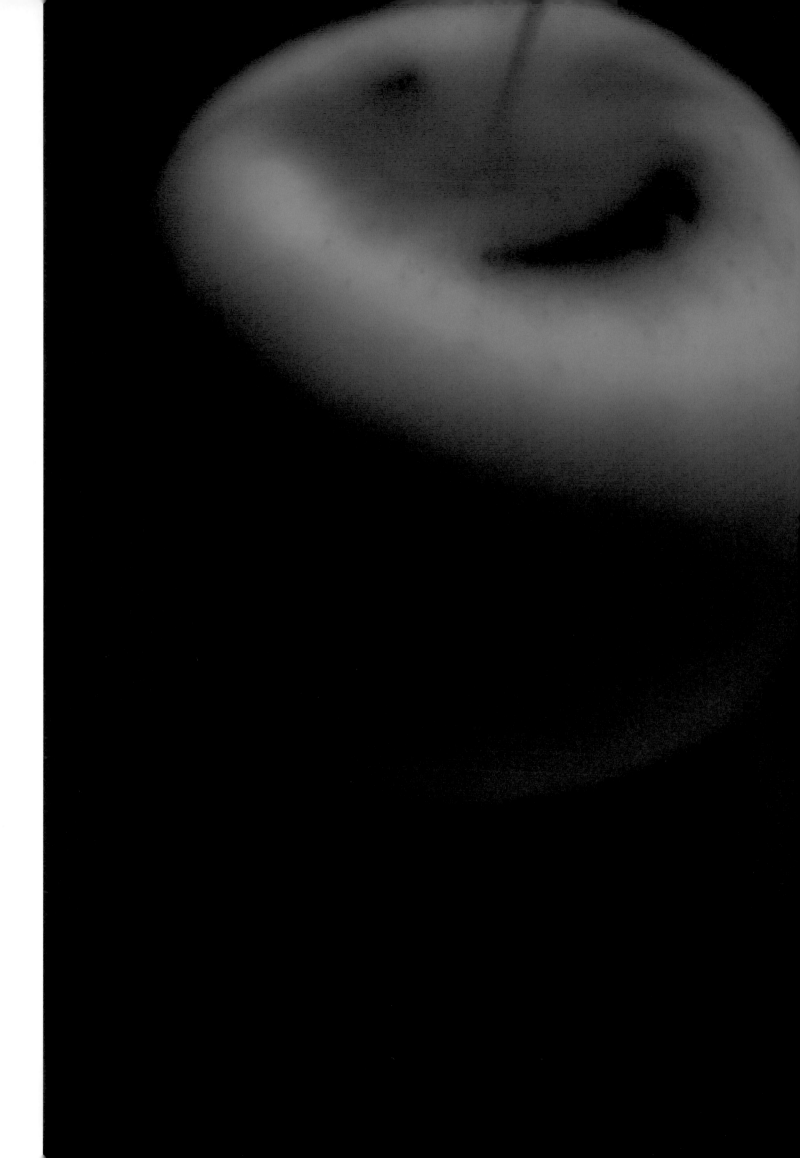

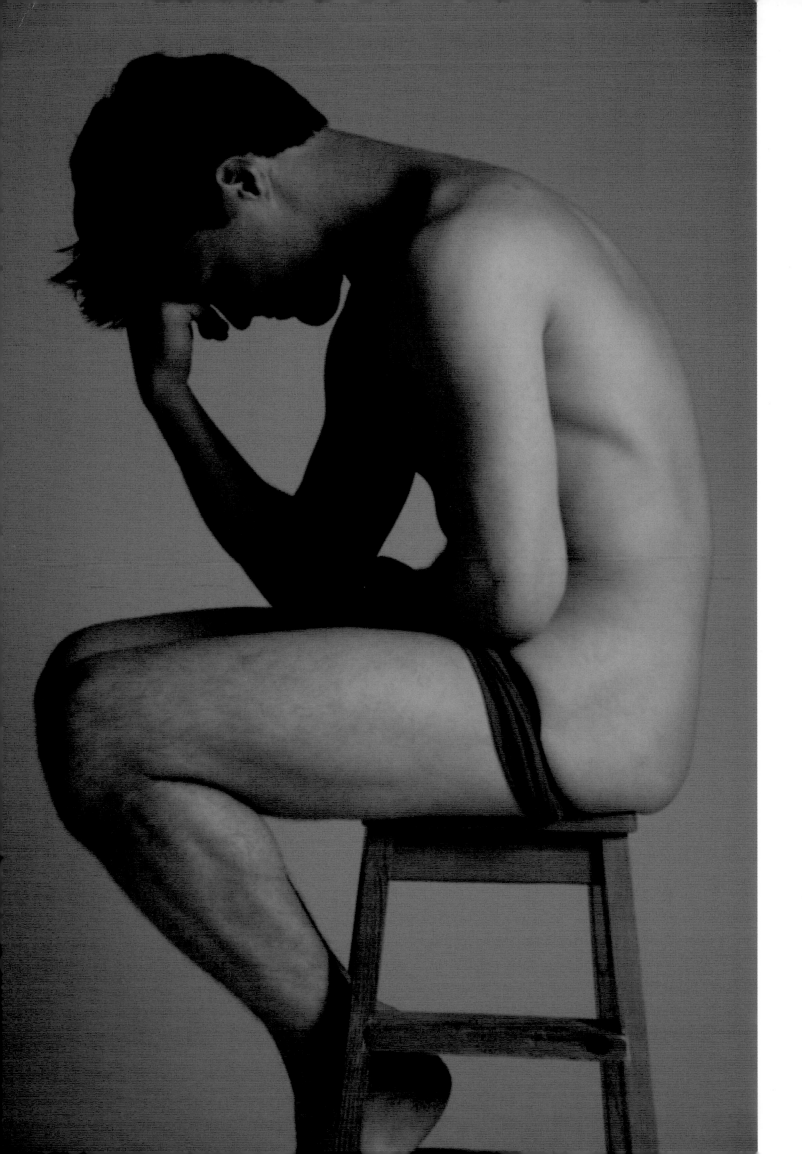

Karnak, 2008

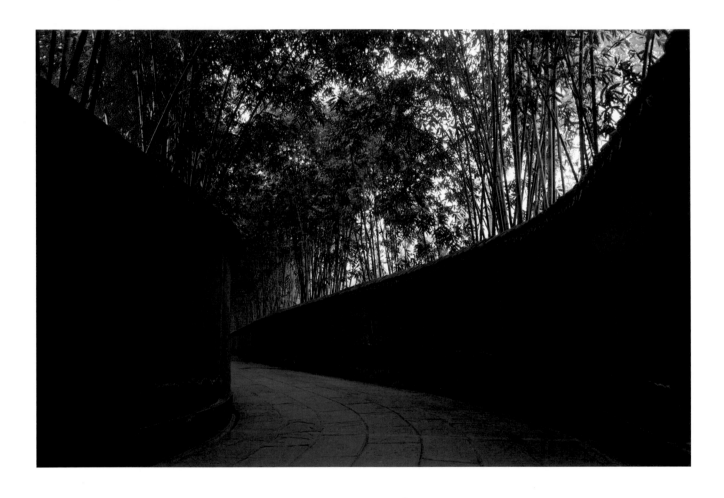

Wu Hou Temple, Chengdu, 2009

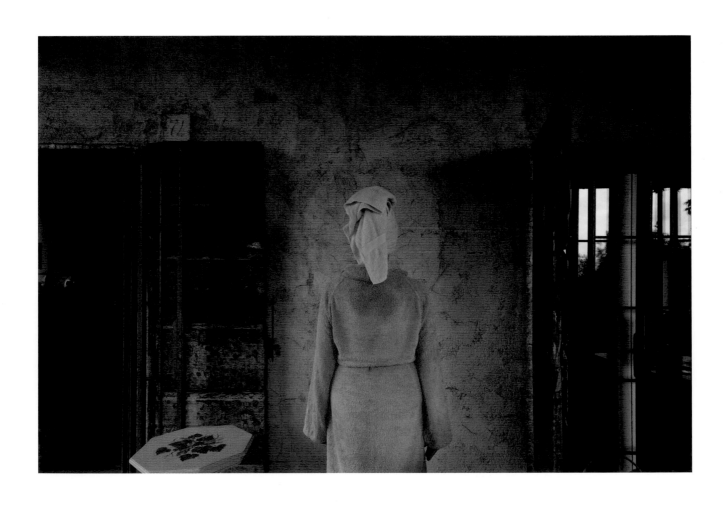

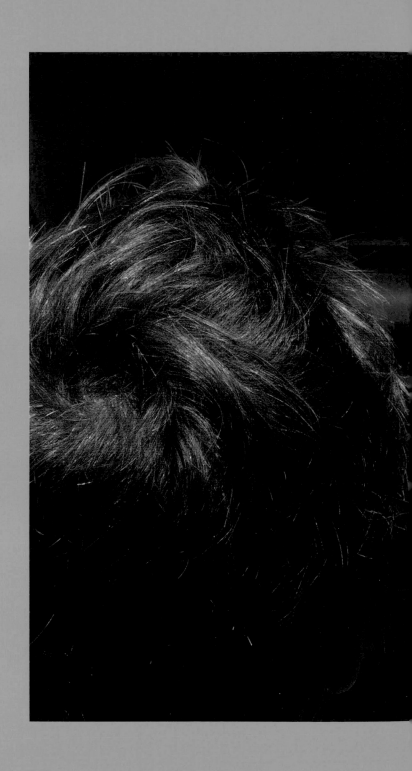

Strange Powers, 2011

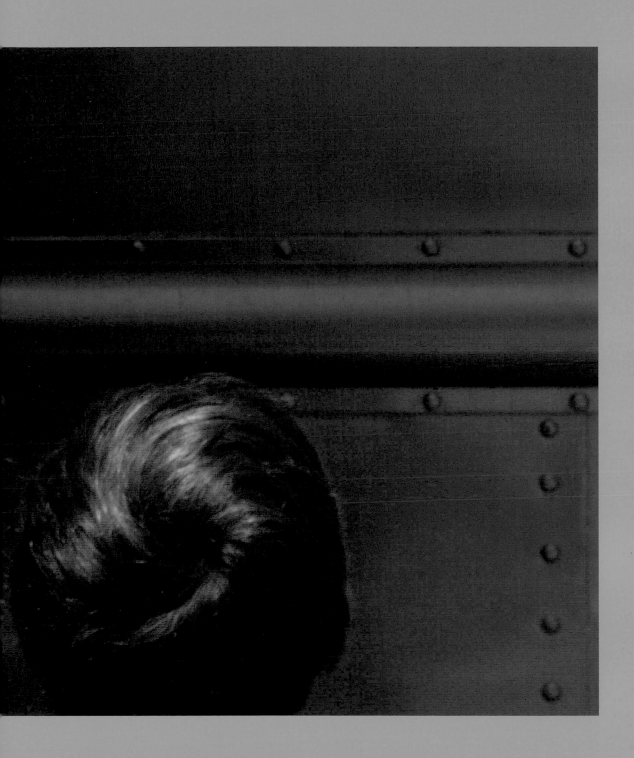

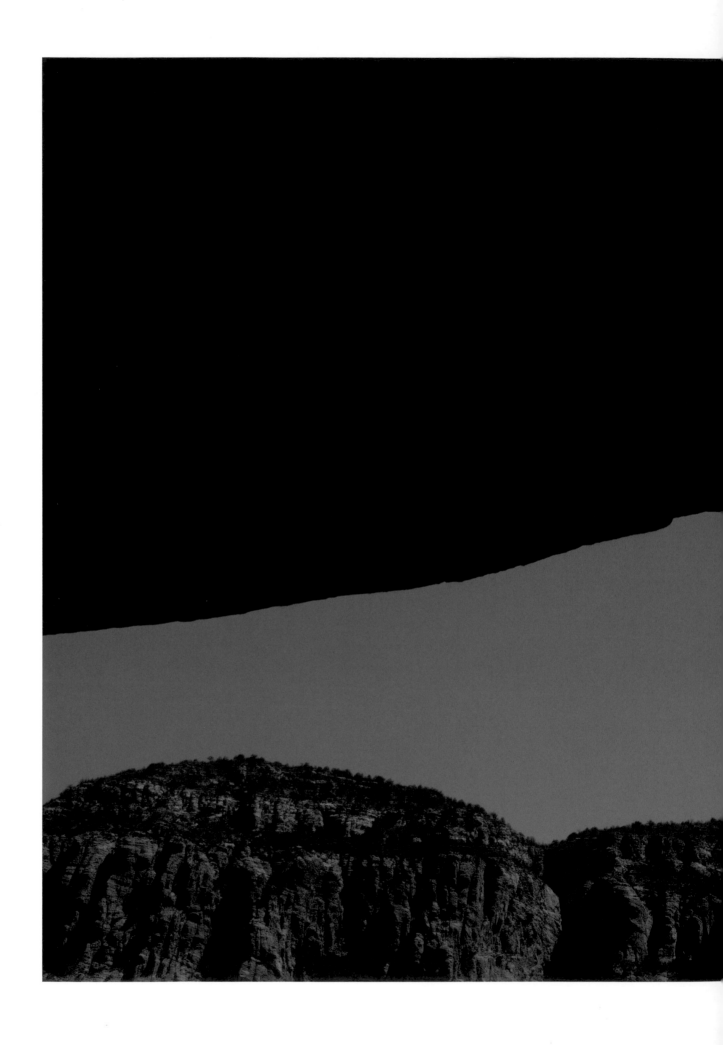

Close Encounters, 2007

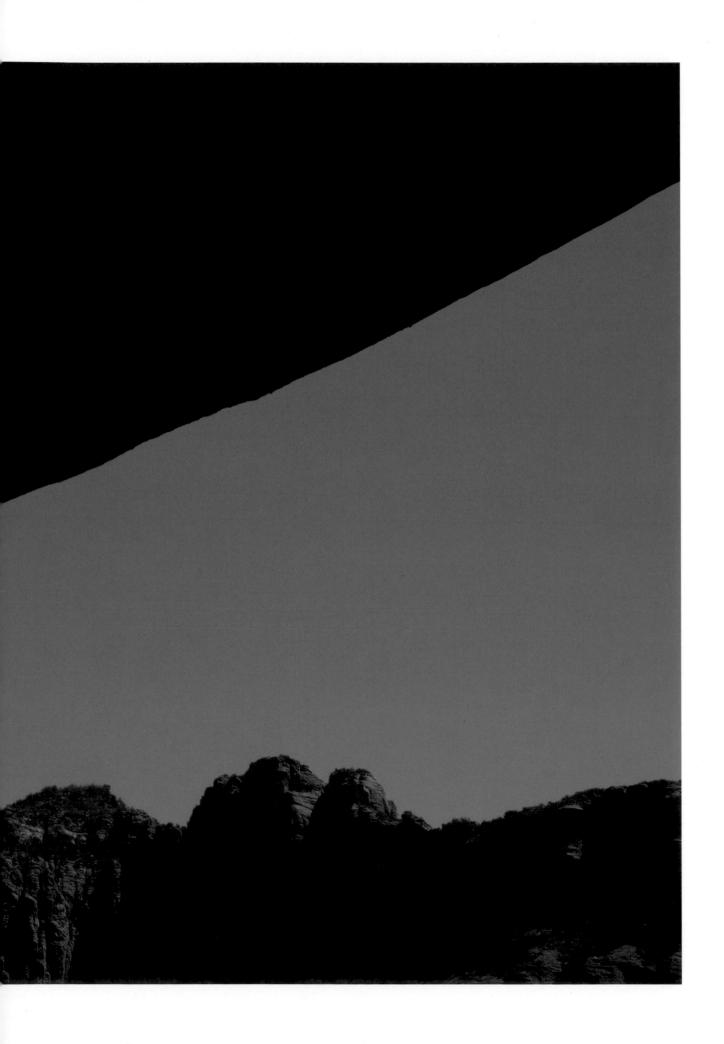

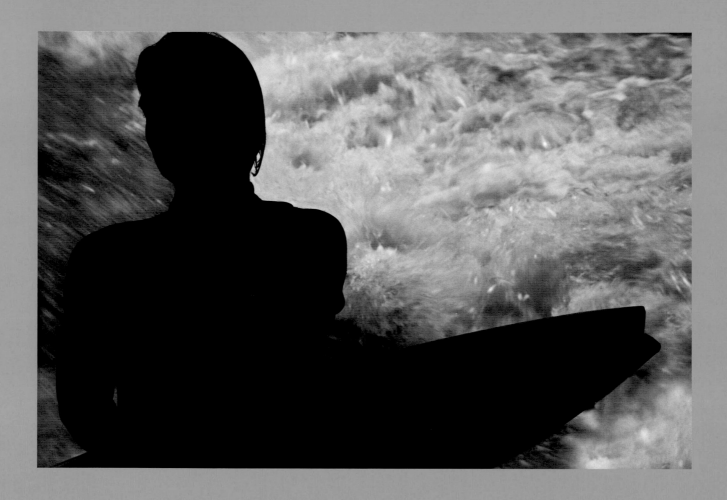

Moon, 2006

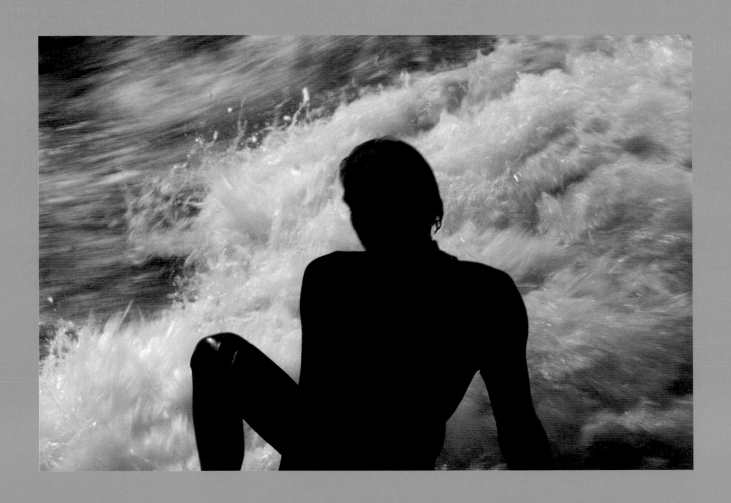

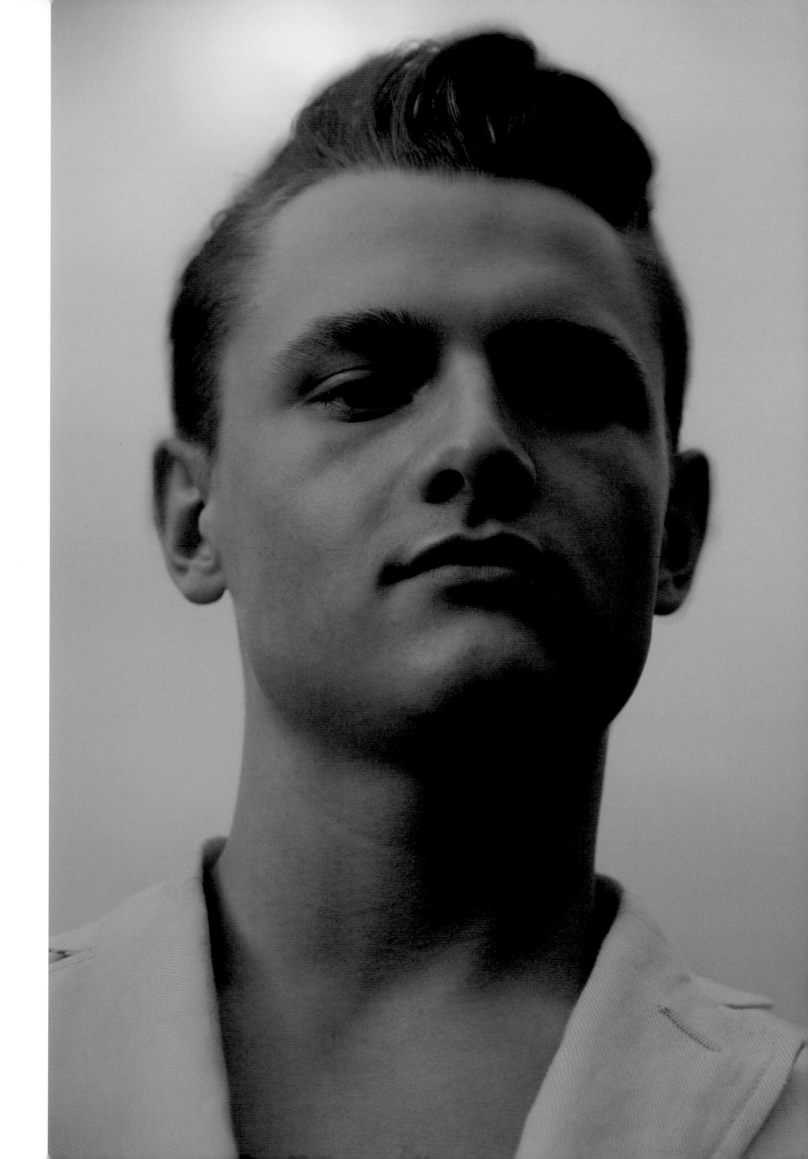

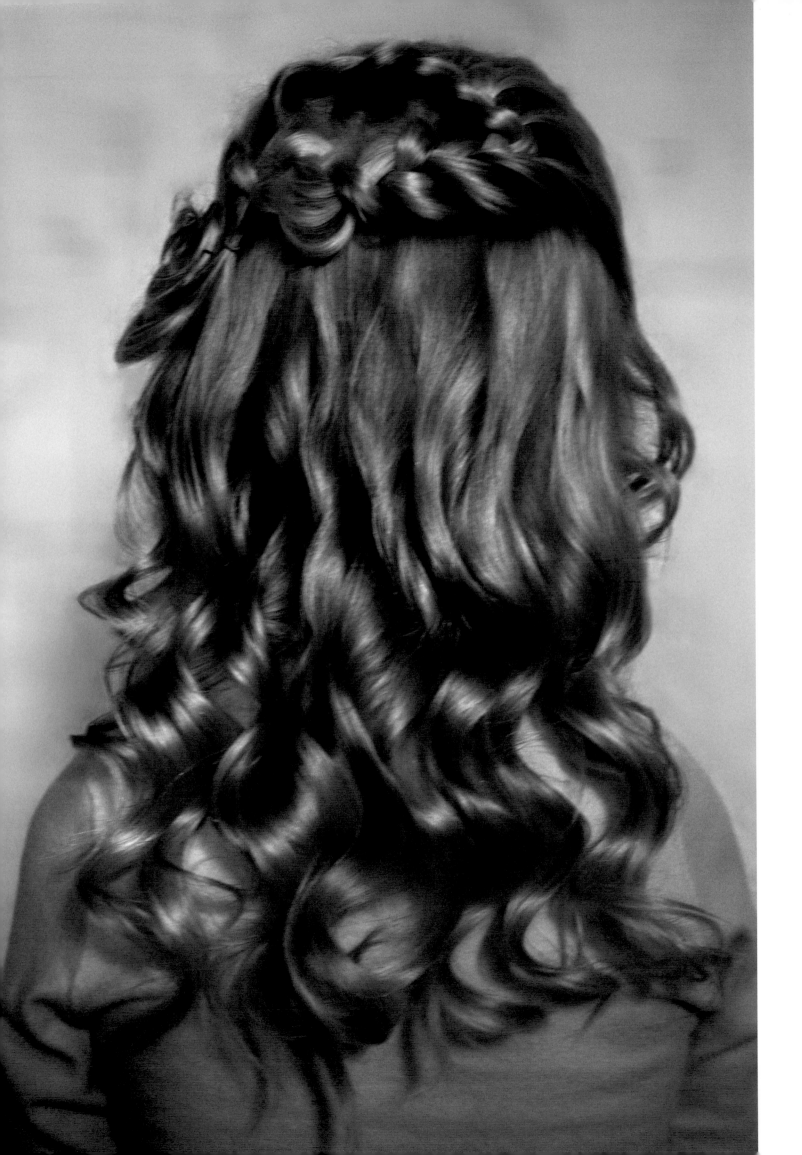

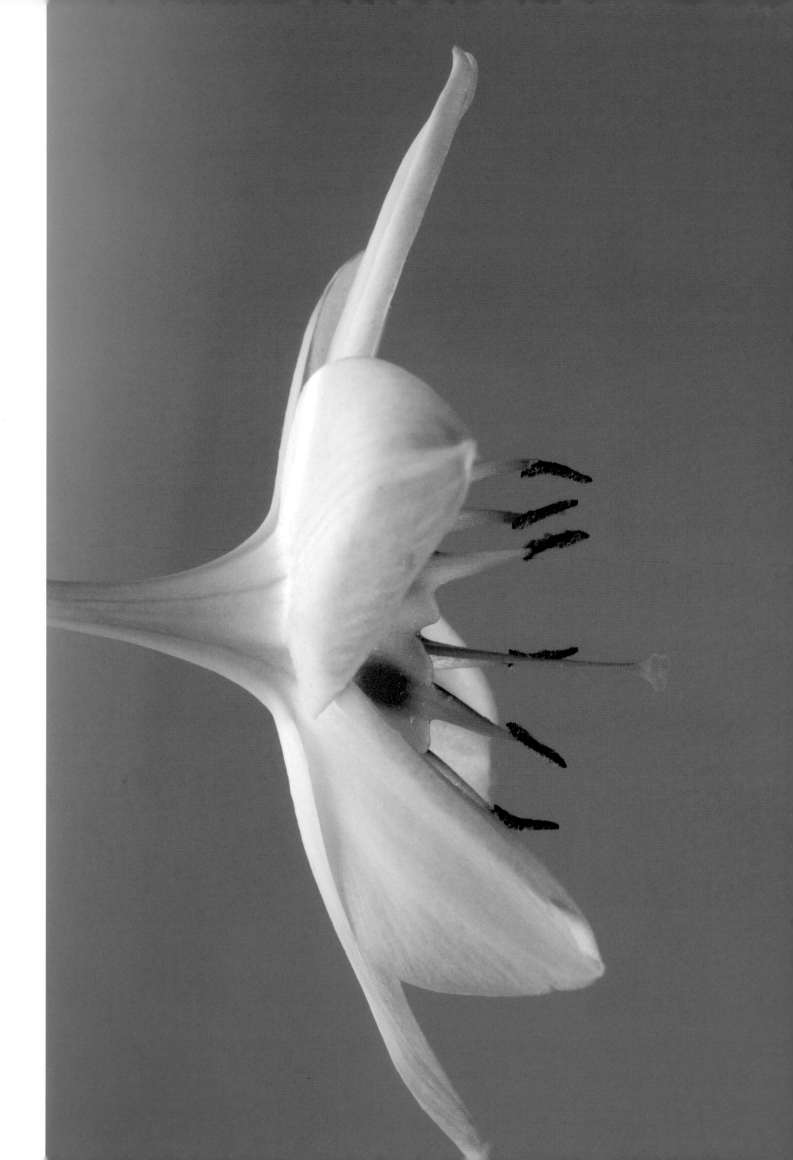

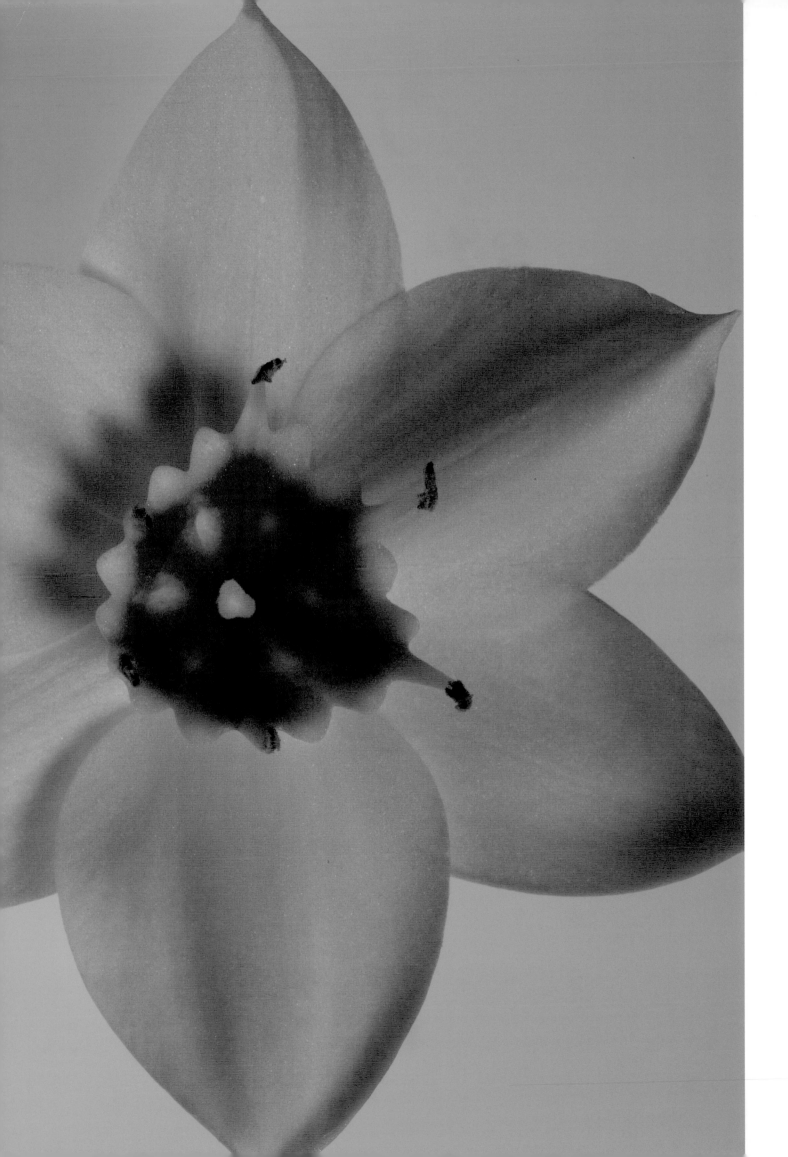

Deep Space 2, 2008

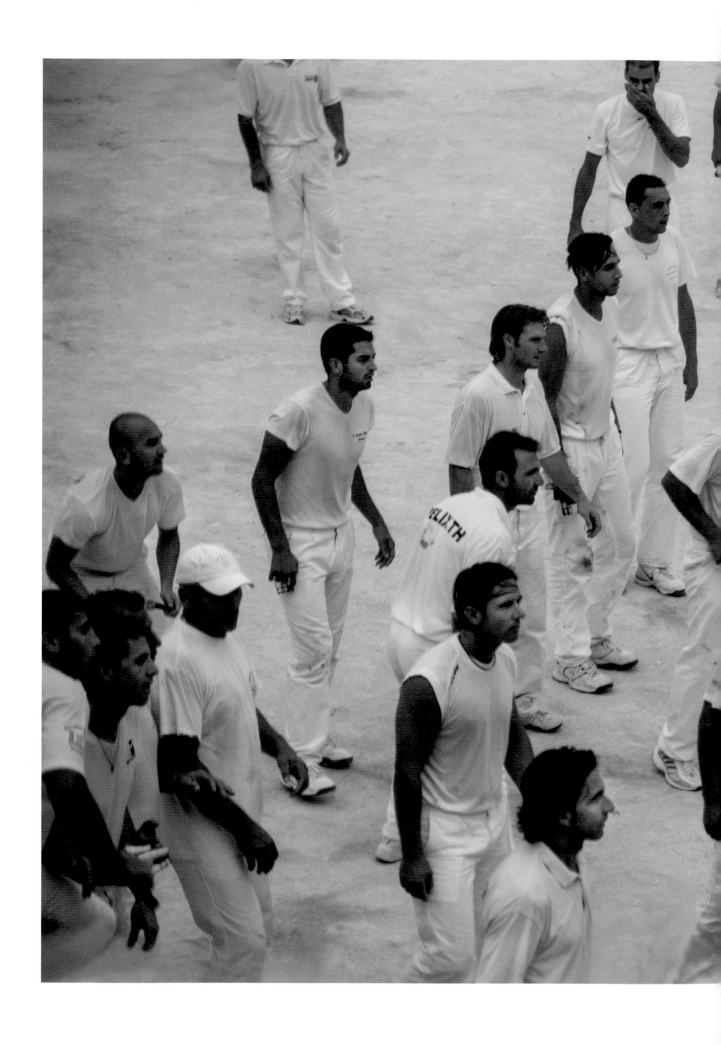

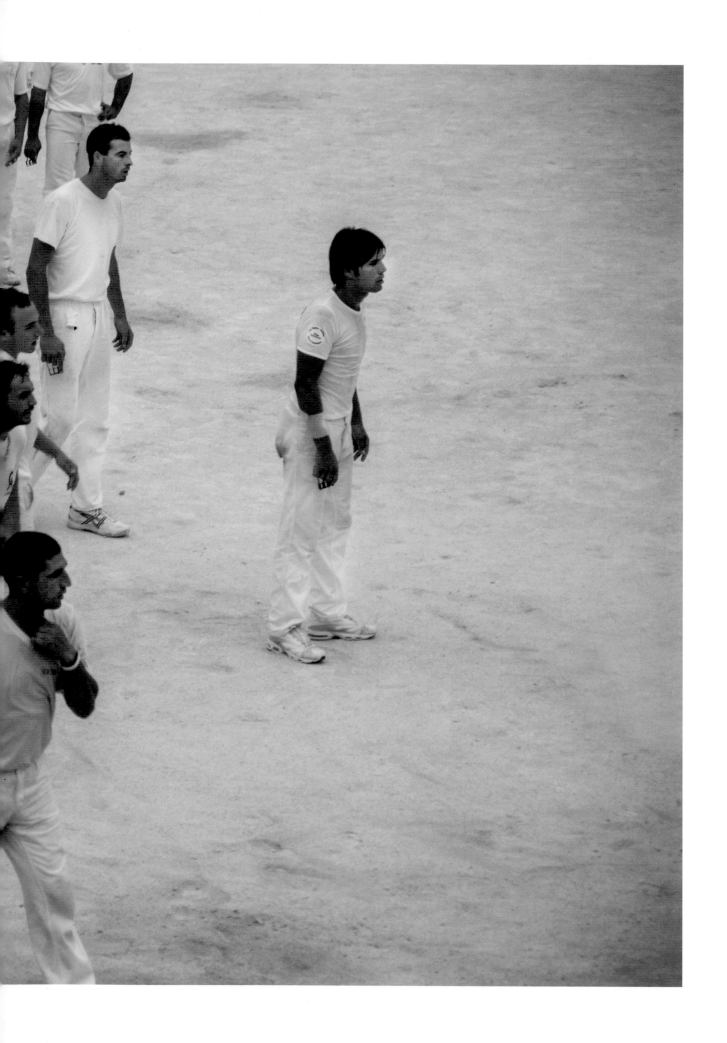

PAUL SOLBERG - SERVICE

Service is a limited edition of 20 digital pigment prints using flatbed scans of SX 70 Polaroids, produced in New York to the highest archival standards.

The Technical influence on the Conceptual Process.

Solberg began experimenting with the Polaroid SX-70 camera and film process in 2009, testing temperature extremes and the response of various films. Freezing film, heating film, searching for a particular characteristic he didn't know until he saw it. A year later, during "Fleet Week", when the military annually sails into the Hudson River to visit Manhattan over the extended Memorial Day weekend, he discovered a particular film stock the same day the military and sailors arrived in May 2010. The fragility of this particular damaged film, while manipulating the tone by manipulating the film's climate, was the narrative solution Solberg was seeking. He got on his bike and threaded through the streets of Manhattan- mainly Time Square- to seek out any service person walking past a clean white building façade, a challenge in the dense walls of electricity. As the first portraits and conversations were experienced, the project was obvious and immediate. It was four 20 hour days until the film ran out.

Solberg's intention of putting together a large body of such works was interrupted when in just days most of the faces abruptly vanished from the developed film. The chemical instability of the film, abruptly, left a blank space where the faces had existed. Many of the images were immediately scanned after photographing, and many vanished with no record. Of the men and women he photographed, these images are what remain. Left with the surviving pictures, Solberg decided to follow the story instead of control it, understanding the missing faces, like in war, is the inevitable true story.

The process began with Solberg's curiosity to capture faces of the young heroes. He saw in his subject's eyes, and learned through their conversations, something of the magic and trepidation of youth. He gained a deeper understanding of their world, and respect for their dedication. Solberg harnessed chance events in his technical process to ultimately produce images of depth and resonance. The faces in Service look almost haunted by early experience, innocence lost too soon. In their world, courage and fear, invincibility and vulnerability, are close companions. The fading, ephemeral quality of Solberg's images speaks to the often unseen trials and sacrifices made, and burdens borne, in the name of service.

Peter Wise, New York City

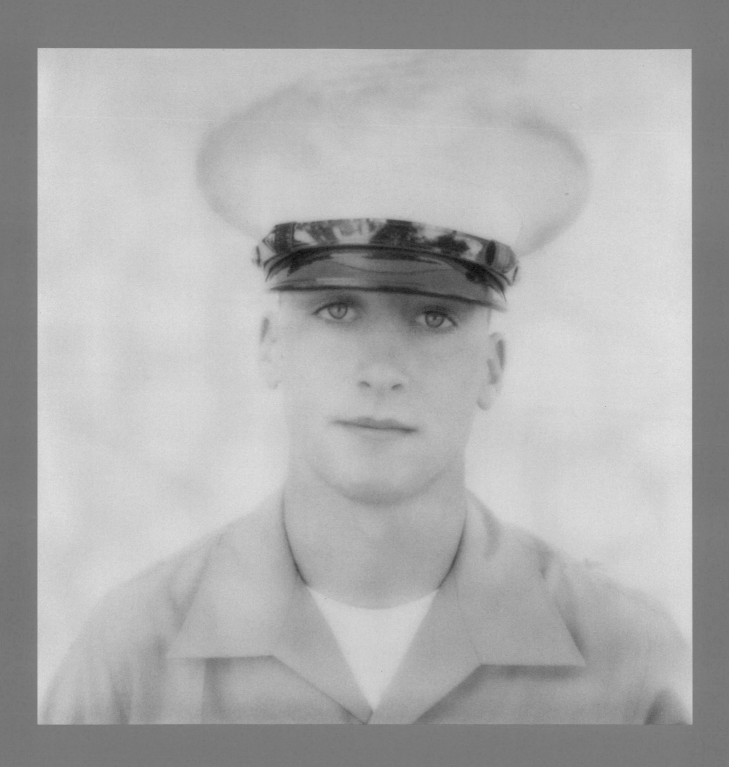

Service 19, 2010

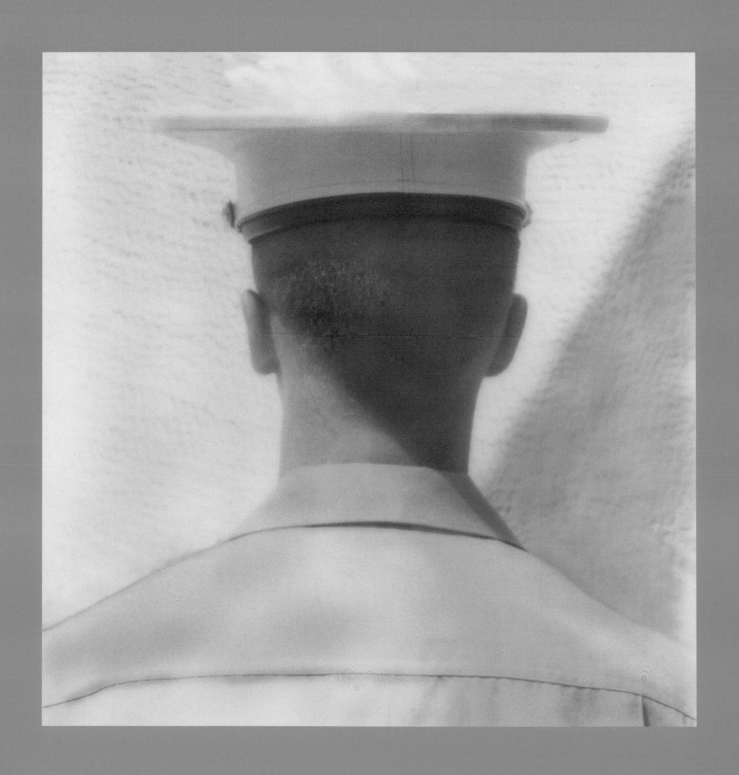

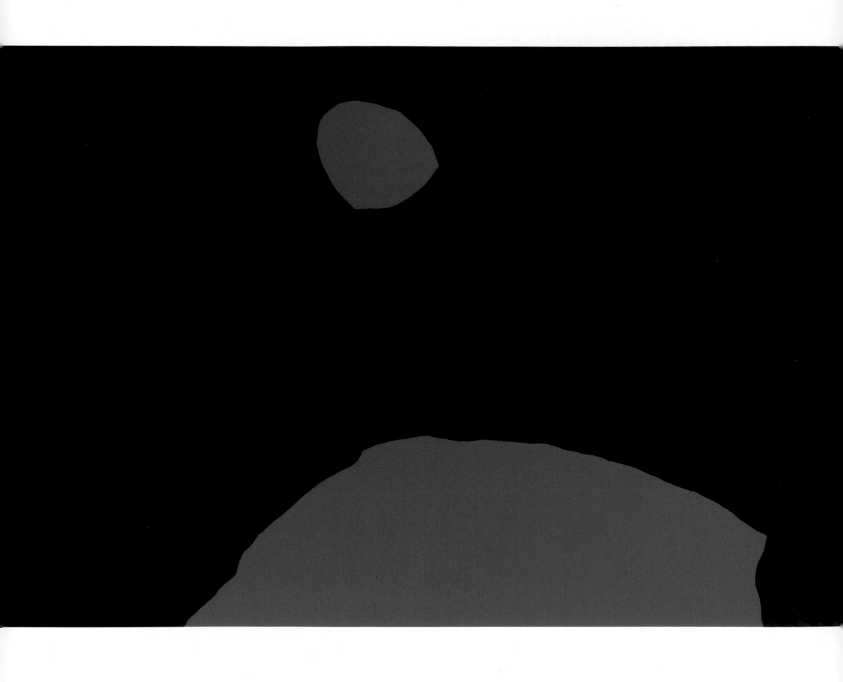

Wind, 2011

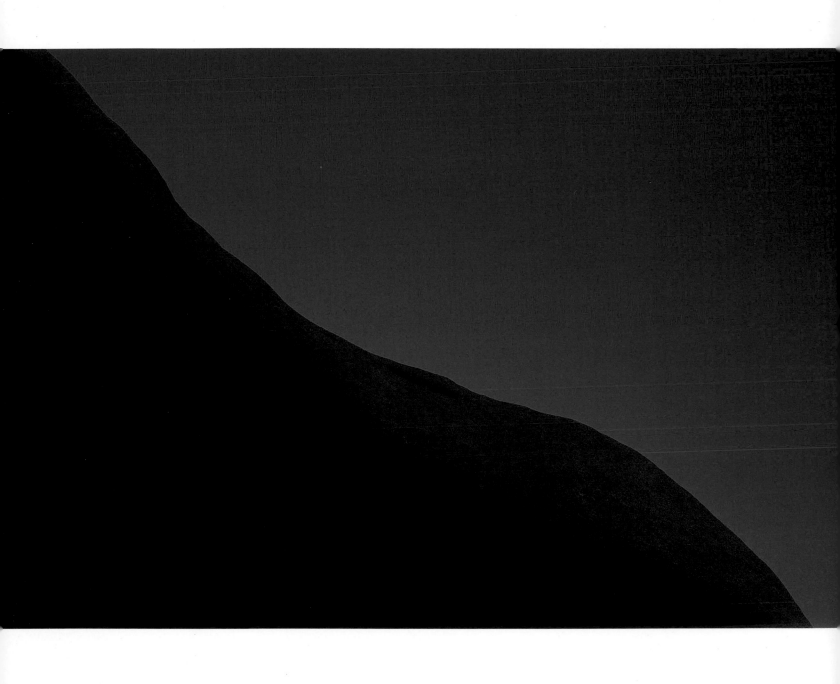

Horse, 2011

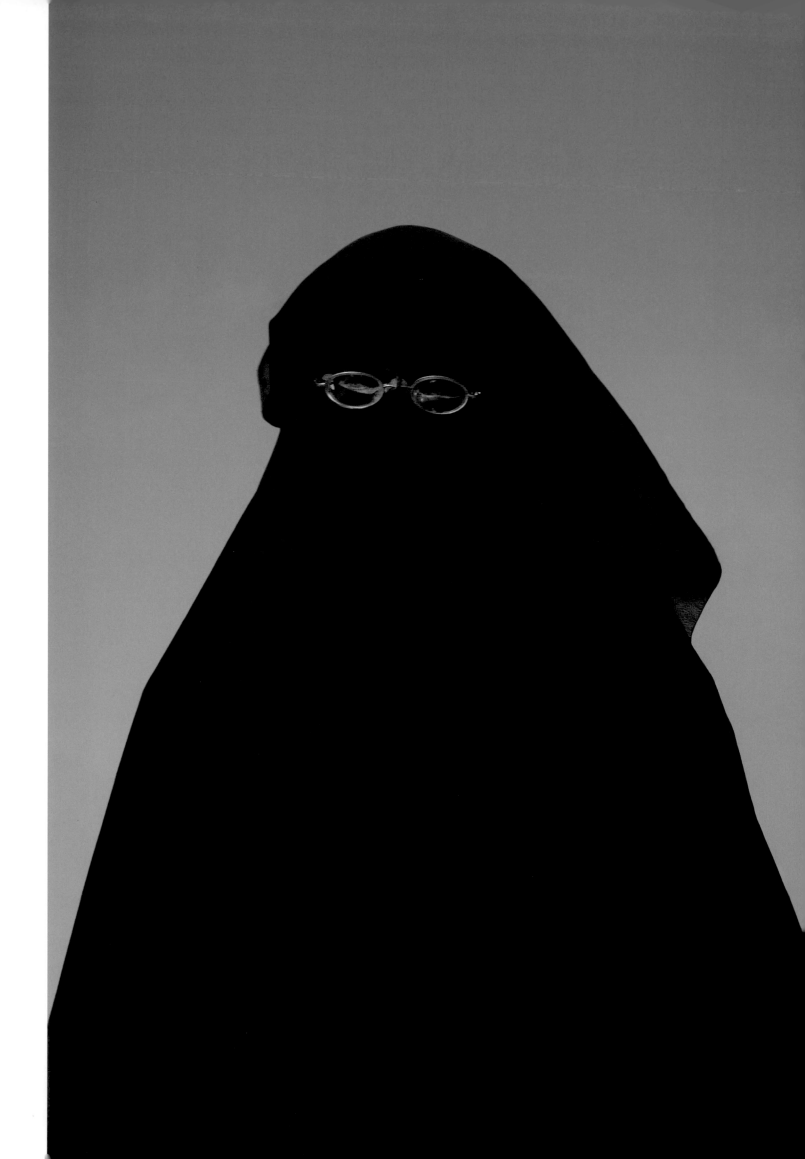

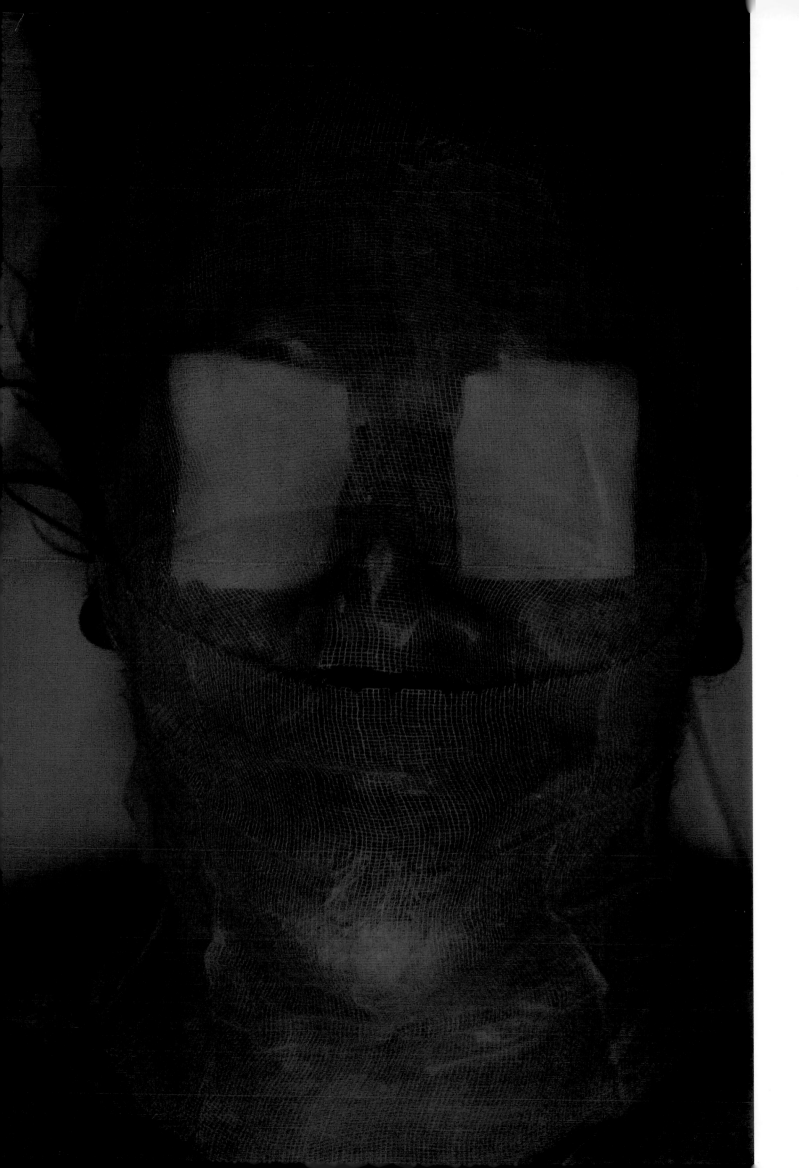

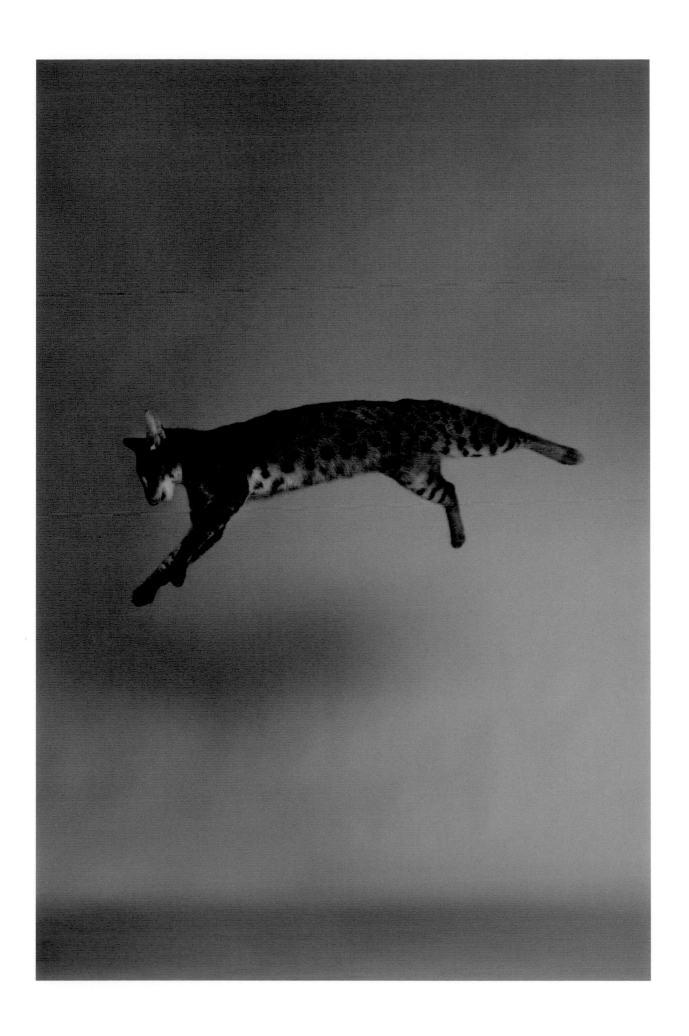

Flight, 2012

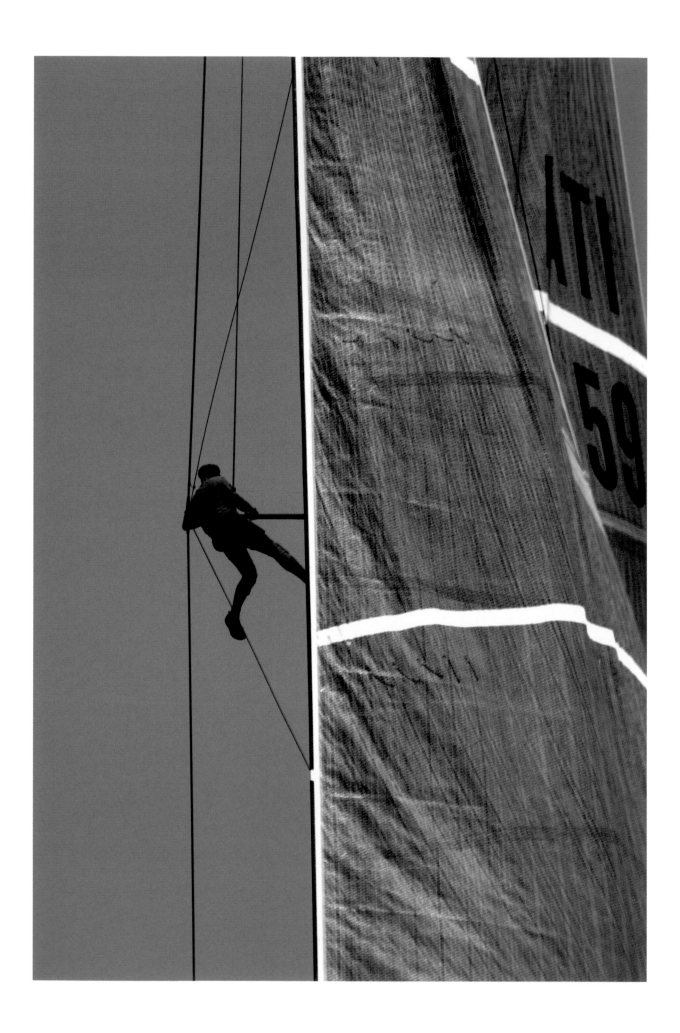

America's Cup, 2006

McGraw-Hill Building, 2007

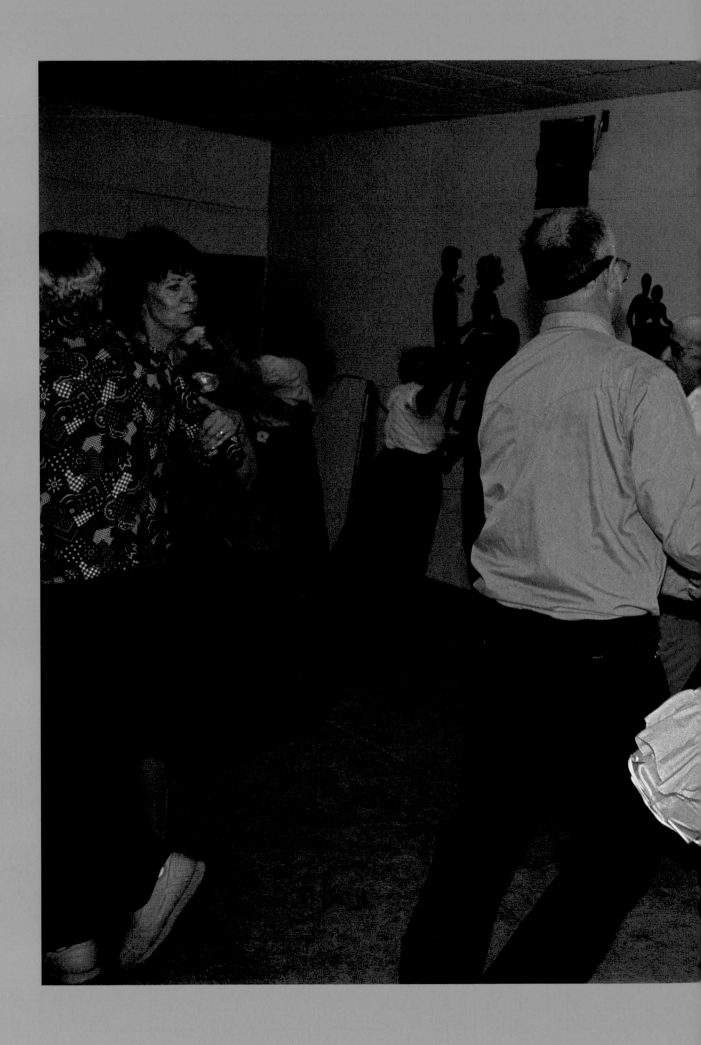

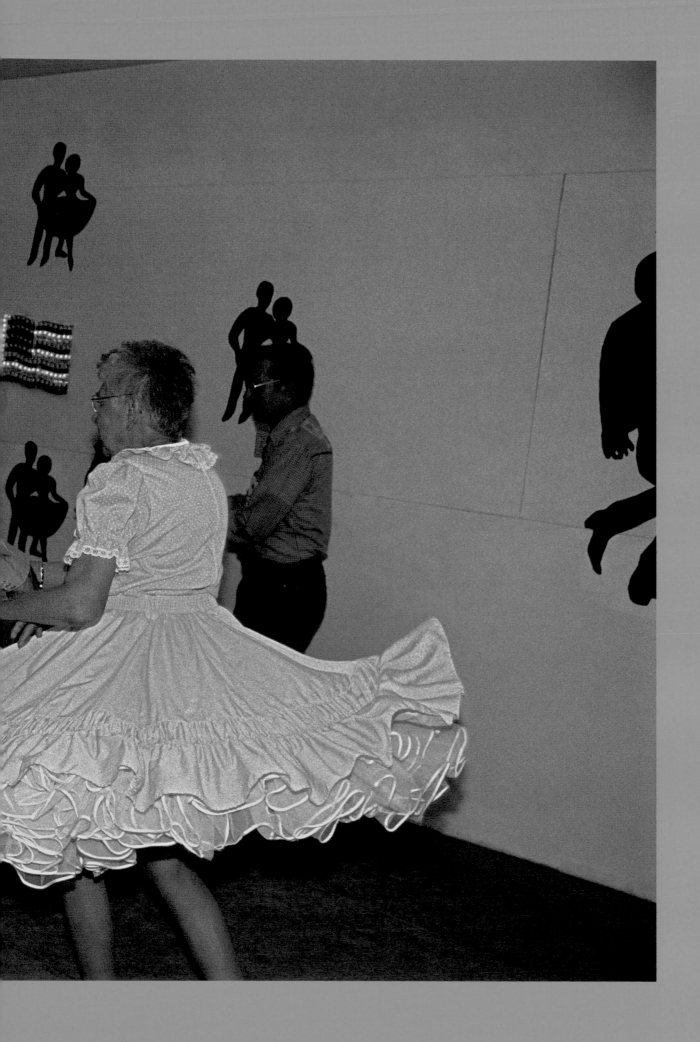

Carousel, 2004

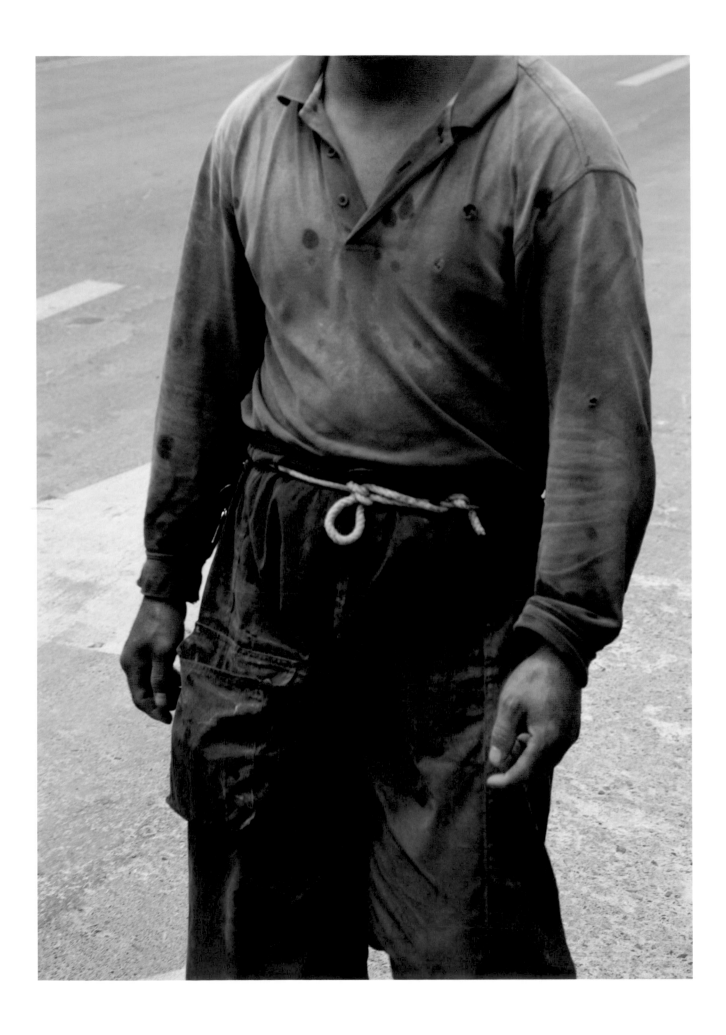

Building Shanghai, 2008

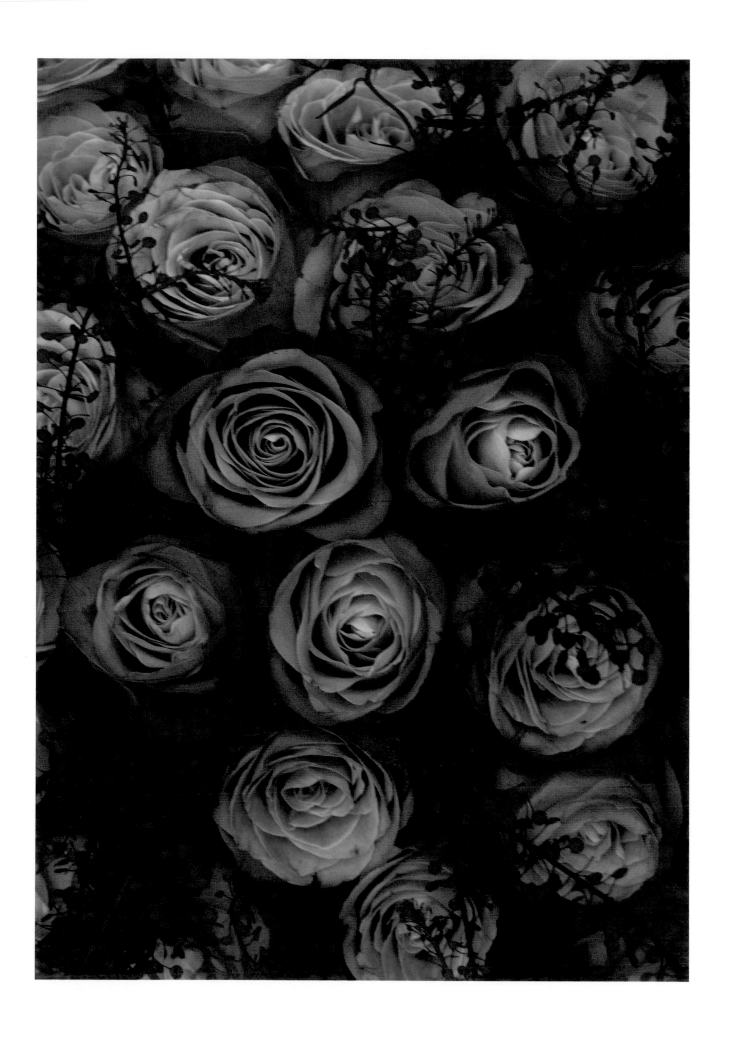

Russian Bouquet, 2012

Josef Albers, 2011 133

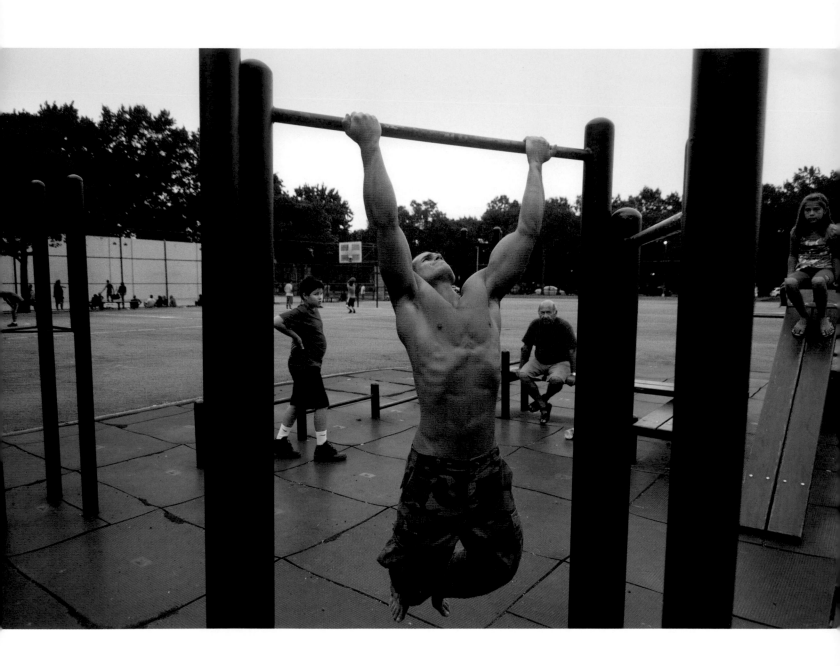

Bronx, 2010

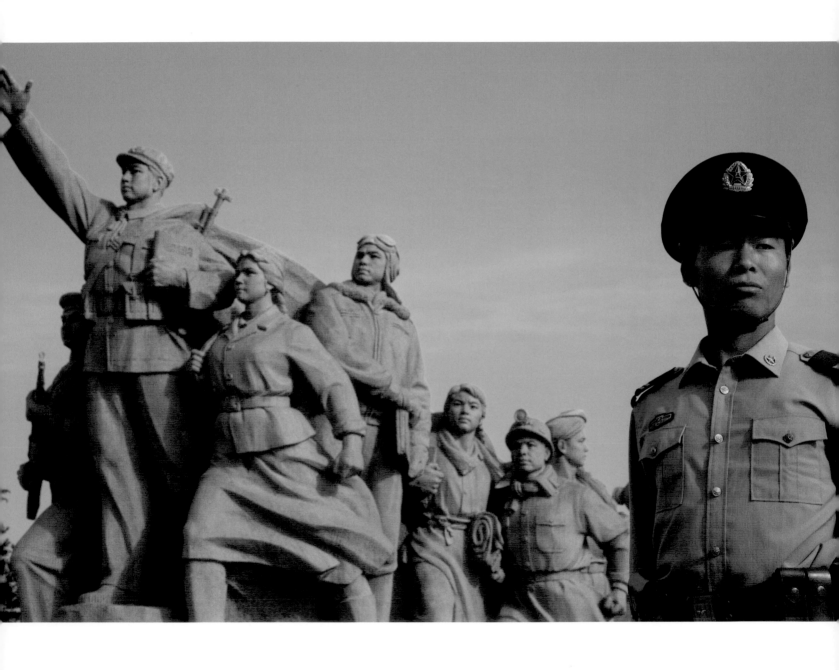

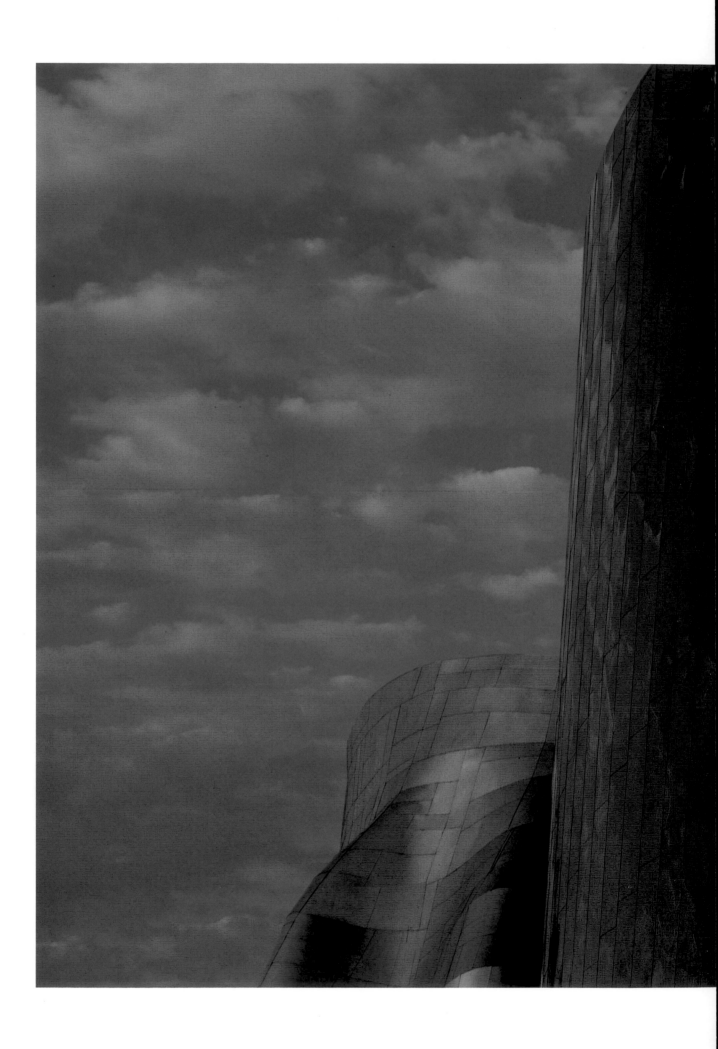

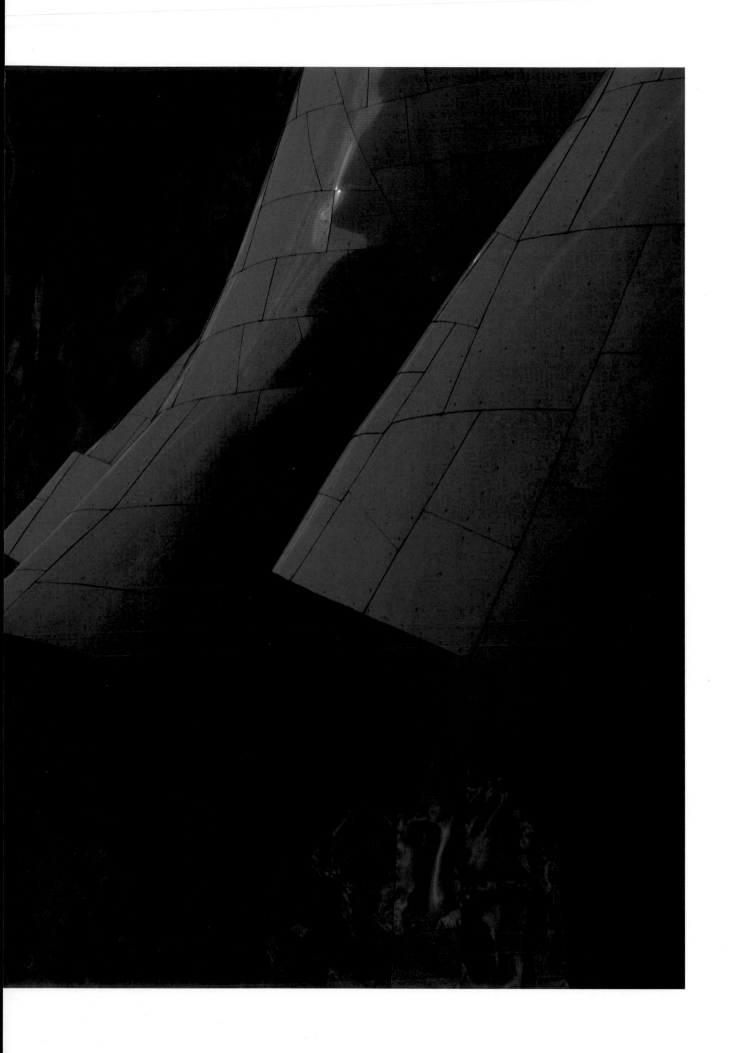

Nile, 2008

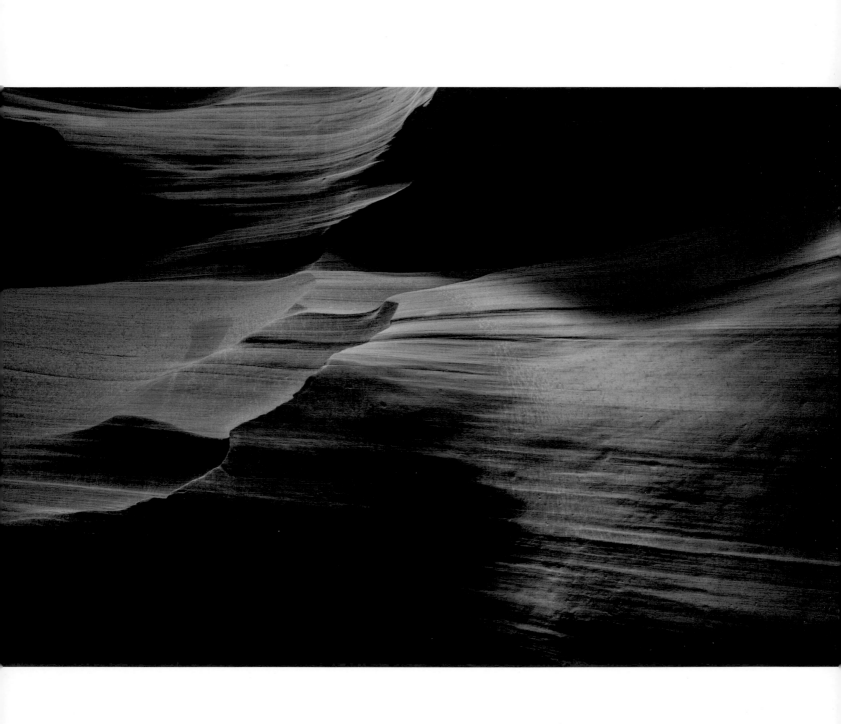

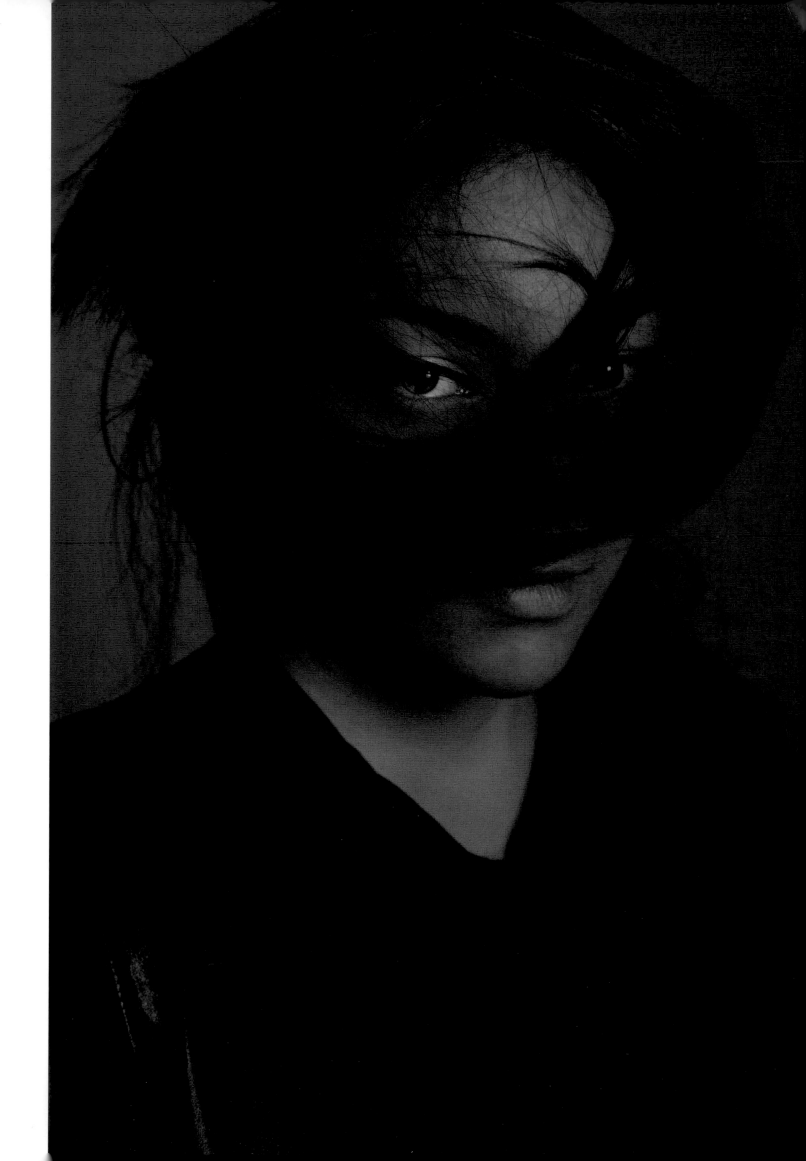

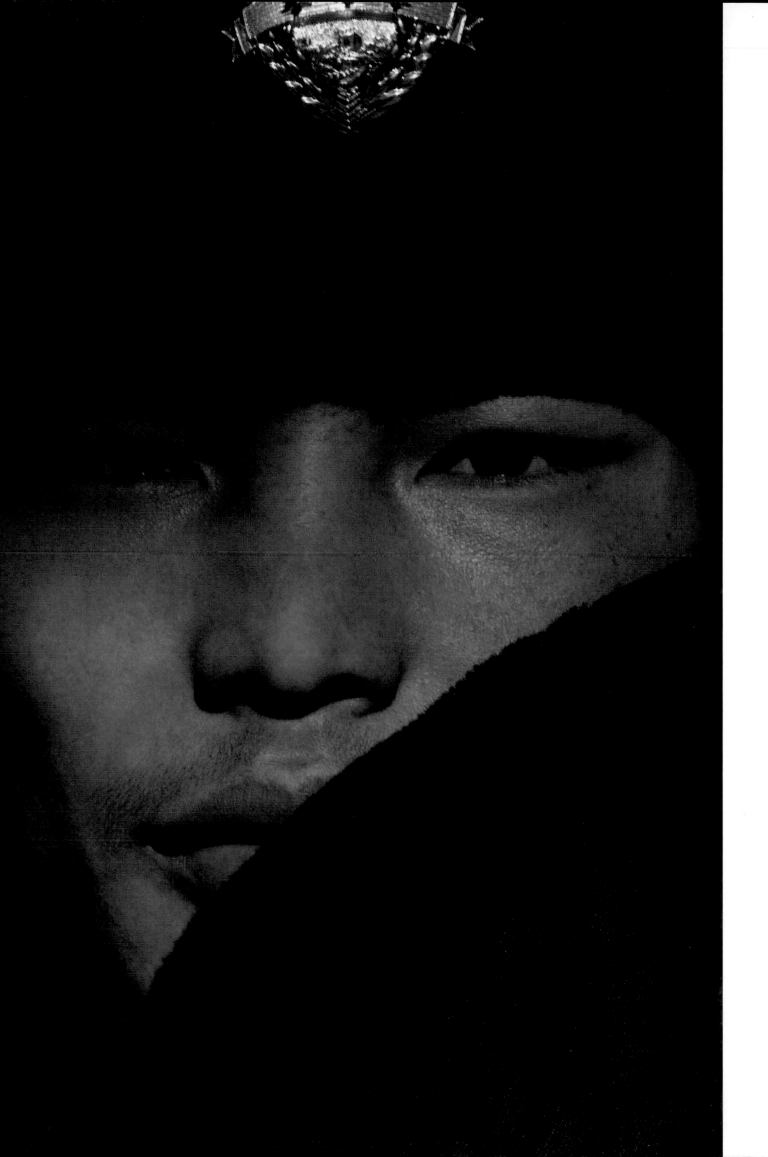

Man in Paris, 2004

Untitled, 2011

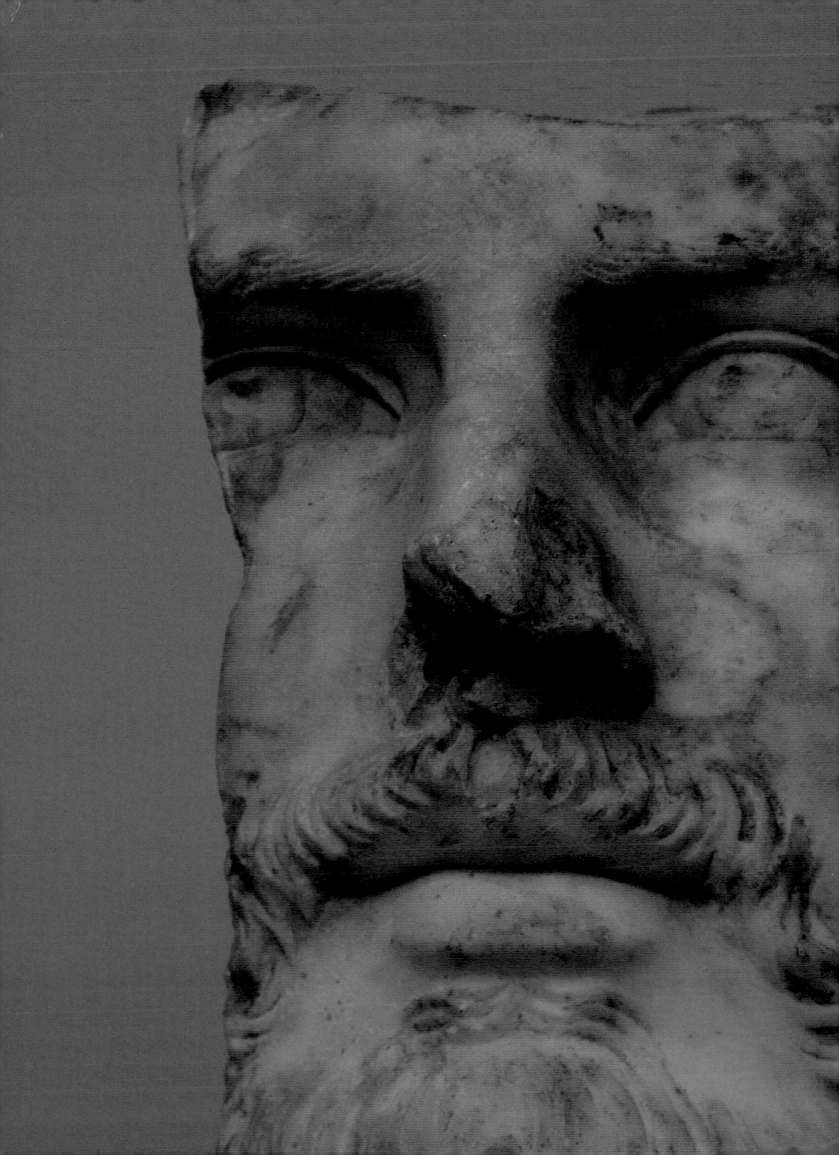

Ghost Town, 2012

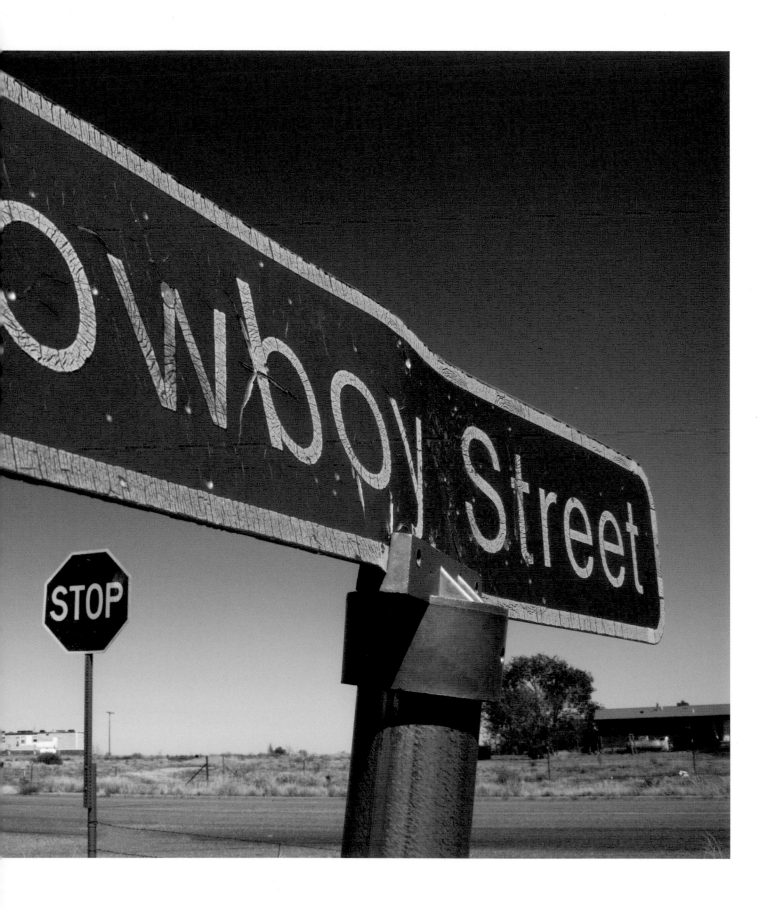

Cairo, 2008

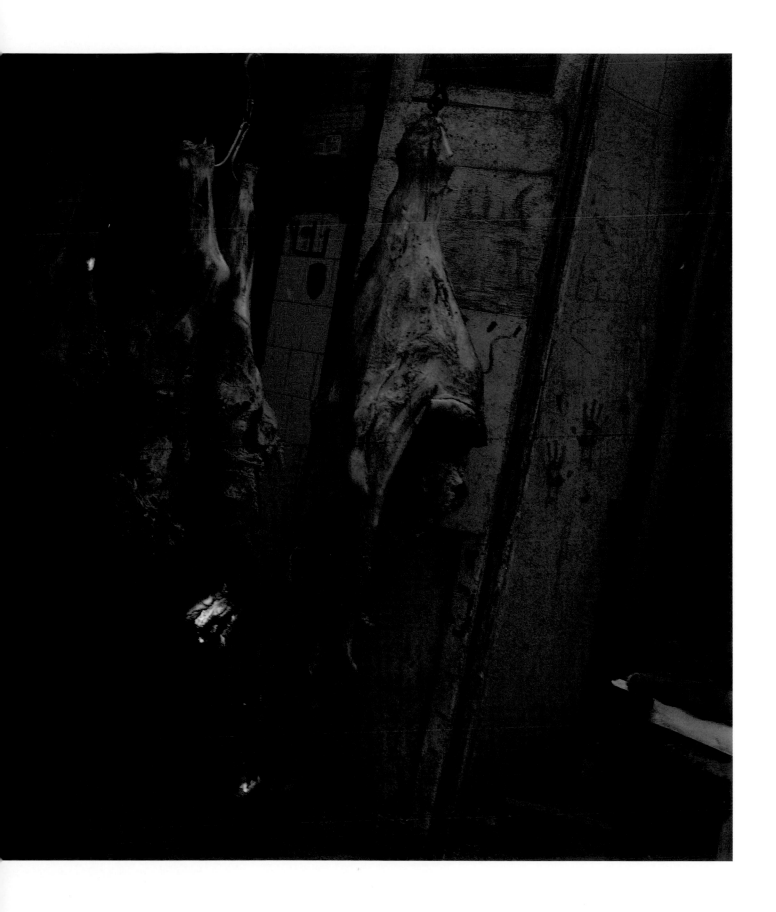

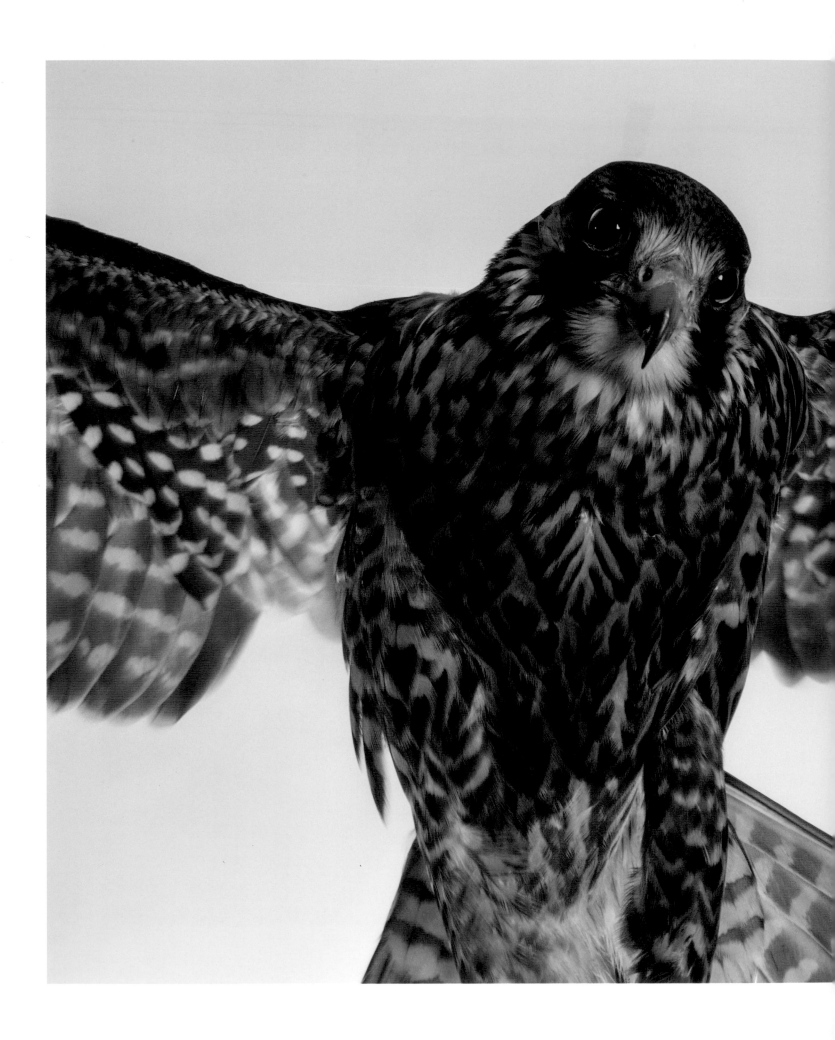

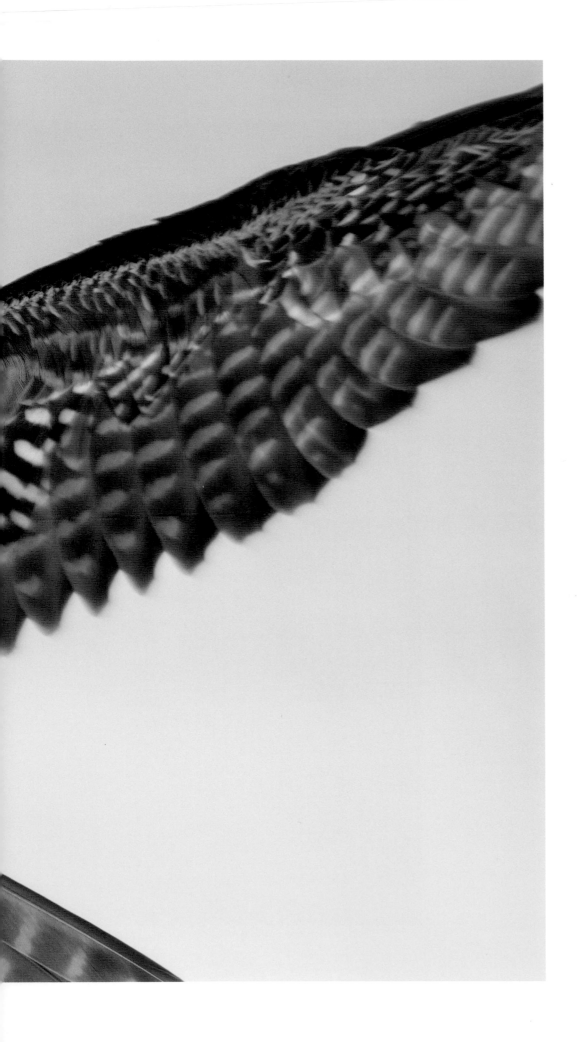

Falcon, 2008

Fred, 2014

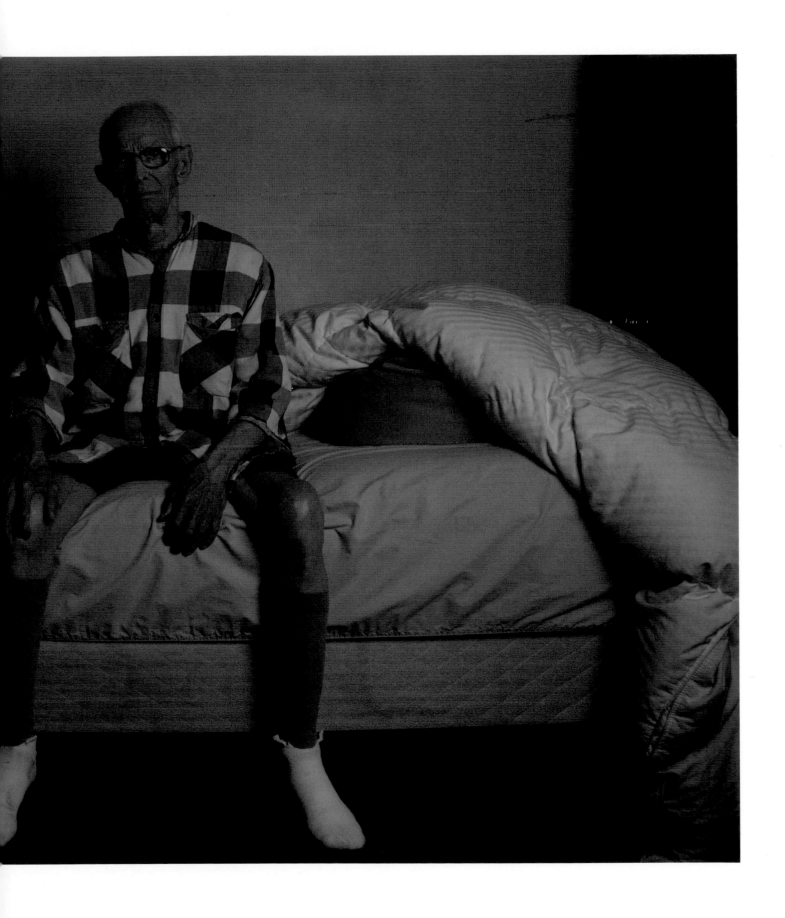

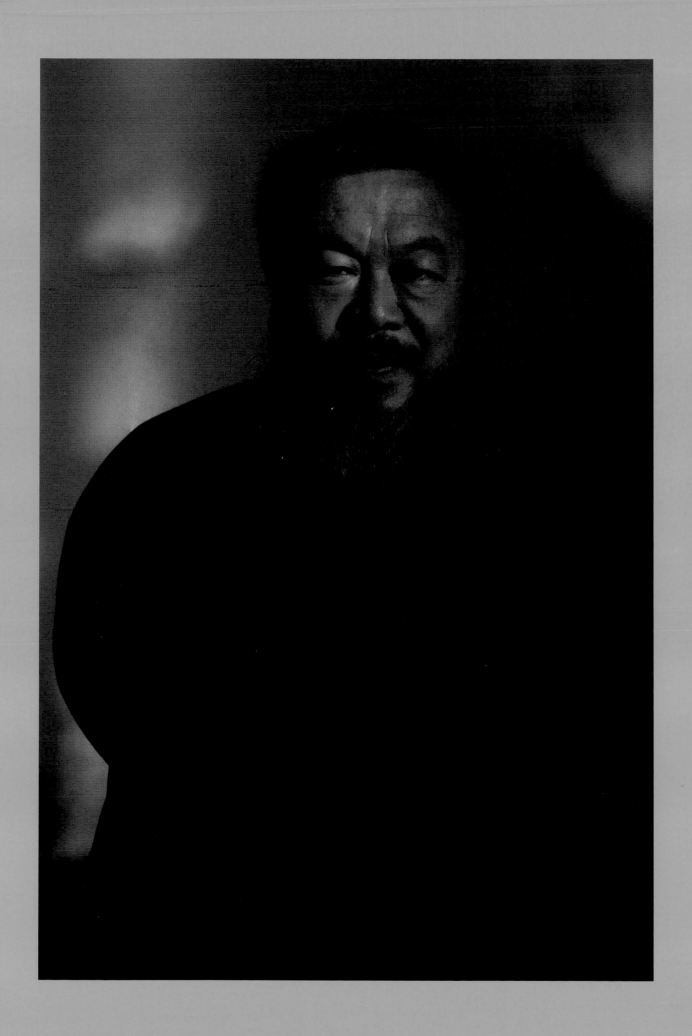

Ai Weiwei, 2008

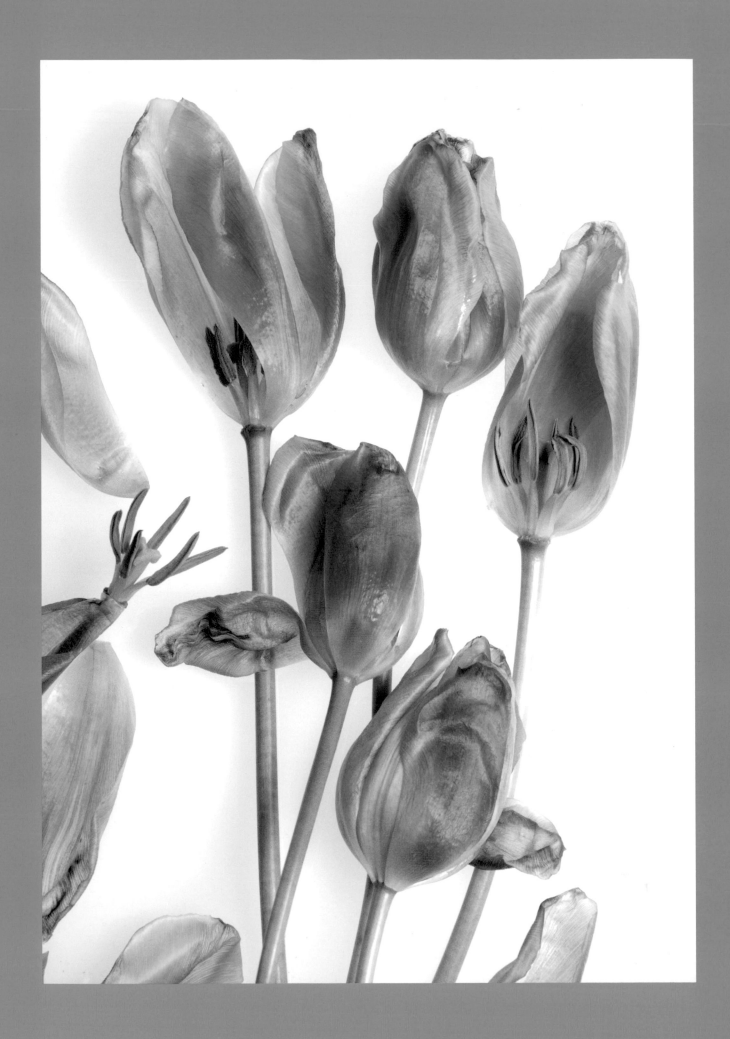

Red Tulip Left, 2008

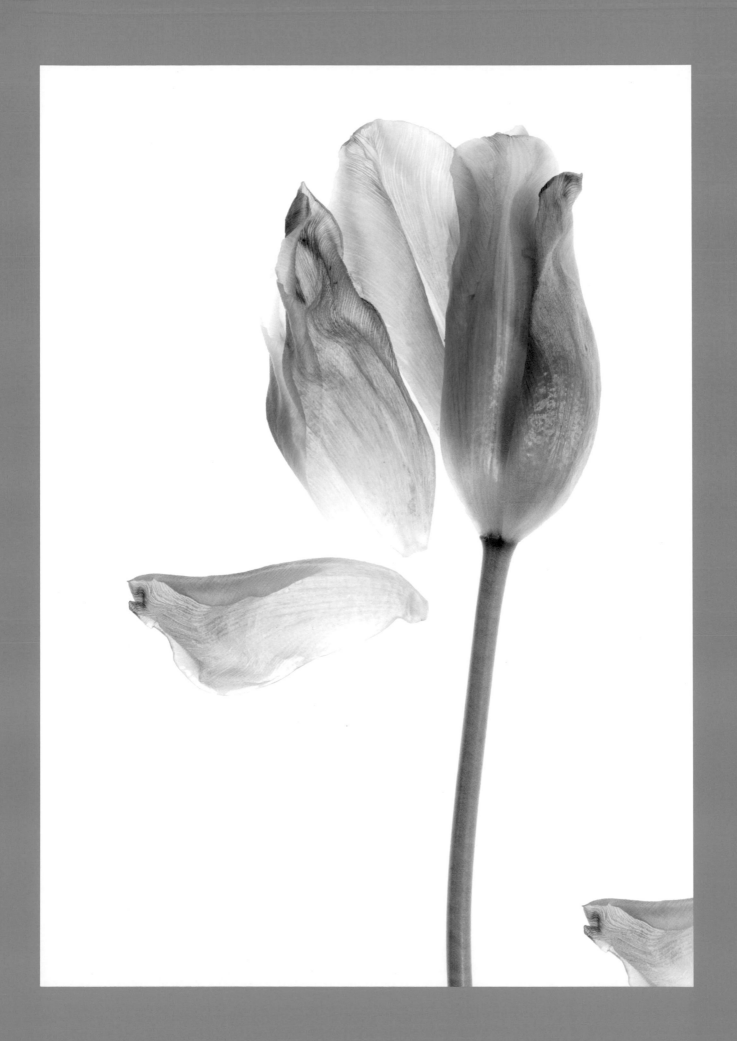

Red Tulip Right, 2008

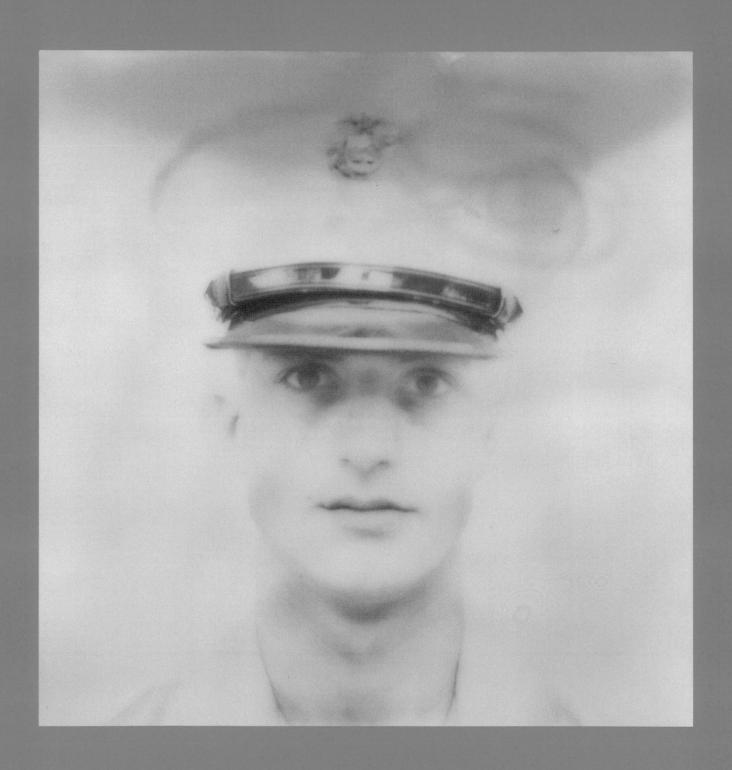

Service 2, 2010

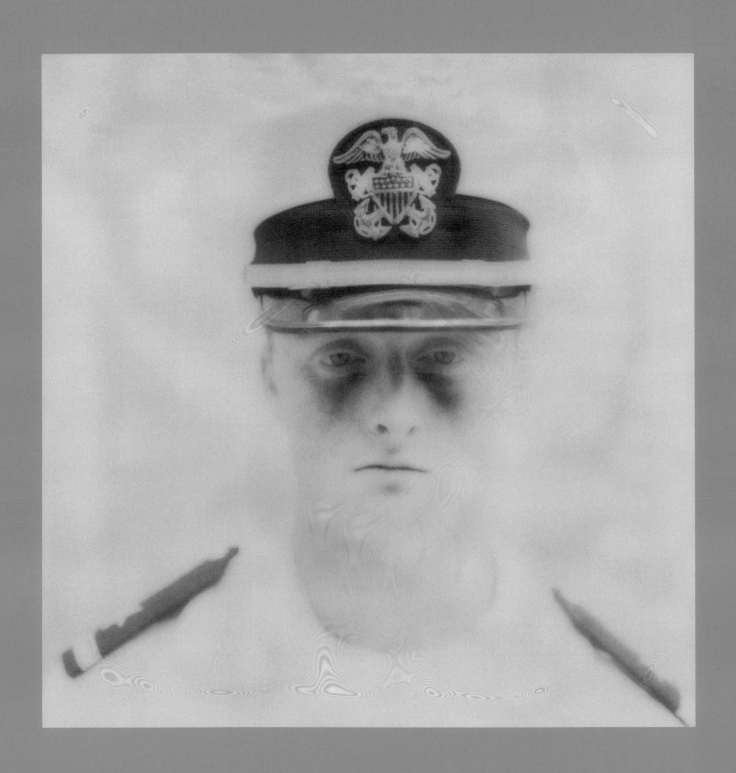

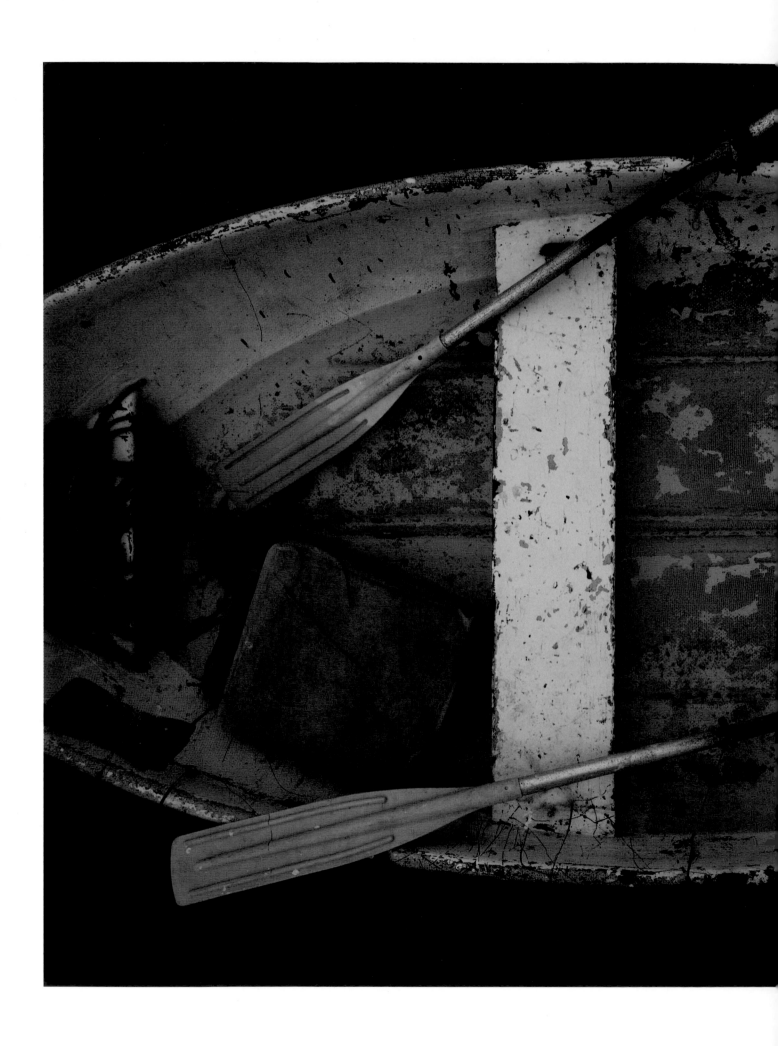

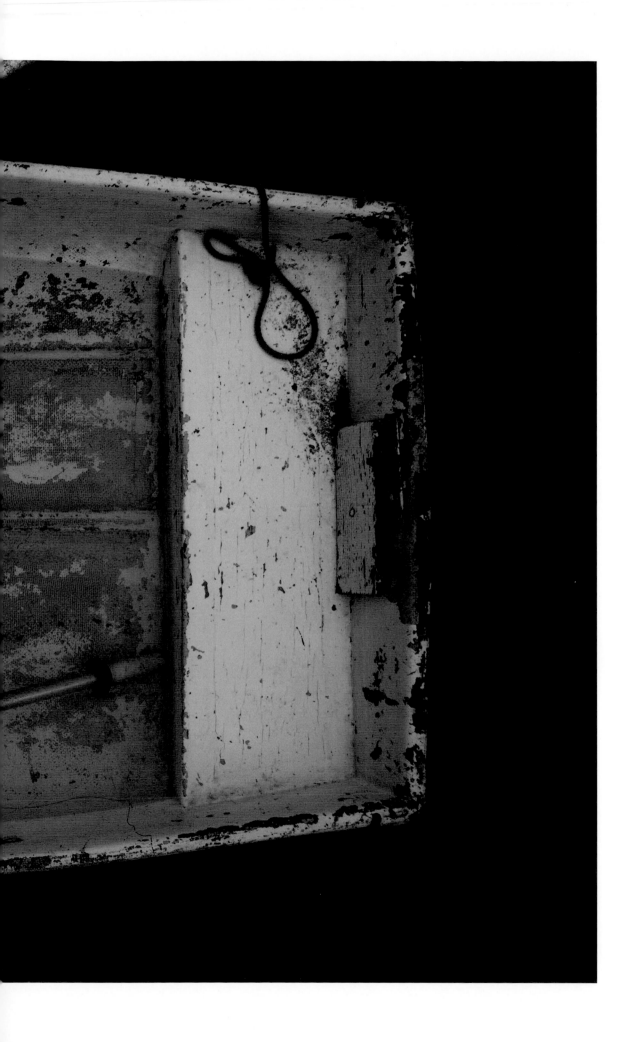

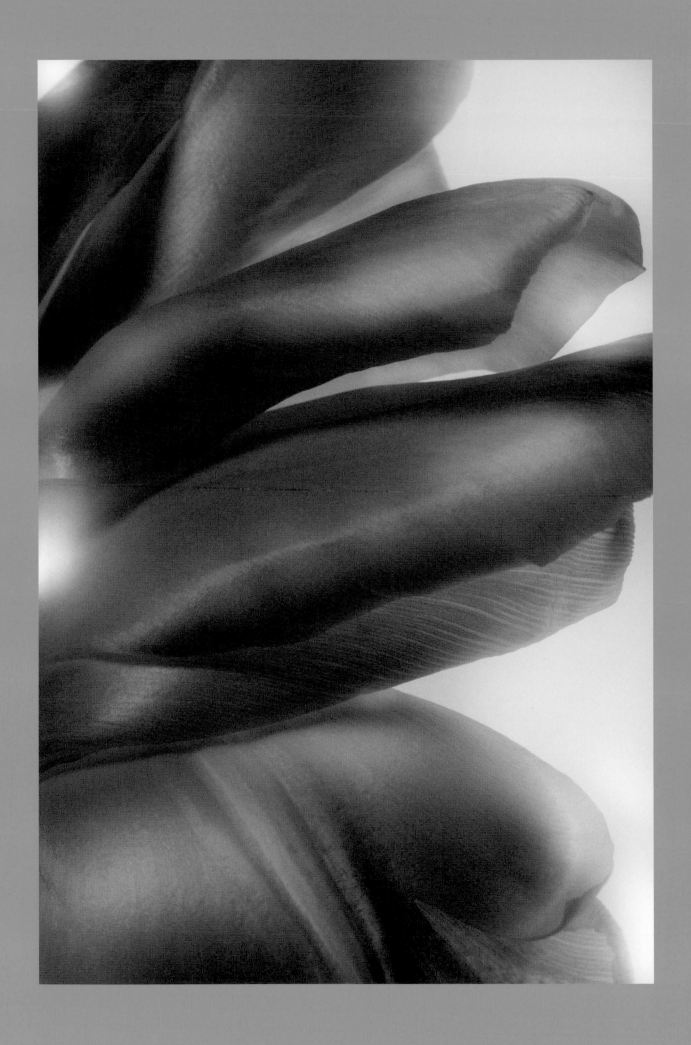

Study 619, 2008

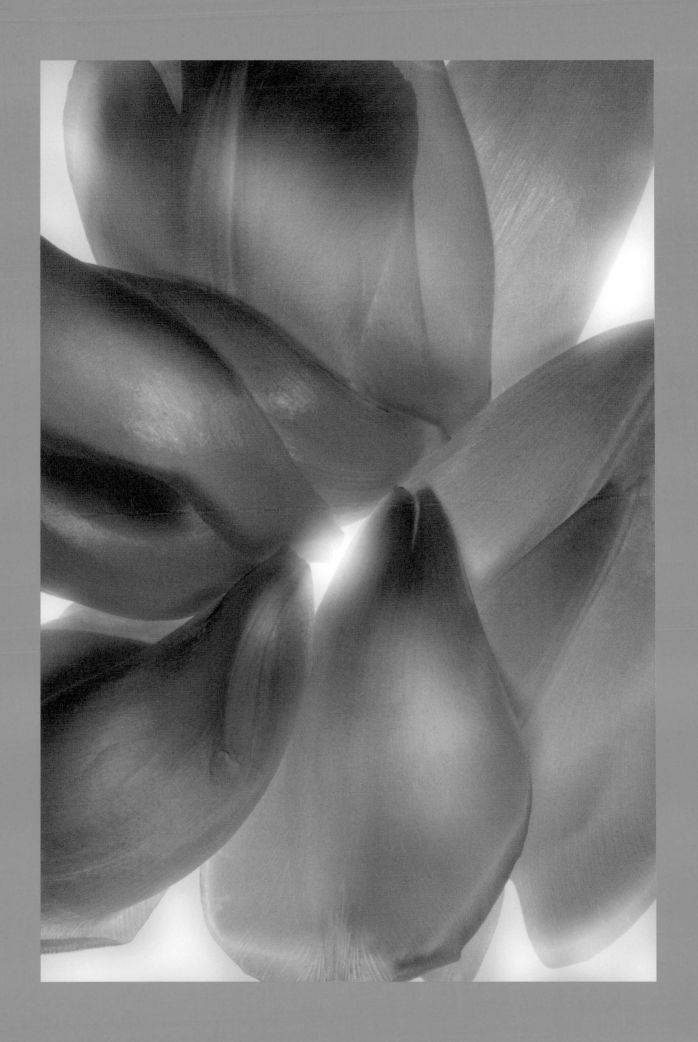

Study 613, 2008

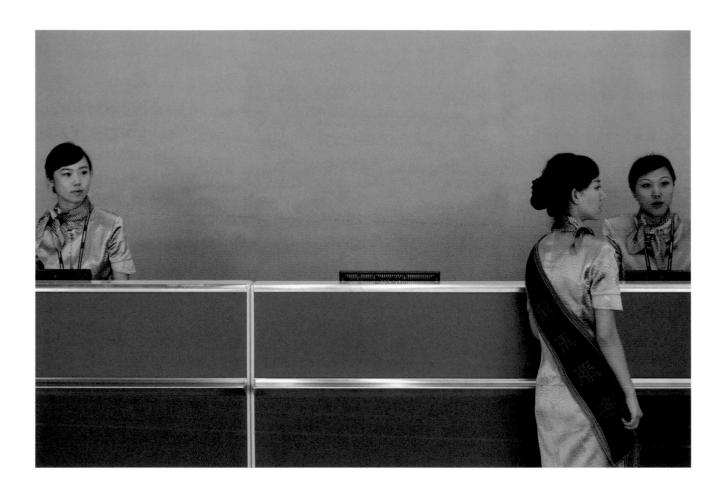

Pink, 2008

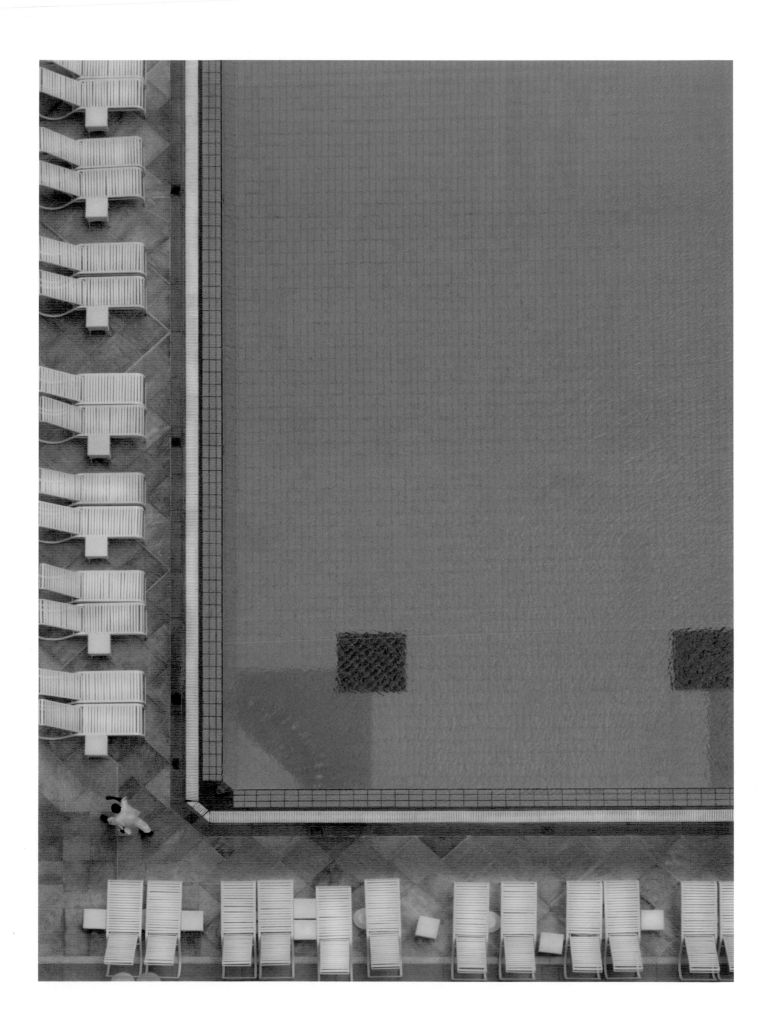

Copacabana, 2011

Swedish Boat, 2011

Swedish Coast, 2011

Aswan, 2009

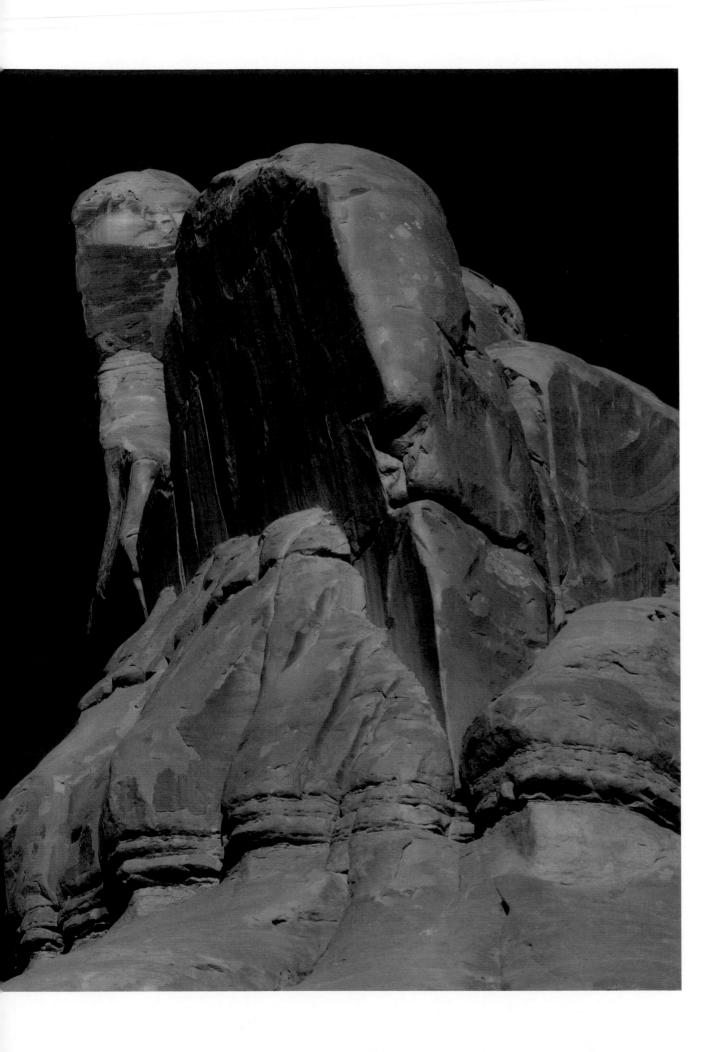

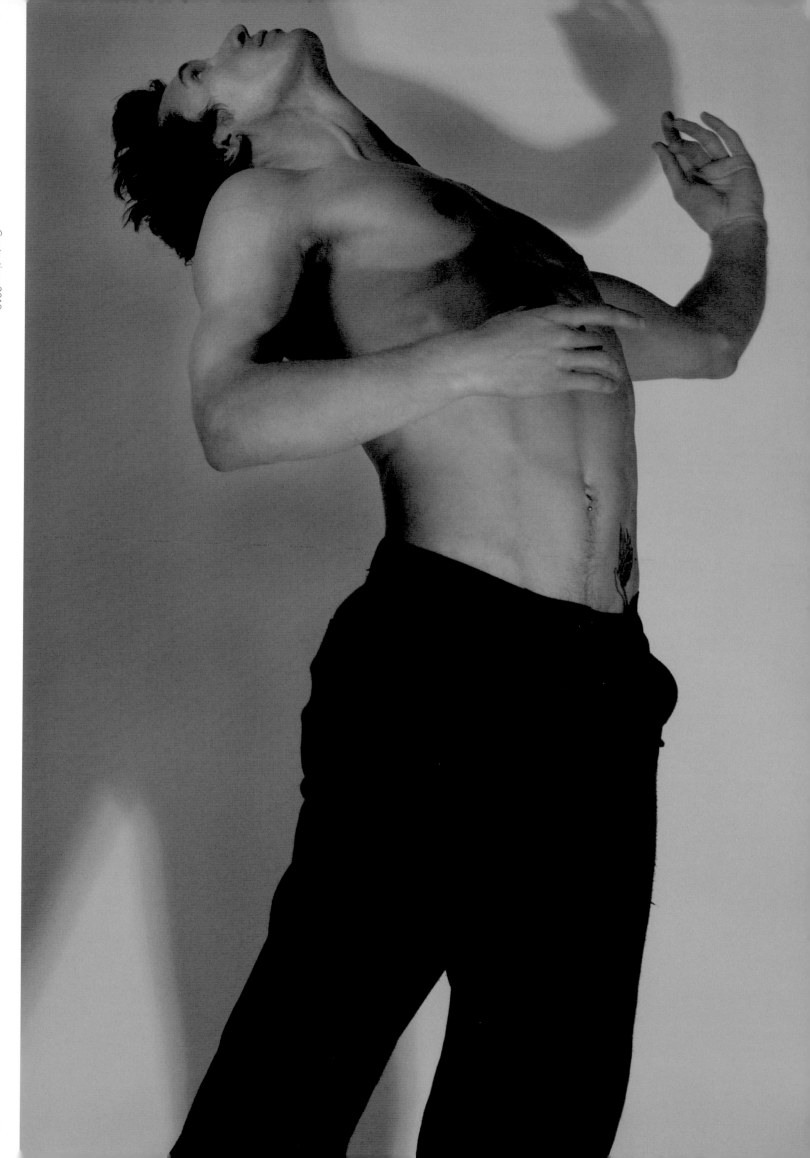

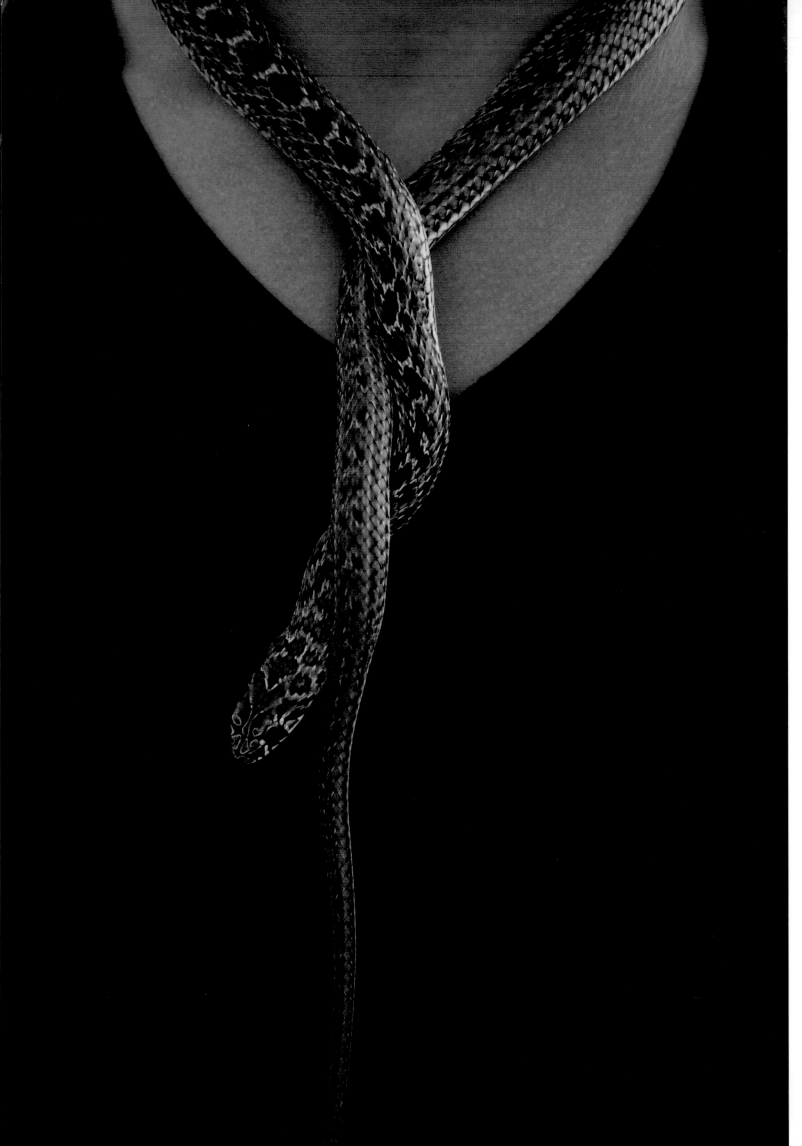

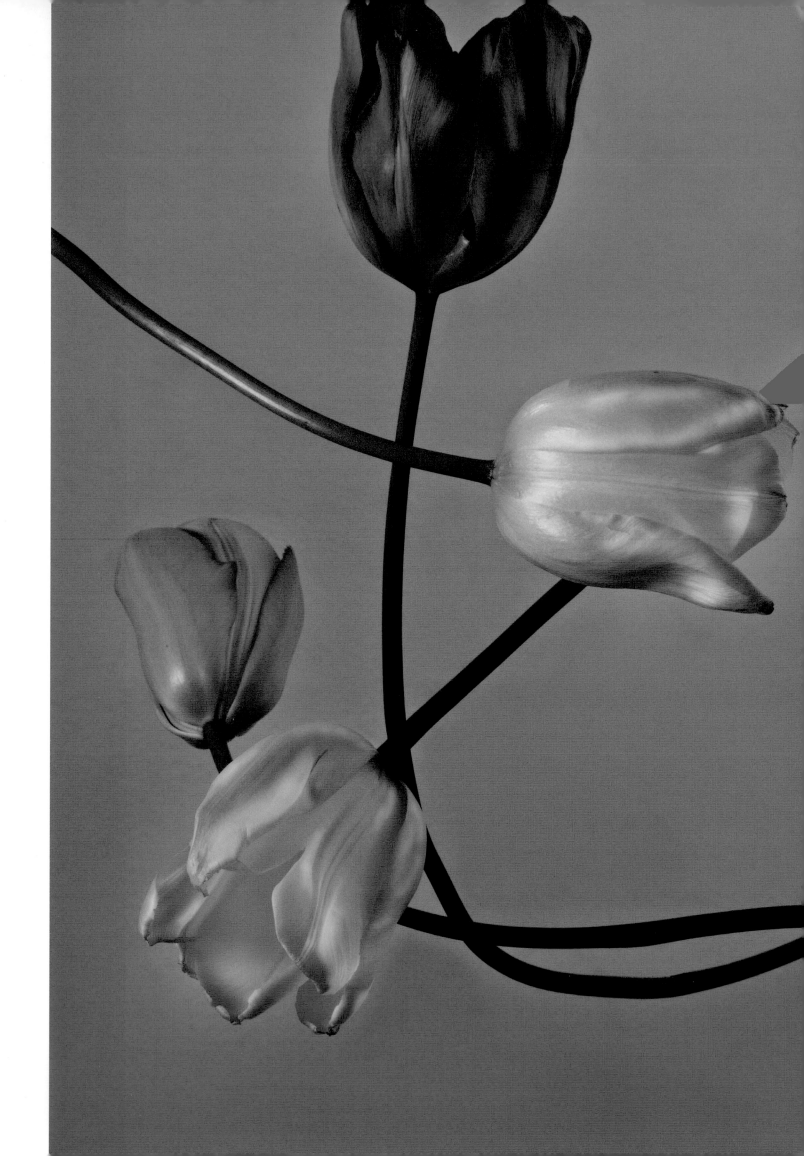

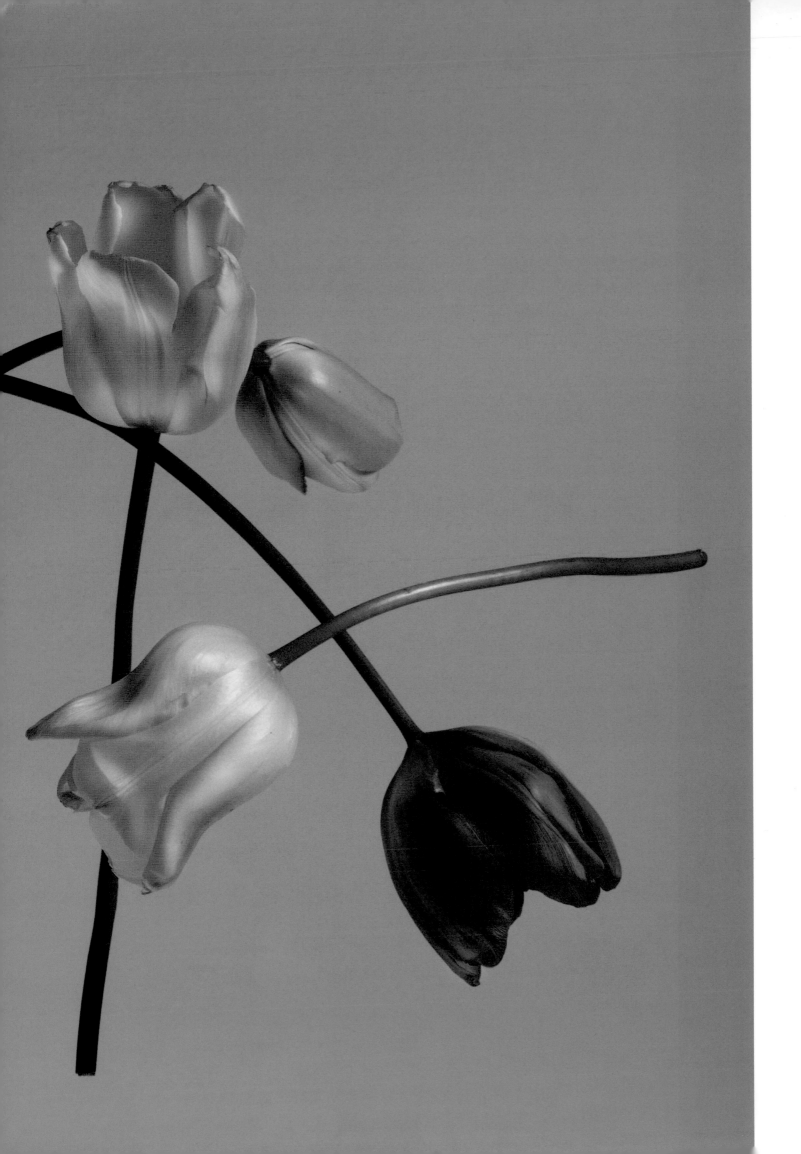

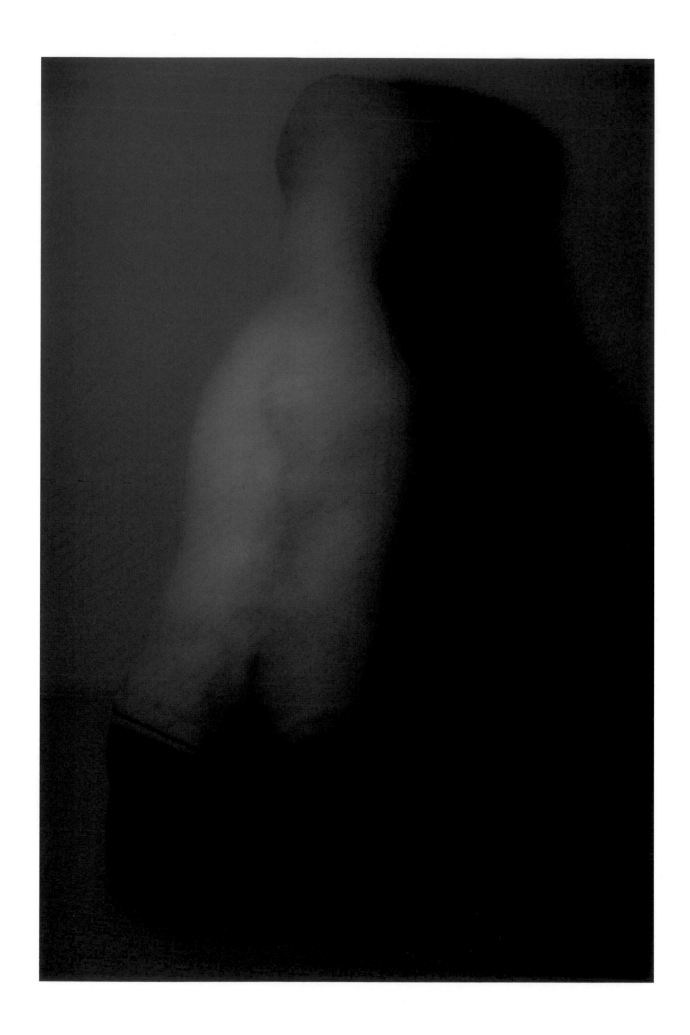

Goya's Butcher, Valencia, 2005

Touching Olives, 2014

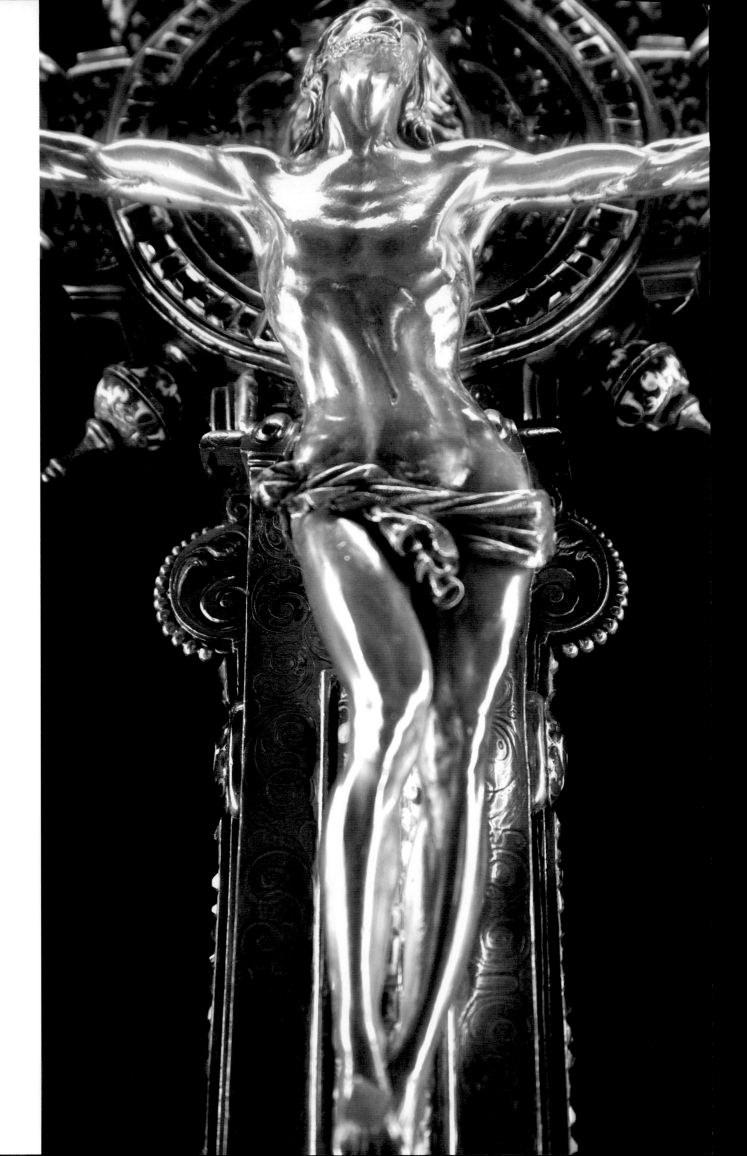

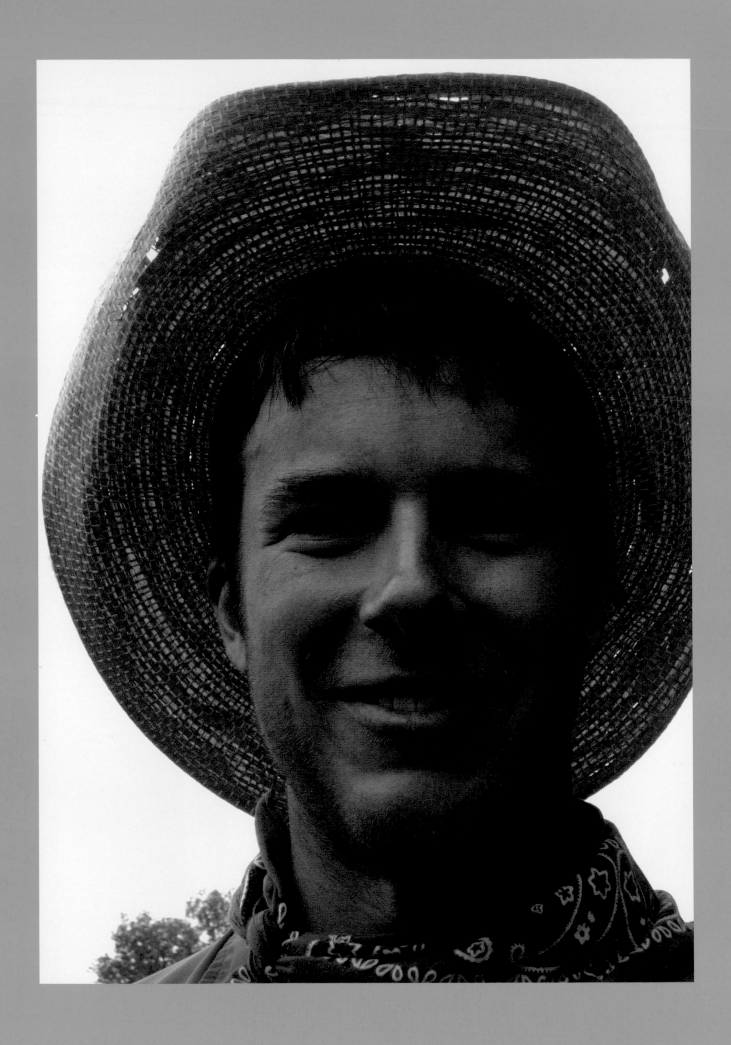

Montana Luke, 2013

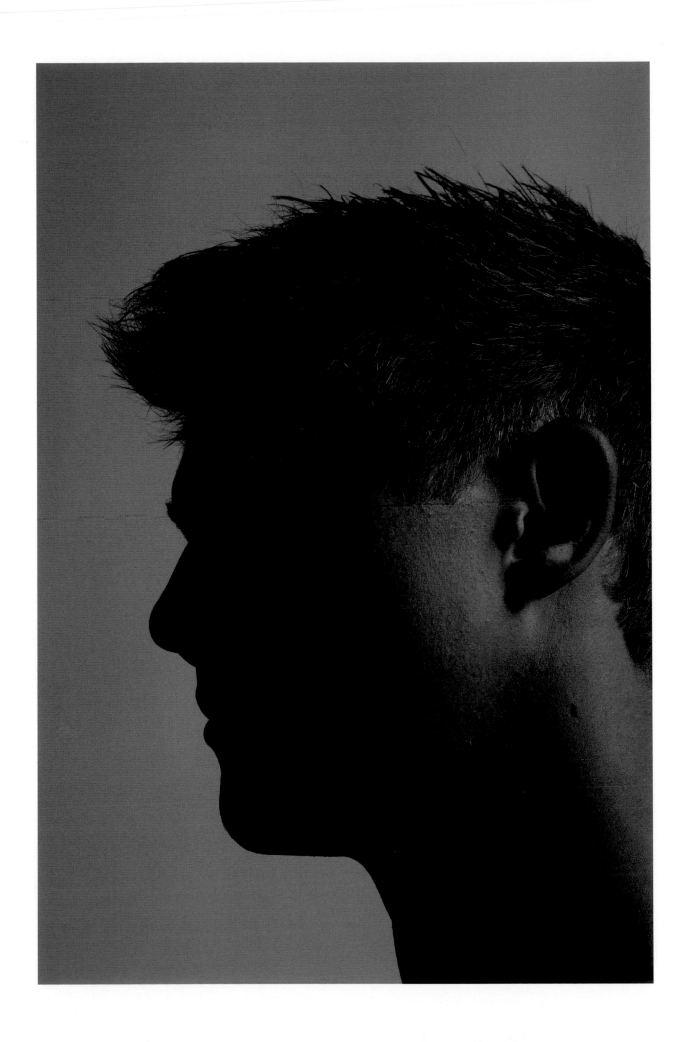

Canadian in NY with Parents, 2010

Hydra, 2014

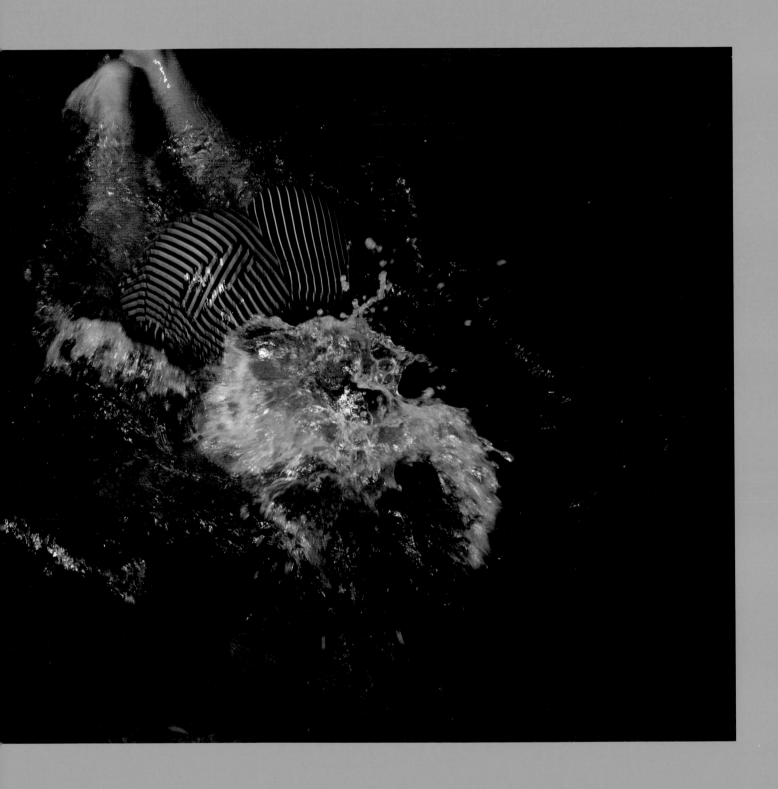

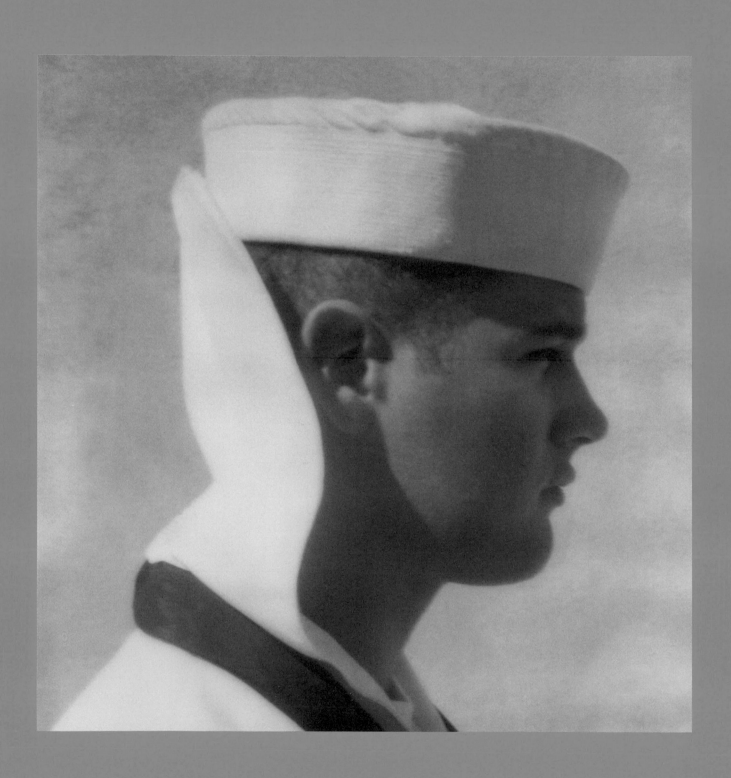

Service 13, 2010

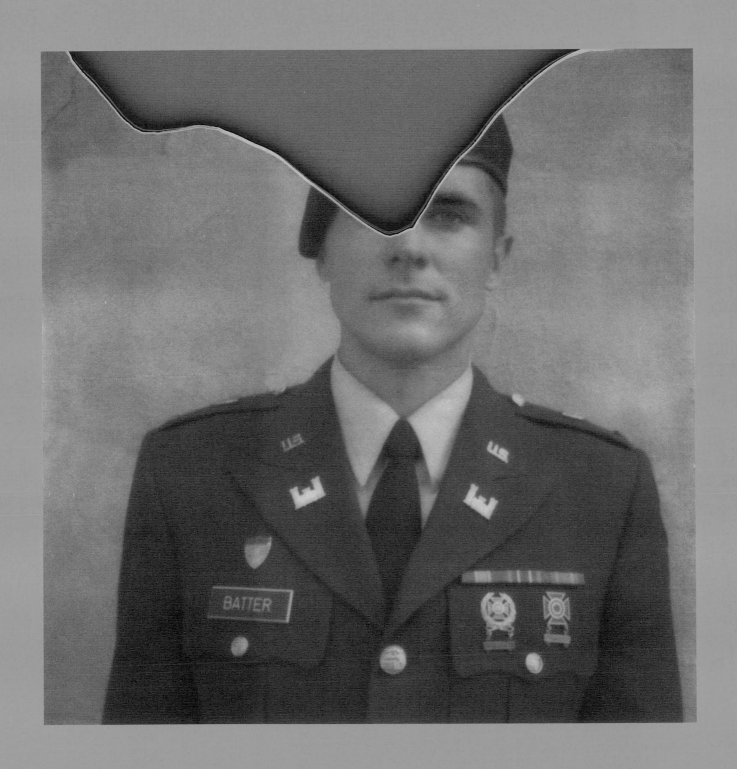

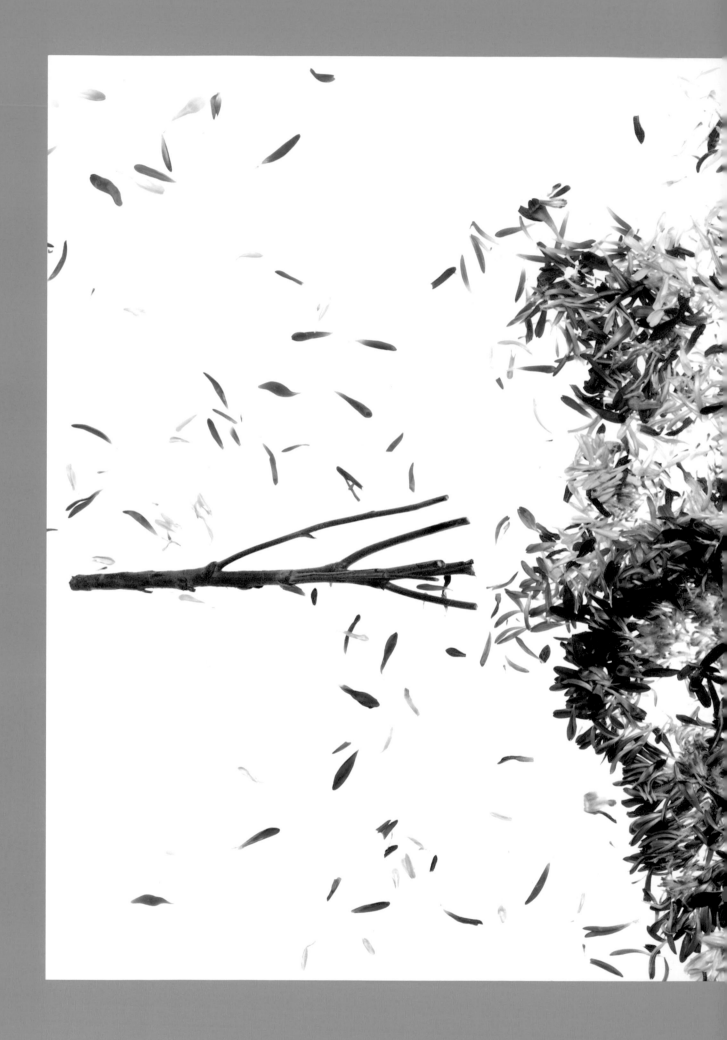

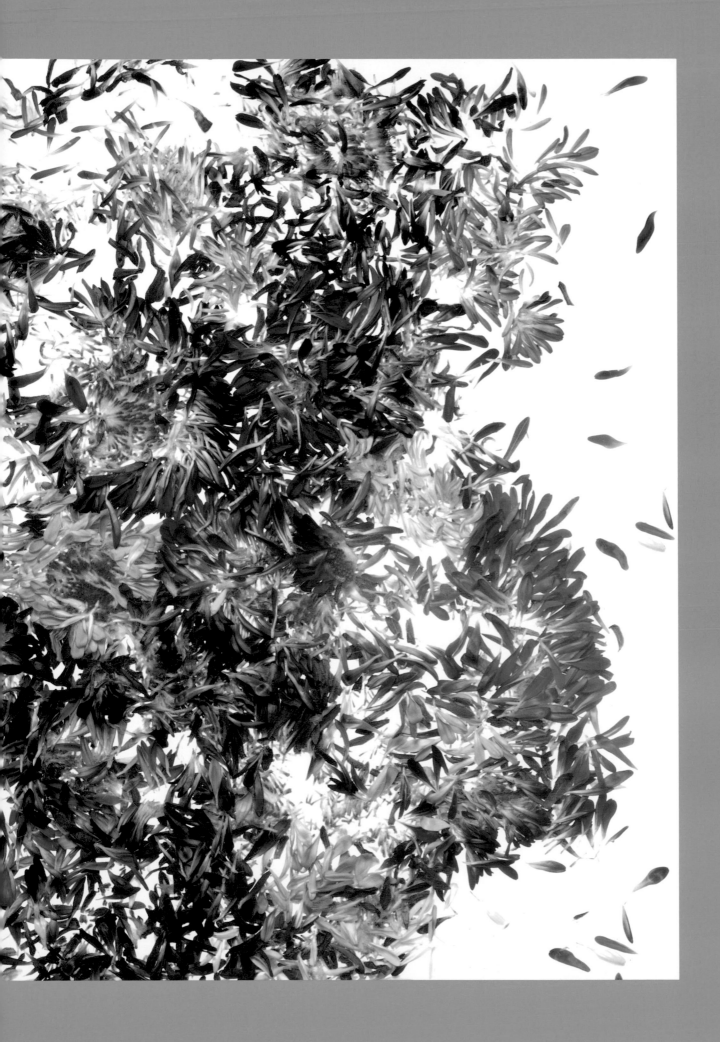

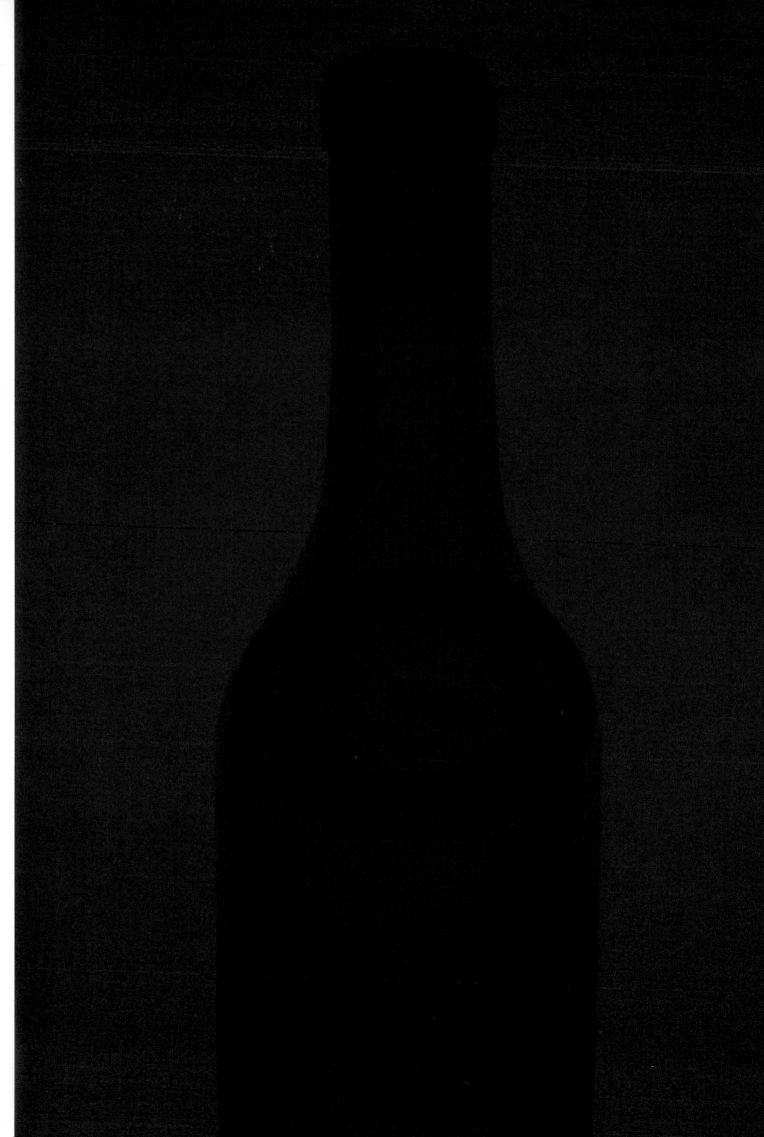

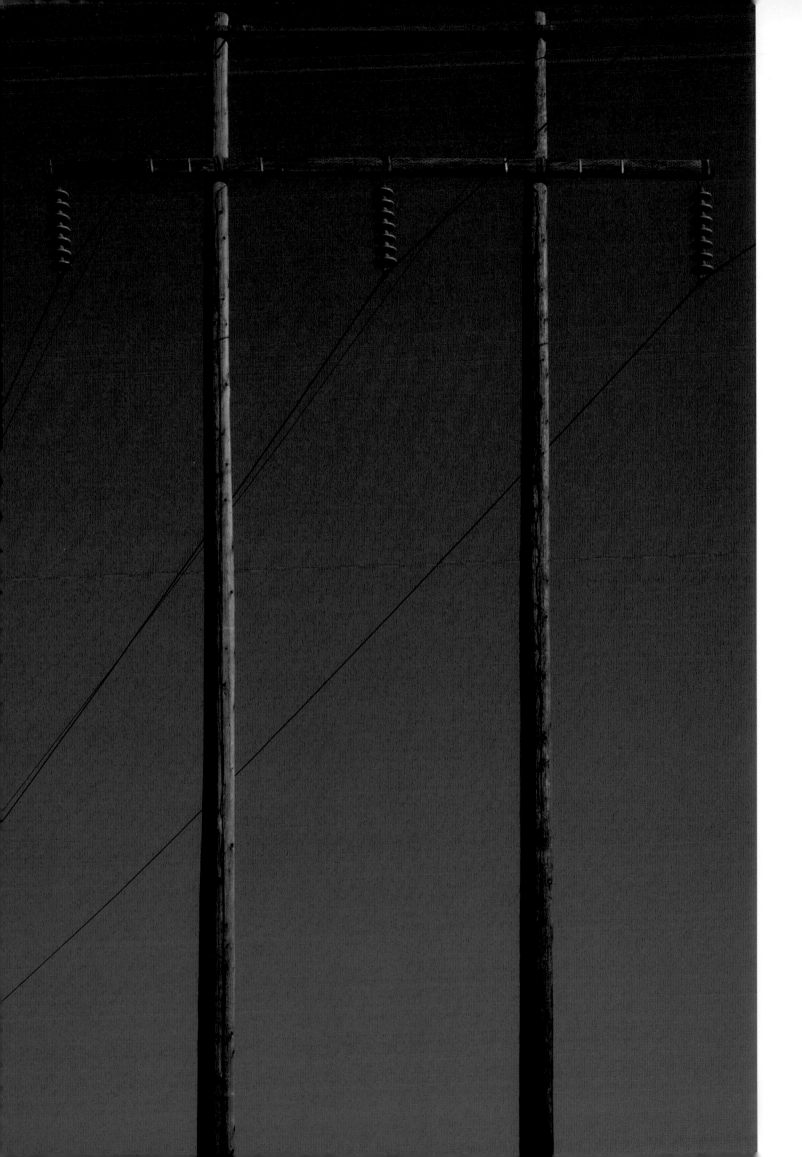

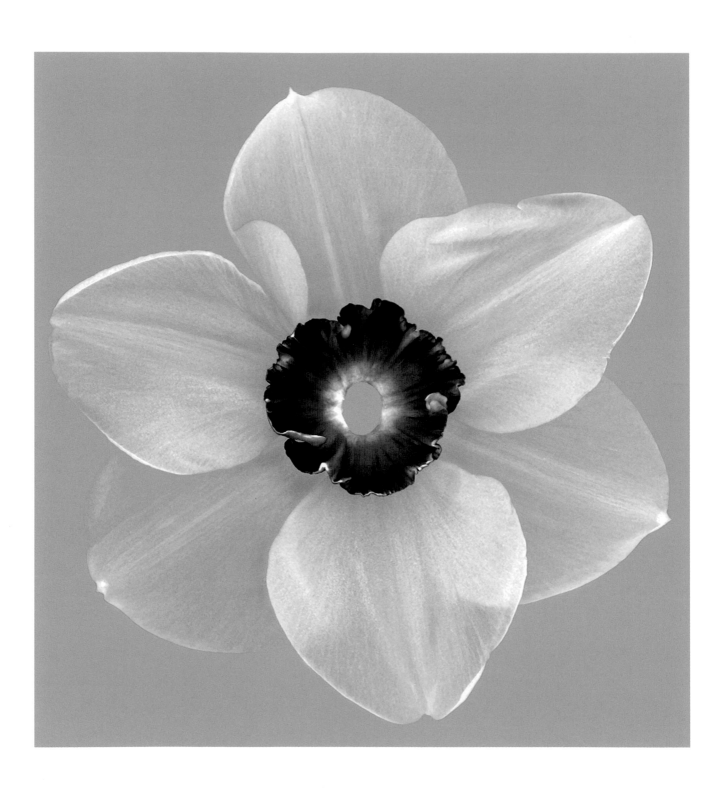

Blossom Dearie, 2007

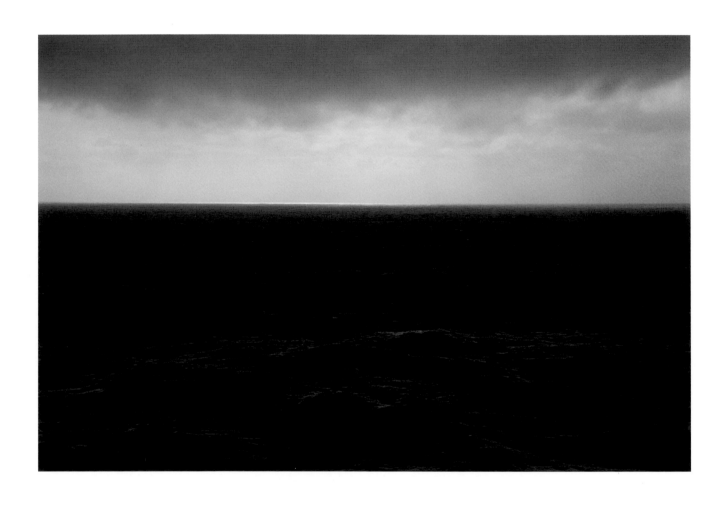

Atacama, 2010

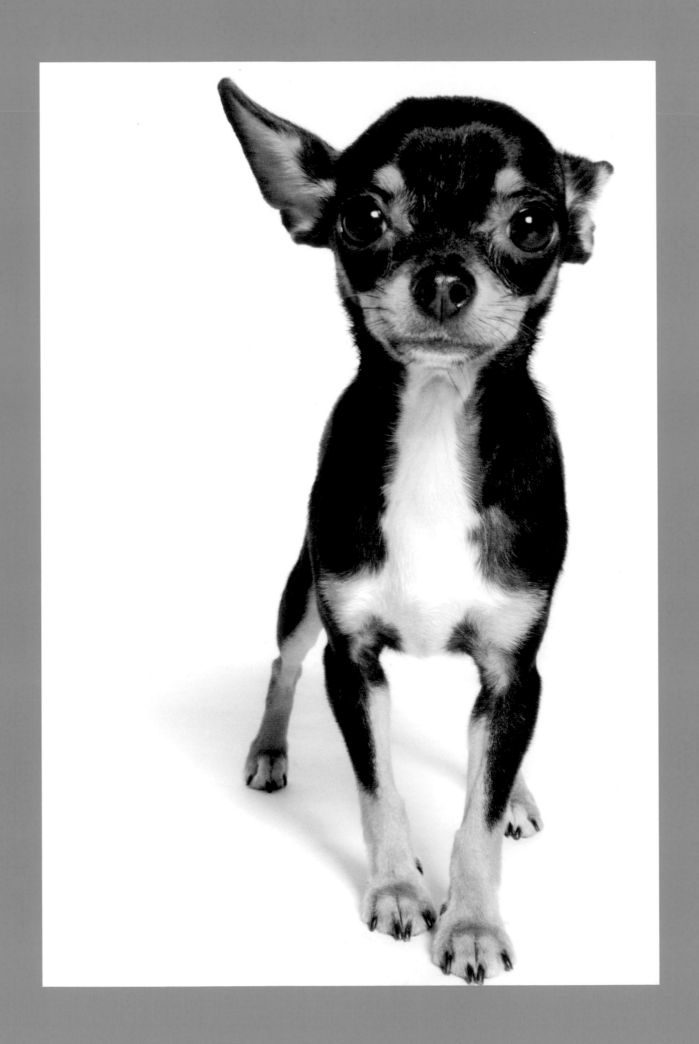

Small Dog, 2007

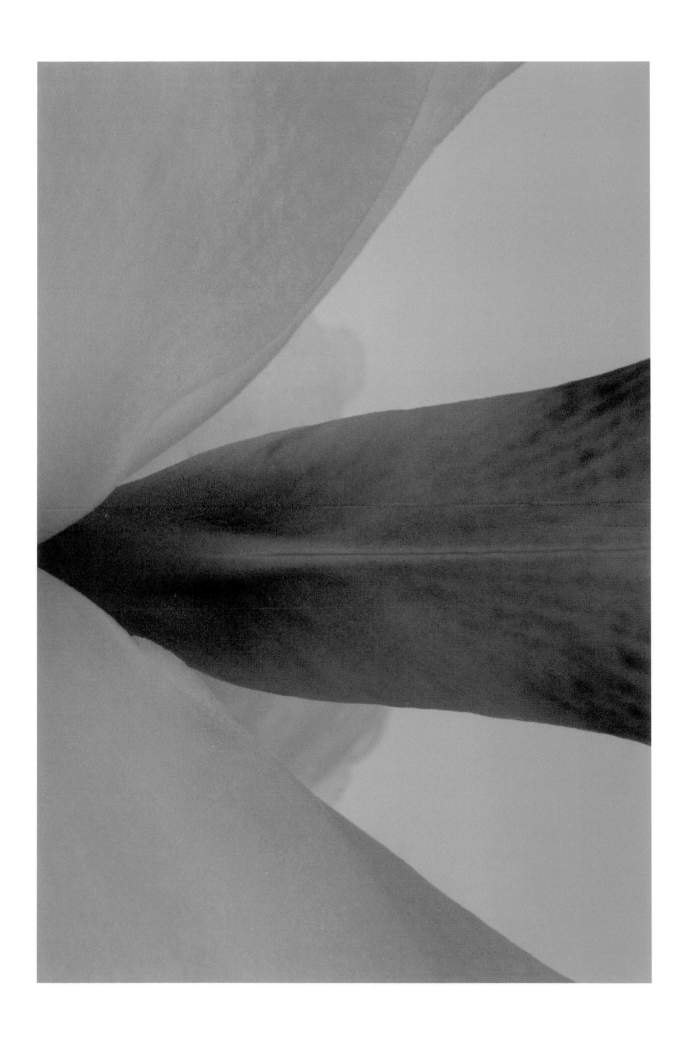

Deep Space 3, 2008

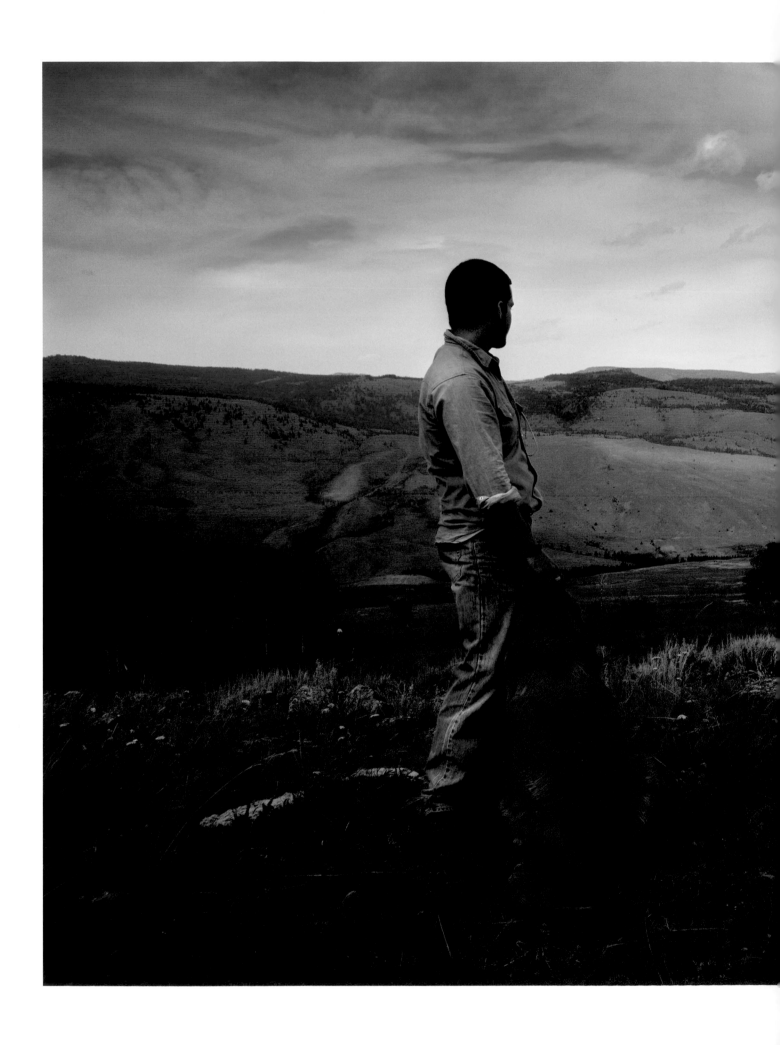

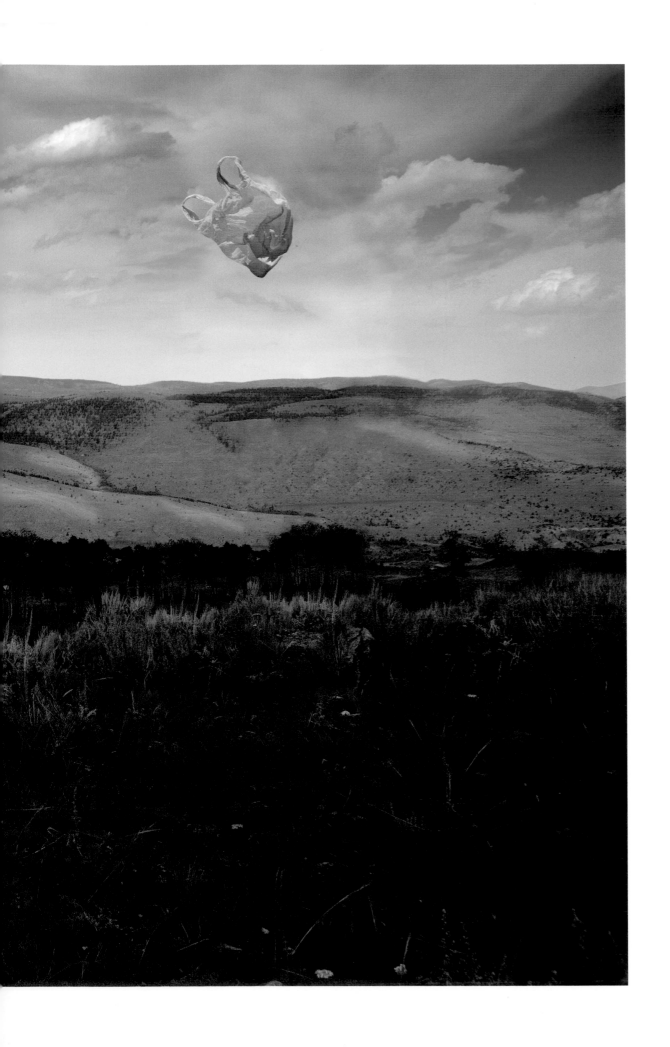

Untitled, 2011

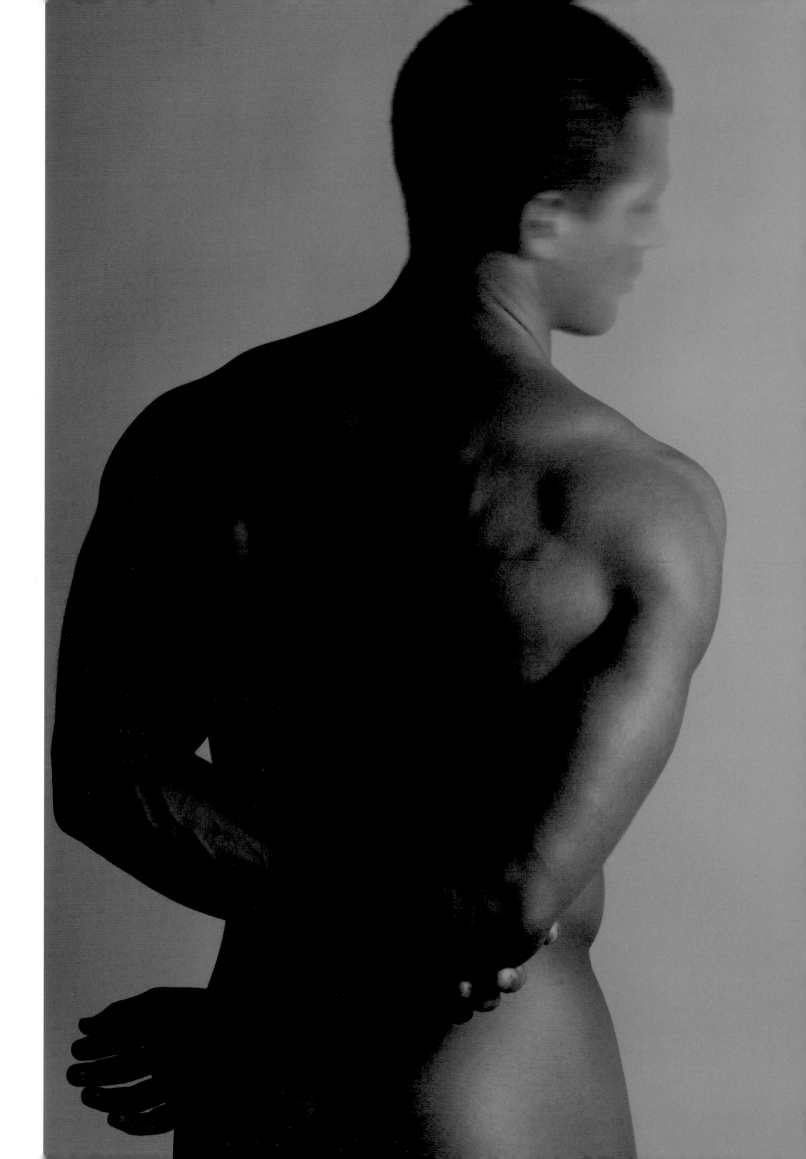

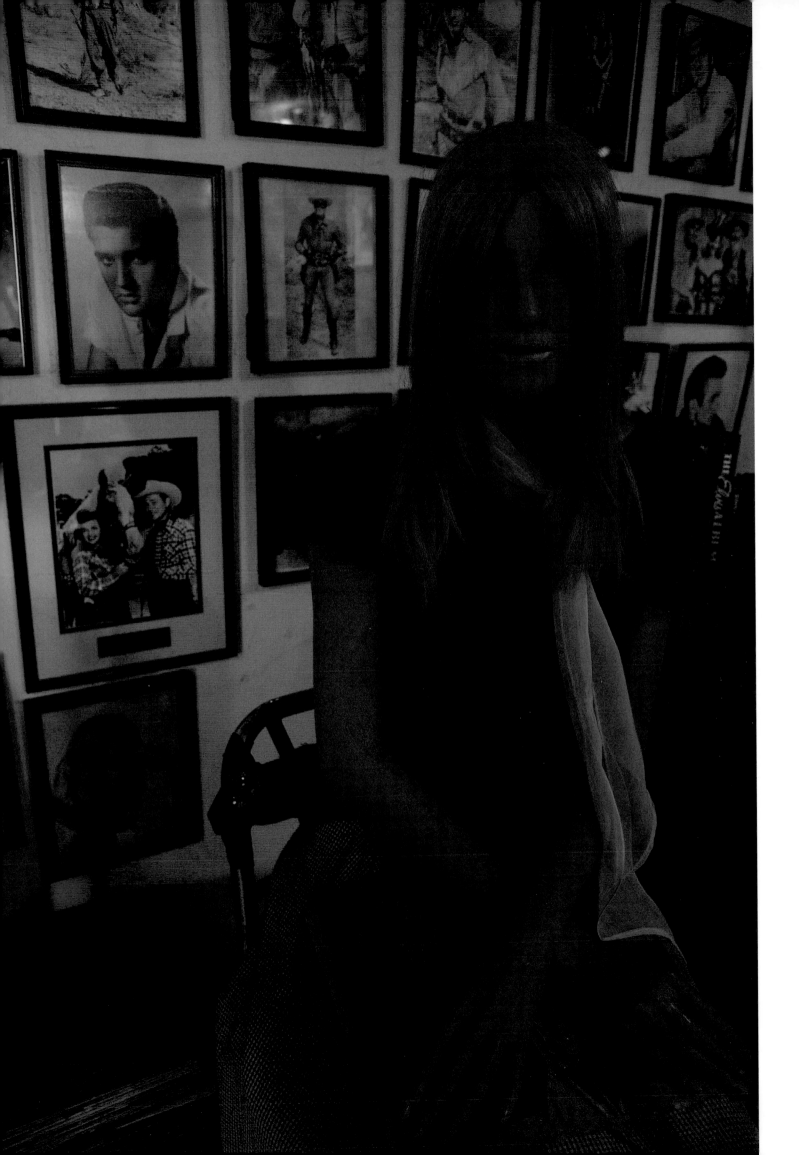

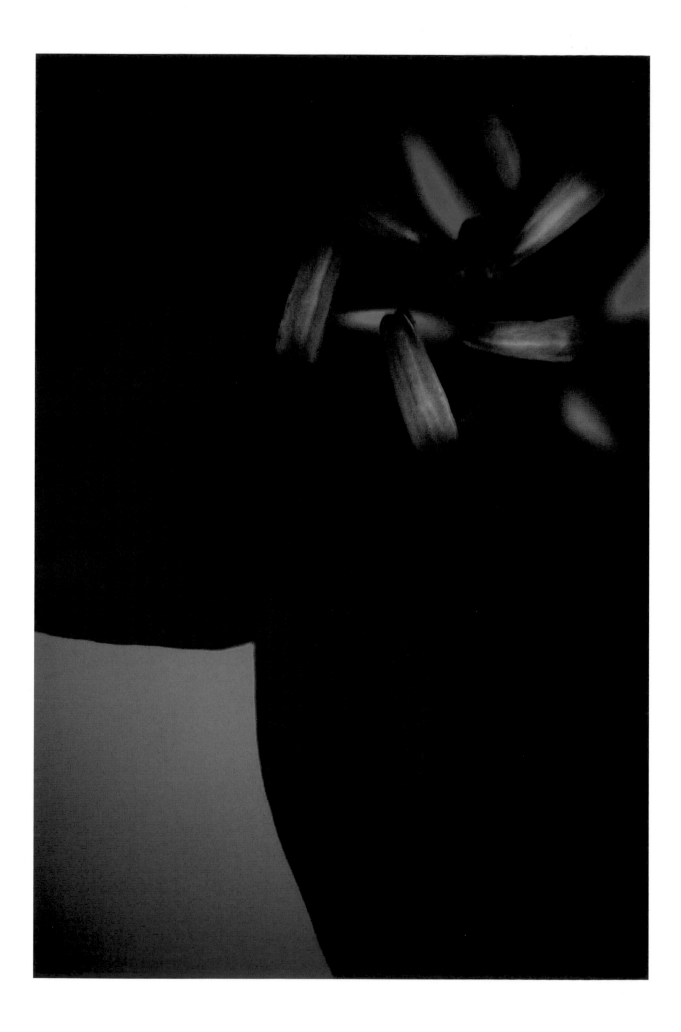

Room 602, 2007

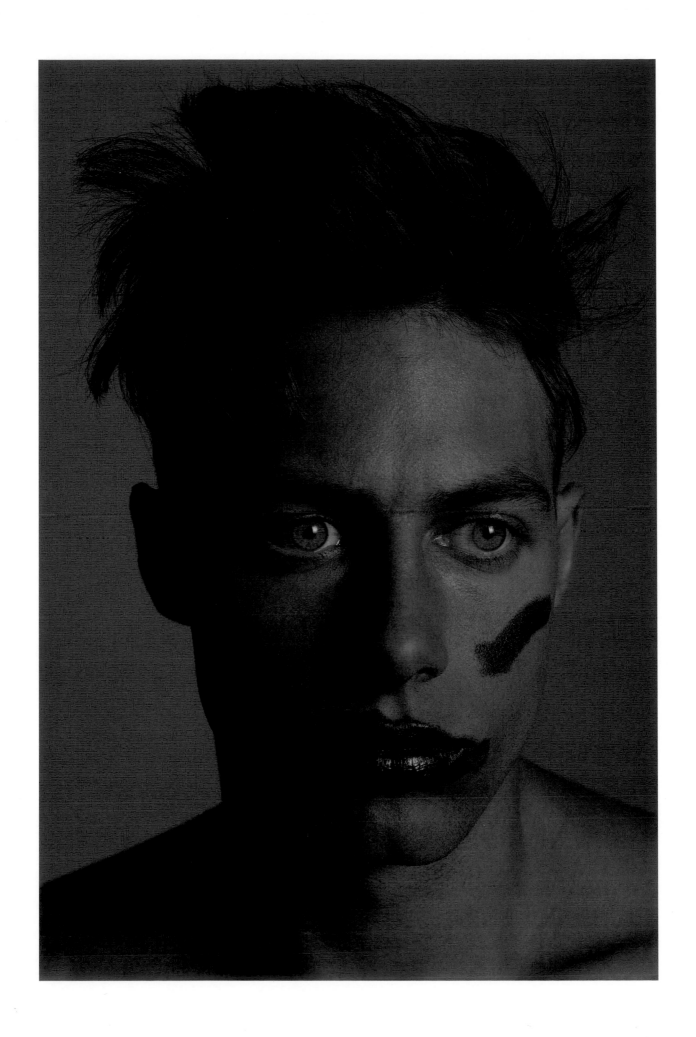

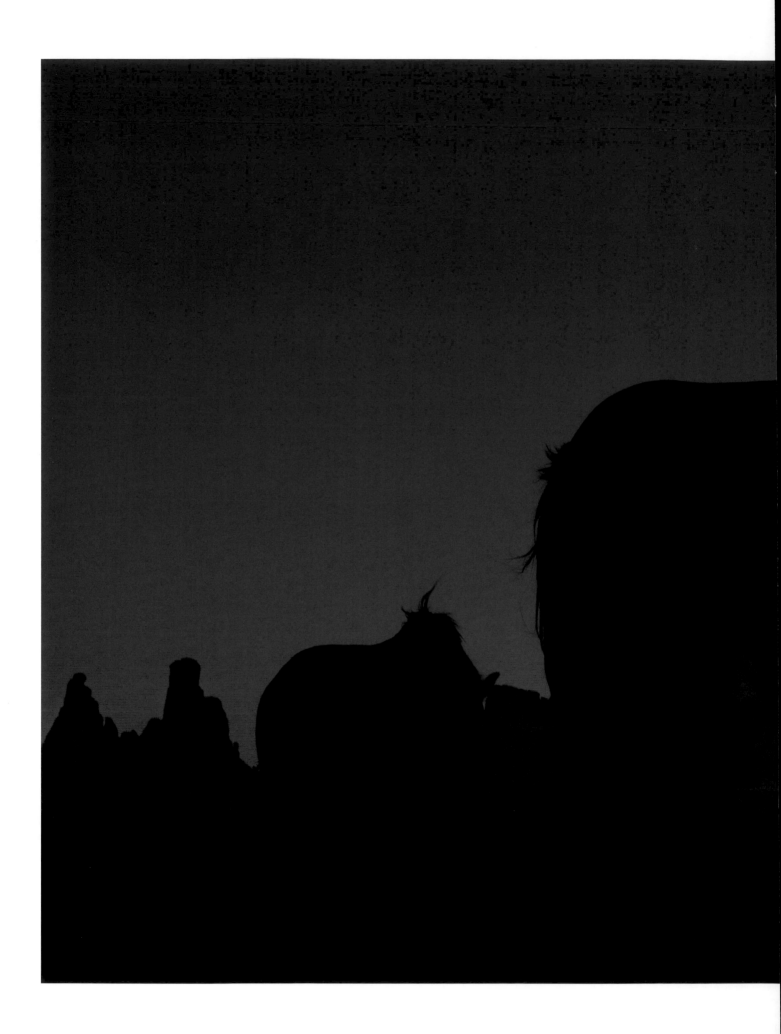

Monument Valley, 2011

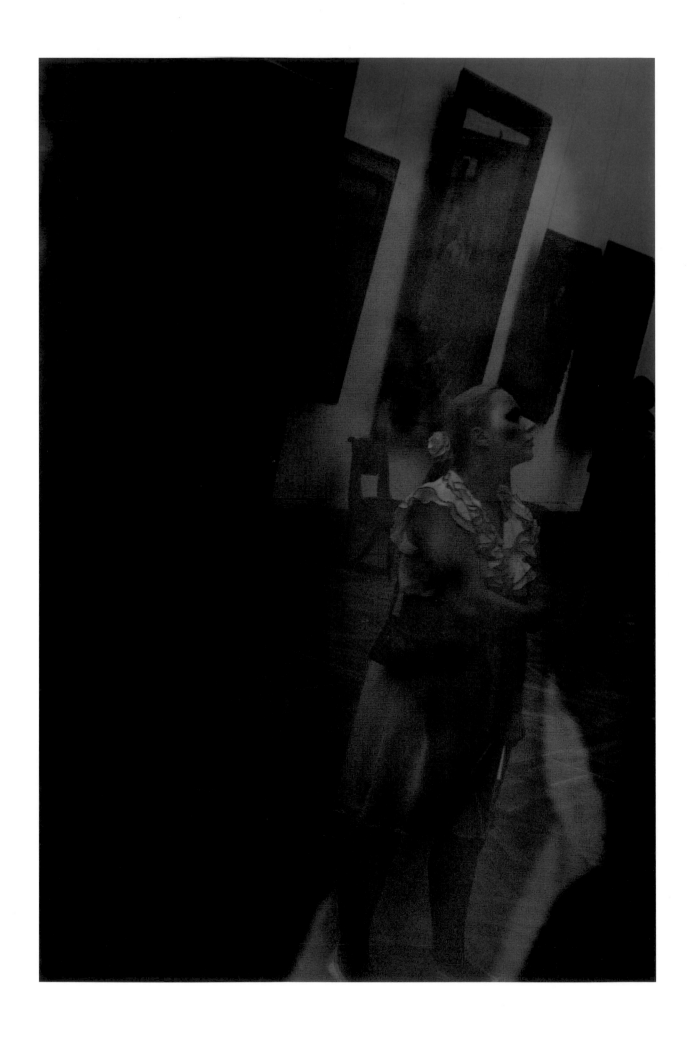

Secret, 2012

Grand Canyon, 2007

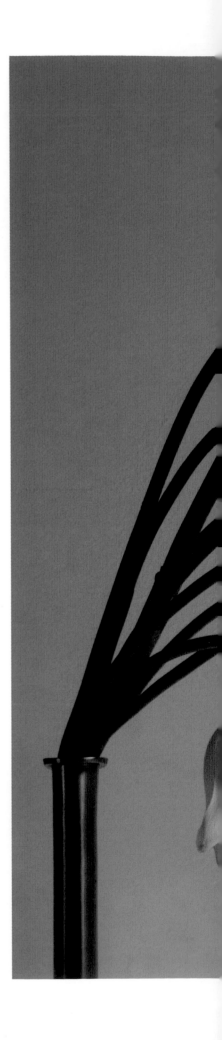

Philippe Petit, 2008

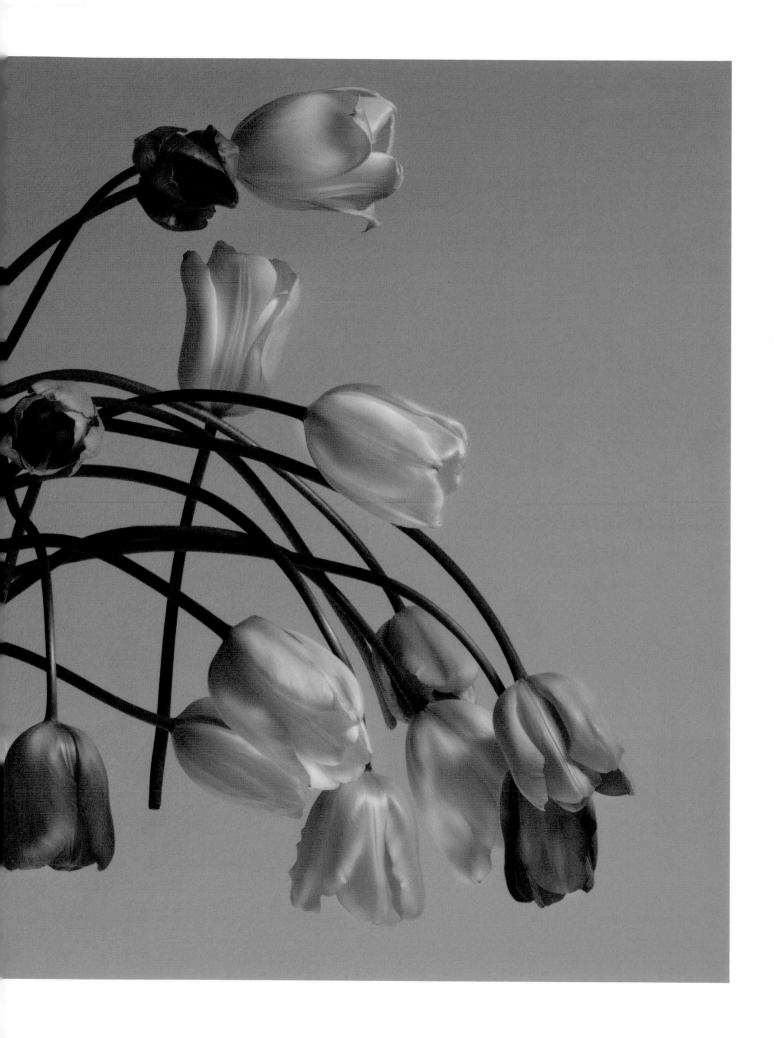

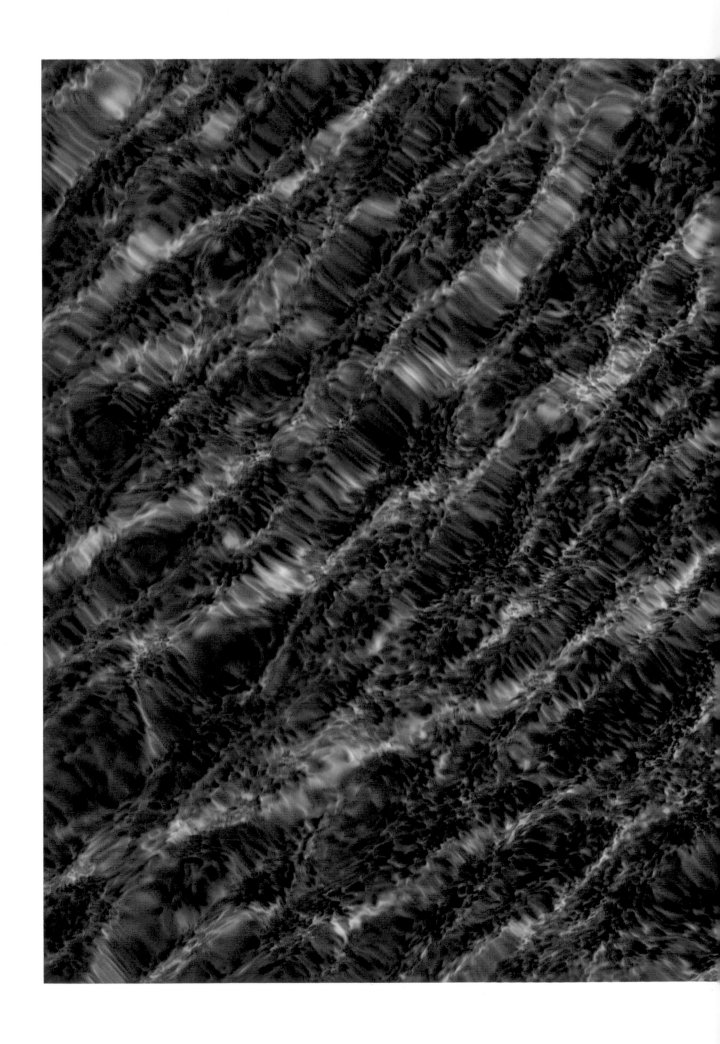

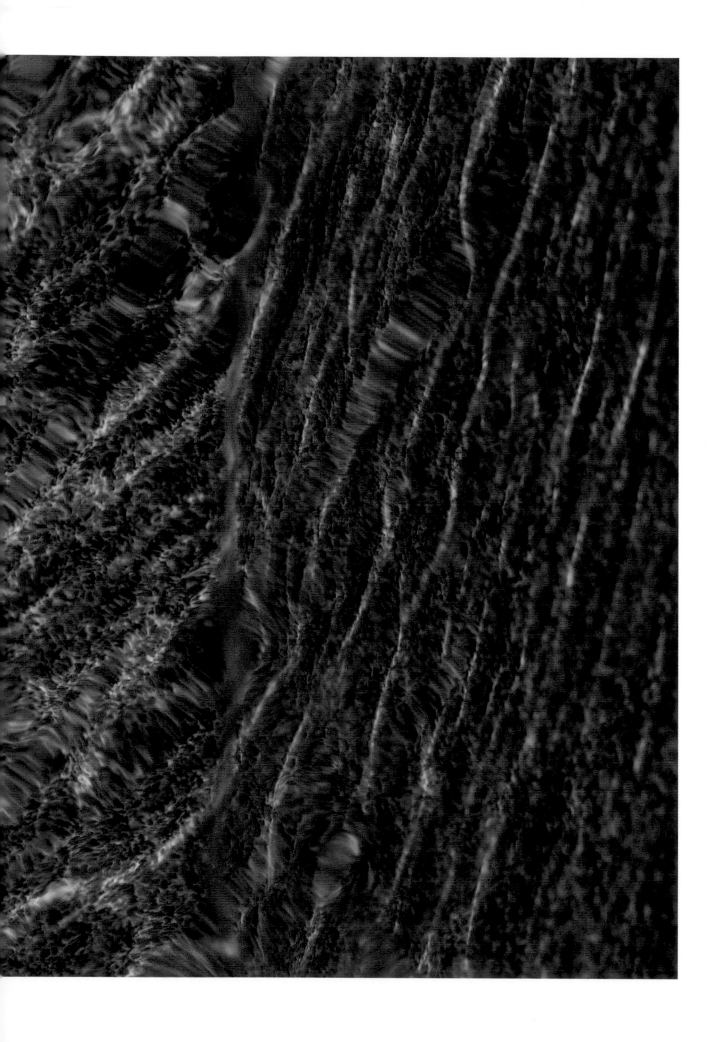

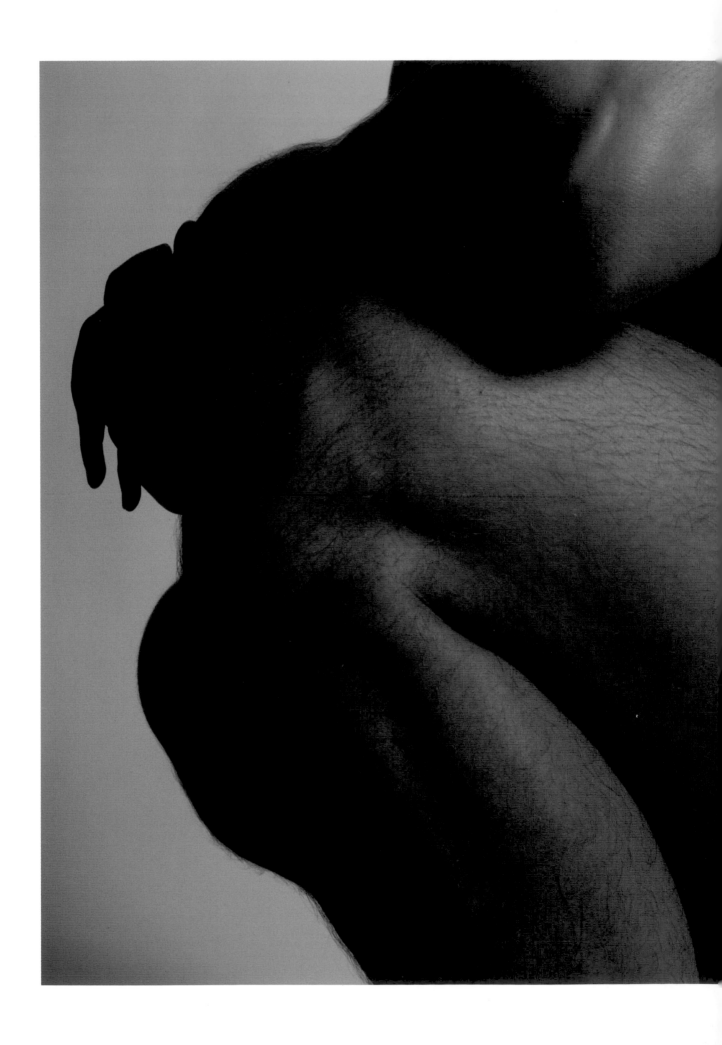

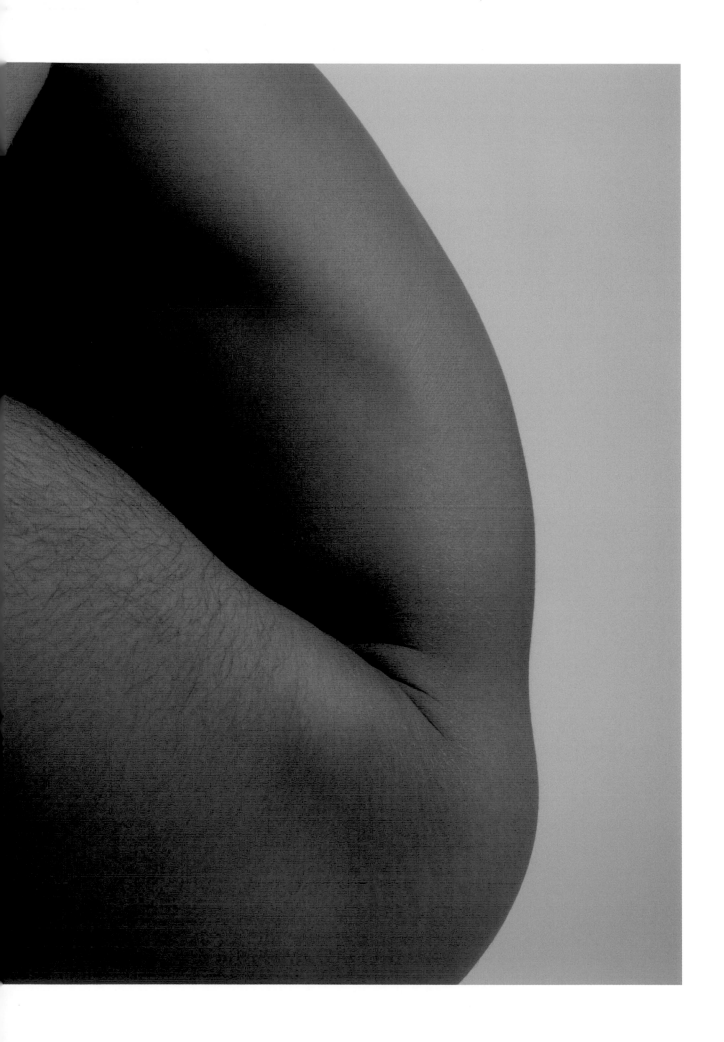

Mountaineer, 2010

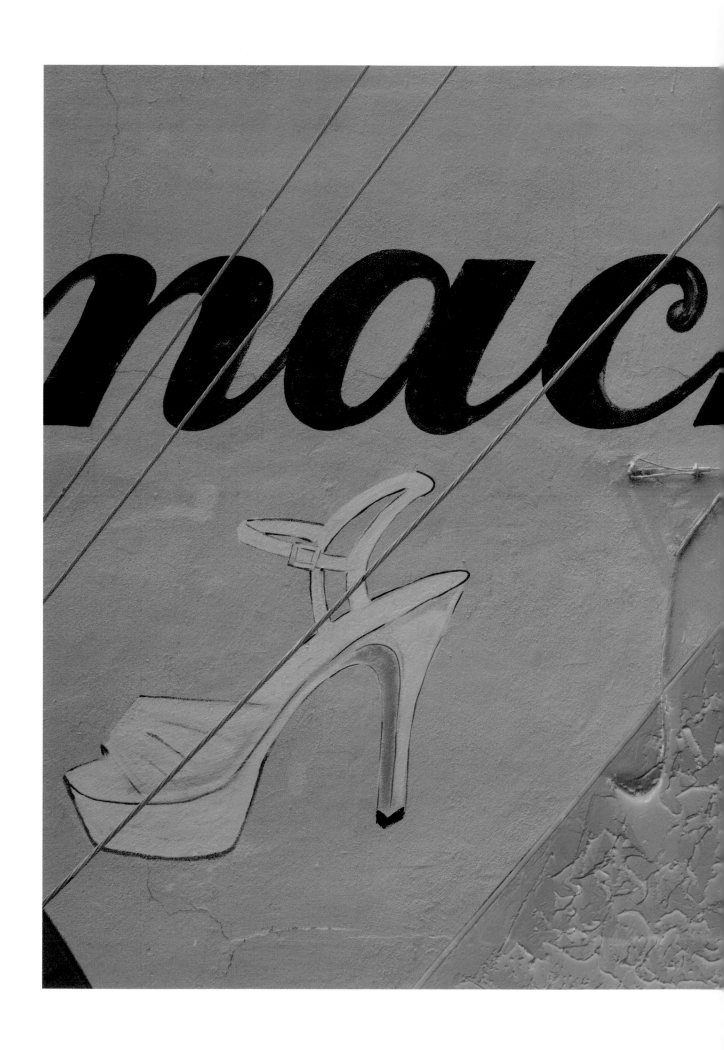

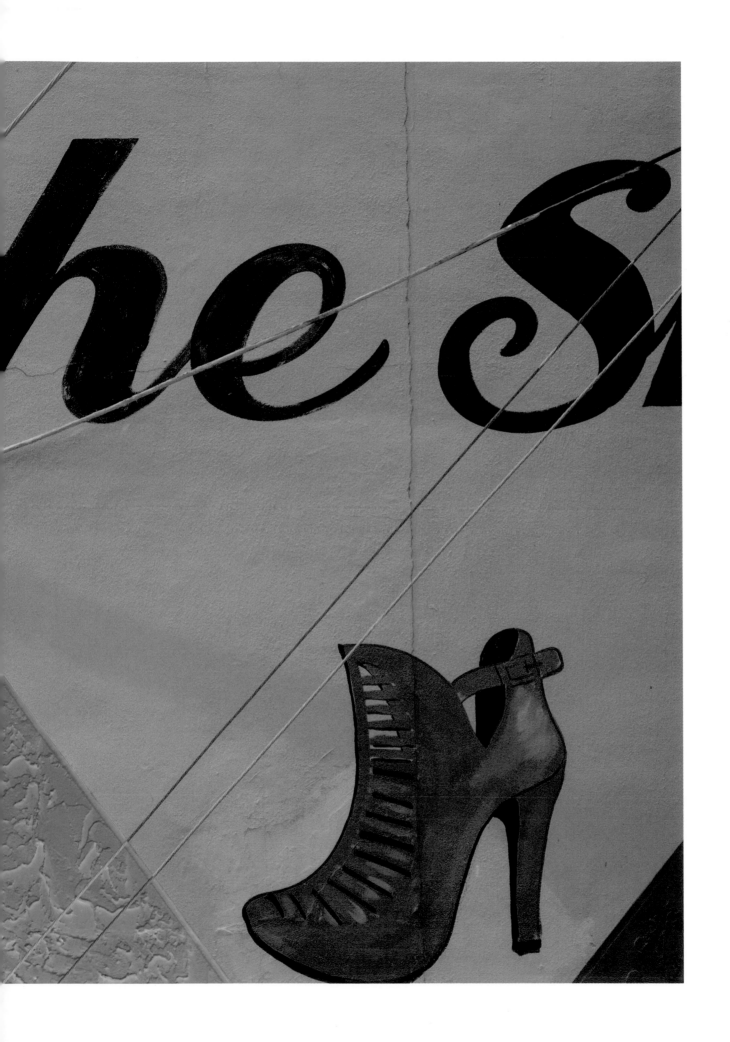

Miami, 2012

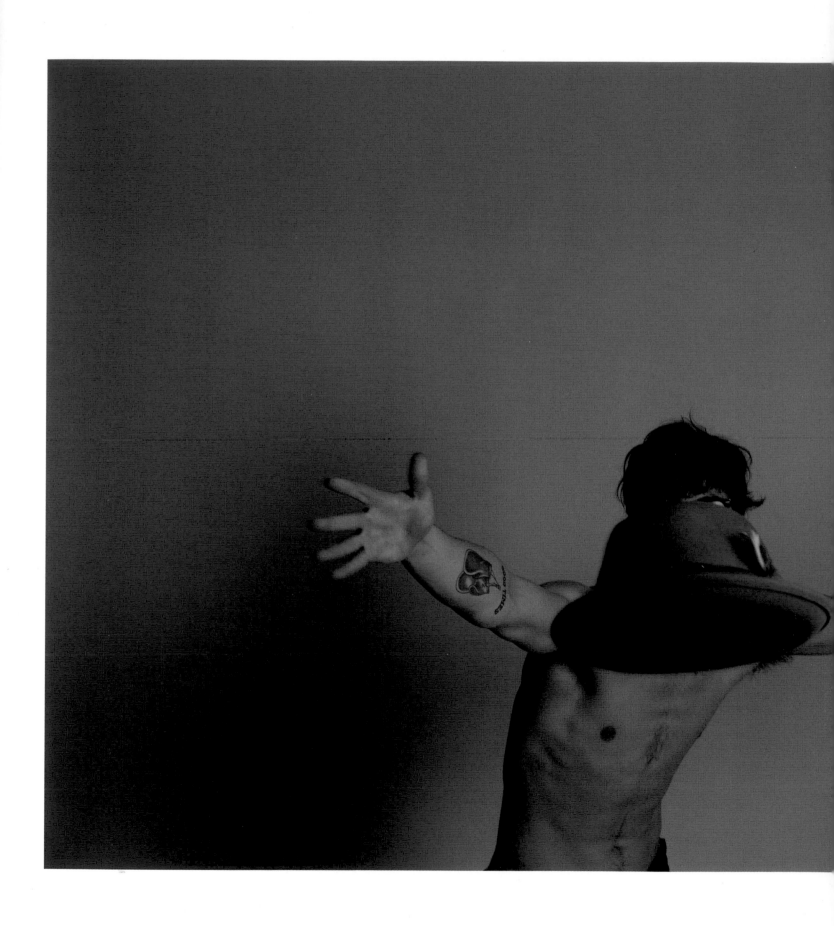

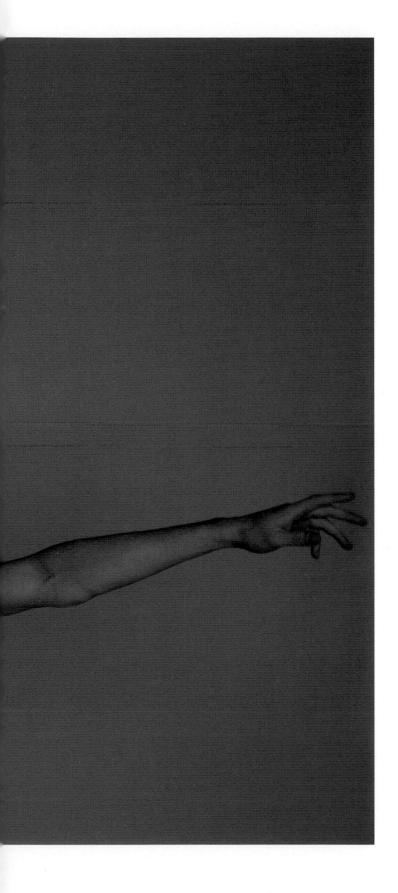

Charlie, 2012

Happy Daddy, 2006

"Paul Solberg's photos are subtle and reflective, both fragile and powerful at once."
- Calvin Klein

"Solberg's work is mystical, hopeful, and timeless; a world in which Solberg lives, and wishes we could all live."
- Jason Sheftell, *New York Daily News*

"They are haunting, these faces, like looking at Matthew Brady war photos. You look at them and you see the cost of war. Calm, quiet, repose before calamity."
- Dotson Rader

BIOGRAPHIES

PAUL SOLBERG (1969, Minnesota), before moving to NYC in 1996, studied Anthropology at the University of Cape Town, and traveled extensively to Bophuthatswana, Namibia, and South America. Solberg began his photographic career with his first published book, *Bloom* (2005), following *Puppies Behind Bars* (2006), *Tyrants + Lederhosen* (2011), and *Tattoos, Hornets & Fire* (2012). First known for his acclaimed still life portraits, the same depth is seen in his human subjects, such as the portrait of Ai Weiwei (2008), and in his haunting portraits of the Armed Forces, in *Service* (2010), which resides in such collections as the Elton John Photography Collection.

Solberg's photographs have been published in *Publisher's Weekly, Le Figaro, CNN, La Lettre, Interview Magazine, WSJ Int'l Edition, Conde Nast Traveler, The Huffington Post*, and *New York Daily News*. Solberg's work has been exhibited internationally in museums and galleries, including: La Casa Encendida (Madrid), Subte Museum (Montevideo), Galerie Sho Contemporary Art (Tokyo), Galerie Hiltawsky (Berlin), Karl Hutter Fine Art (LA), Casa de Costa (NY), Peter Marcelle Project (NY) and Galerie Catherine Houard (Paris).

Solberg lives in New York City

JOSÉ GUIRAO has been a major force in the avant-garde art movement in Spain for more than twenty five years. He has held top managements positions at numerous arts and cultural institutions, including Director of the National Museum Centre of Art Reina Sofía in Madrid, where he was responsible for the remodeling of the museum's permanent collection and the driving force in the Museum Extention (1994-2000). Director of Fine Arts and Archives of the Spanish Ministry of Culture (1993-1994), and Director of Cultural Heritage of Andalusia Boards of Governors (1988-1993).

Since 2001, he has been a director at La Casa Encendida, a multipurpose, cultural space and museum belonging to the Montemadrid Foundation, fostering some of the most important figures in contemporary art, including Patti Smith, Antoni Tapies, Juan Goytisolo, John Berger, and Nobel Peace Prize-winners Shirin Ebadi and Jody Williams. Today, Guirao serves as Director of the Montemadrid Foundation, where he continues to head one of the world's most dynamic enclaves for the arts.

Guirao lives in Madrid, Spain

EXHIBITIONS

2005 Ralph Pucci, New York, "Bloom" premiere
2005 Galeria Sandunga, Granada, Spain
2007 Flo Peters Gallery, Hamburg, Germany
2008 Sebastian Guinness Gallery, Dublin, Ireland
2009 Casa Encendida Museum, Madrid / "Mistaken Identity"
2009 Centro Ricerca Arte Attuale, Verbania, Italy / "Flower Power"
2010 Flo Peters Gallery, Hamburg, Germany / "Three!"
2010 SUBTE Museum, Uruguay / "Mistaken Identity"
2010 Clic Gallery, New York / "City Surf"
2010 Christopher Henry Gallery, New York / "Solberg"
2010 Karl Hutter Fine Art, Los Angeles/ "Tyrants + Lederhosen"
2011 Galerie Hiltawsky, Berlin, Germany / "Andy Dandy + Other works"
2012 Catherine Houard, Paris / Hilton Brothers Makos Solberg
2012 Galerie Sho Contemporary Art / "SERVICE"
2012 Outdoor Exhibition, Fort Lauderdale, FL / Hilton Brothers "1OUTSIDE"
2013 Miller Gallery, Cincinnati / "The Hilton Brothers, Christopher Makos, Paul Solberg"
2013 Casa de Costa, New York/ "SERVICE"
2013 Kiwi Arts Group, Art Week Miami / featuring "SERVICE" series
2014 Boyd | Satellite Gallery, New Orleans / "Paul Solberg SERVICE"
2014 Peter Marcelle Project, New York / "The Hilton Brothers, Christopher Makos, Paul Solberg"

ACKNOWLEDGMENTS

Pau Garcia, Dotson Rader, Rob Roth, Laura Braggion, Christy + Lou Cushman, Linda + Andy Safran, Florian Bälz, Andreina Longhi, Federico Orsi, Lusi Nesbitt, Alicia Romay, Marc Lannoy, Helena Iorio, Sam Shahid, Maria Dawkinson, George Frowick, Arsalan, Enrique Pastor, Camilla Alfthan, Panos Kaliabetsos, Demetri Chriss, the Smatt-Robbins Family, Eric Domege, Christian Roth, Steinunn Sigurd, Páll Hjaltason, Maxime Deau, James Moore, Keith Guldalian, Charles Myers, Samantha Chadwick, Yan Ceh, Danila Kozlovsky, Ana Garcia, Tom Shaffer, Shasha Liu, Dr. David + Kim Ouyang, Chris + Anna Balian, Tom Ligon, Todd Sanfield, Pierre Amour, Barclay Bram, Jean-Jacques Naudet, Laura Mainer, Alison Yeung, Mark Sink, Martin Cis, Anna Robbins, Olivier Giugni, Rolland Miro, Panos + Danay Manias, Michael + Beth Richards, Carolina Olcese, Bertil Espegren, Holly + Ben Vaughan, Jerome Sans, Max Gleason, Sissy Johnson, Jason Costa, Josh McNey, Lizzette + Constantino Pozzi, Allison Georgio, Graham Walsh, Lisa Silhanek, Kate Shanley, Robert Lococo, Roland Chakkal, Peer-Olaf Richter, Pat Loud, Troy Taylor, Shaun Gunderson, Tomás Snoreck, Aliona Doletskaya, Julie Cushman, Betsy Fox, Hans + Ulla Pochhammer, Clément Zheng, Mick Kopetsky, Helene Brown, Paloma Garcia, Stewart Shining, Ida Rislow, Claudia Rispoli, Rudolf Booker, Kelly Klein, Julie + Faisal Al Hejailan, Laura Mainer, John Barboni, Ginette Bone, Blake Boyd, Jorgen + Tanya Rosenberg, Eric Shiner, Ned Kelly, Chris Salgardo, Cindy Sherman, John D'Aleo, Jacques Fieschi, Sara Waddell, Ian + Verena Cameron, Joao C, Lauren Brown, Nicholas Armstrong, Shelly + Vincent Fremont, James + Catherine Xu, Ralph Pucci, Marcel + Carmen Etter, Sam Bolton, Roseanne Barr, Nils Aberg, Robyn Jensen, Joey Rosa, Fiona Cibani, Mark Montgomery, Peter Marcelle, Dr. Fahad Kahn, Wade Williams, Catherine Coleman, Sir Elton John, Michele Anthony, Ai Weiwei, Kevin Calica, Stephen Kinsella, Ed Shilling, Loraine Boyle, Andreas Eberhart, Paul Washington, Patti Bruni, Yara Sonseca, Dorothy Blau, Emilio Saliquet, Antonio Molina, Carolina Olcense, Enrico Bruni, John Esposito, Nadine Dinter, Calvin Klein, Catherine Enright, Dennis Shah, Pilar Vico, Alex Bentley, Rick Mayo-Smith, Salem Cibani, Pamela Chelin, Luba Michailova, Joan Kenney, Peter Wise, José Guirao, Mary + Conrad Solberg.

Special thanks to Chris. The aerial view we share is like no other. Marta, your unflappable support keeps me creatively conscious.

Laura Braggion for opening the doors and letting us take over her 17 Century Etruscan casale for 10 days on Lake Bolsena, sharing the place where Cy Twombly and William de Kooning worked and played. It was the perfect wild environment to work on this book, amidst the heavy wind and artist's ghosts banging on the windows.